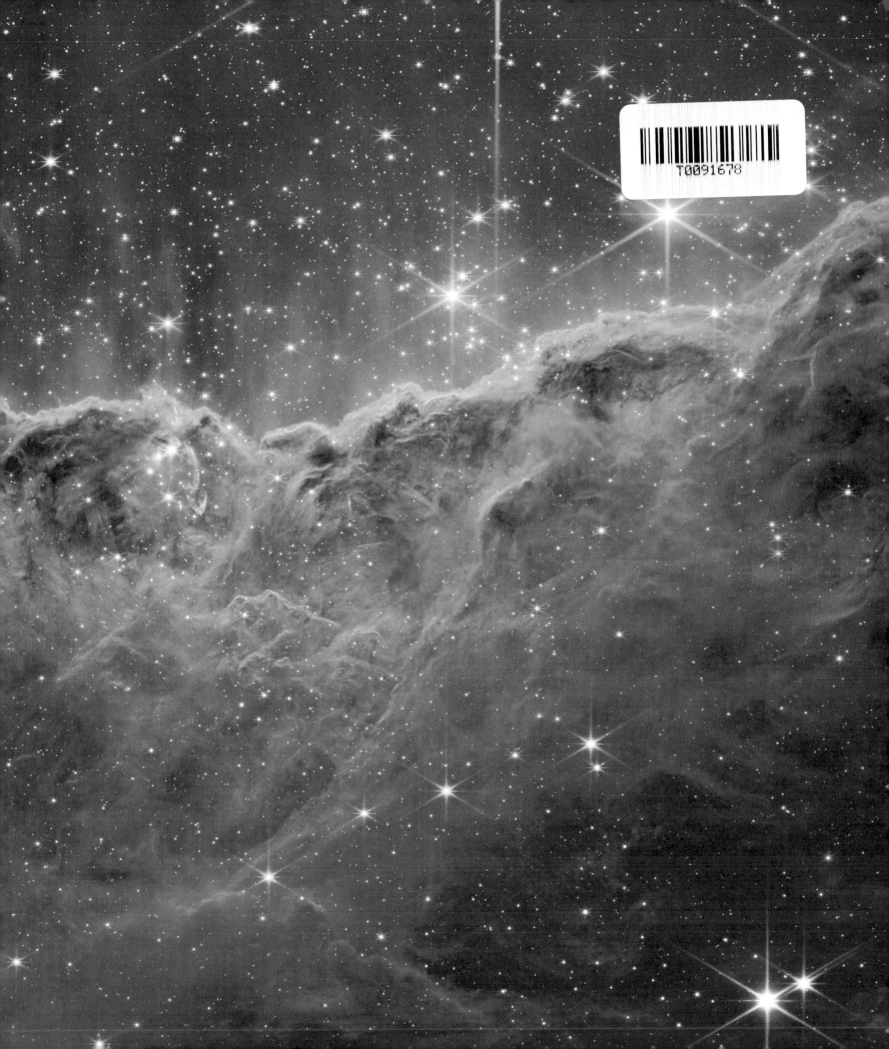

Inside the Star Factory

Inside the Star Factory

The Creation of the James Webb
Space Telescope, NASA's Largest and
Most Powerful Space Observatory

NASA Photographer Chris Gunn,
with Christopher Wanjek

The MIT Press
Cambridge, Massachusetts
London, England

publication supported by a grant from
The Community Foundation for Greater New Haven
as part of the **Urban Haven Project**

The MIT Press would like to thank the anonymous peer reviewers who provided comments on drafts of this book. The generous work of academic experts is essential for establishing the authority and quality of our publications. We acknowledge with gratitude the contributions of these otherwise uncredited readers.

This book was set in URW DIN by The MIT Press. Printed and bound in China.

Unless otherwise credited, all photographs by Chris Gunn.

Endpaper image: A peek inside a star factory. Captured in infrared light by JWST's Near Infrared Camera (NIRCam) and Mid-Infrared Instrument (MIRI), this region of the Carina Nebula some 8,000 light-years from Earth and spanning many light-years across is bursting with a multitude of newly formed stars, many never before seen. Credit: NASA, ESA, CSA, STScI.

Library of Congress Cataloging-in-Publication Data is available.

ISBN: 978-0-262-04790-6

10 9 8 7 6 5 4 3 2 1

To my wife, Yeme, and my daughter, Blaine.
—Chris Gunn

To my mentor Steve Maran, for his years of direction, friendship, and wit.
—Christopher Wanjek

Contents

Preface
A Cosmic Journey

Step outside tonight and peer up at the dark sky through a drinking straw. Pretend that's your telescope. Your field of view will be less than a quarter of an inch, or around 6 millimeters. Yet in that tiny line of sight lie more than 100,000 galaxies far *far* beyond what you can see. In every field of view the width of a straw—to the east, west, north, and south—lie another 100,000 galaxies.

How many galaxies are there in the universe? How soon did they form after the Big Bang? What did the first galaxies look like? What kind of stars did they possess? Were their shapes molded by the strong gravity of black holes? Did galaxies start small and merge? Did they form along filaments of unseen dark matter, like pearls on a string? Likewise, when and how did stars first form? And when did planets and the conditions for life as we know it—liquid water and protective atmosphere—begin to emerge? Are we alone, or are there other Earth-like planets with life in our galaxy and beyond? We have as many questions about our origins as there are stars in the sky, it seems. The James Webb Space Telescope will help to answer them.

The past few decades have brought a windfall of knowledge about our universe and our place within it. During the years that the Webb Telescope, or Webb for short, was in development, astronomers have found evidence for the Big Bang and birth of the observable universe 13.77 billion years ago. They have found evidence of black holes everywhere, including the centers of most galaxies. They have found evidence of planets everywhere, too, orbiting the vast majority of stars in our galaxy. And most perplexing, astronomers say there is a mysterious force, dubbed dark energy, that seems to be accelerating the expansion of the universe, pushing every galaxy farther and farther away from each other.

Now enter the James Webb Space Telescope. The most ambitious space-based astronomy project ever conceived, Webb has bold goals of observing the first stars and galaxies, documenting the structure and evolution of the universe over its current lifetime, uncovering the creation of new stars and planets, and searching for bio-signatures from Earth-size planets in other solar systems. Webb's successful launch and deployment marks the culmination of three decades of planning, building, sweating, and fretting by NASA and its international partners, the European Space Agency and the Canadian Space Agency.

This book documents, in photographs, the building and launch of the James Webb Space Telescope, which constituted more than 100 million person-hours to bring to fruition. Every element of Webb's creation pushed new engineering boundaries. The primary mirror: nothing like it. What you'll see in these photographs is a gold-plated mirror 6.5 meters, or 21.3 feet, in diameter comprising 18 independent hexagonal segments that need to behave as one, unprecedented for a space-based observatory. Beneath that reflective gold is a base of beryllium, a rare metal mined solely in Utah that needed to be uniquely purified, processed, and polished to meet the challenging specifications of the mission in terms of flatness and rigor to endure a temperature of around −230°C (−382°F). Also, that sunshield: nothing like it. That's five spaced layers of a tissue-paper-thin material called Kapton coated with reflective aluminum and, in parts, silicon. This shield, the size of a tennis court, enables the telescope to passively cool to the necessary −230°C for the infrared instruments to operate properly. Layer by layer, the shield diminishes the sun's heat, which hits the first layer at 110°C. And the deployment of the telescope itself: there is nothing like it. The massive telescope and sunshield needed to be folded to fit into the rocket delivering the telescope to space and then unfolded 1.5 million kilometers from Earth.

Bold concepts such as the James Webb Space Telescope take time and money to turn into reality. Derided as the "telescope that ate astronomy," billions of dollars over budget, ten years over schedule, nearly canceled twice, Webb was always too big to fail. The engineering team behind this project was keenly aware of the challenges and the pressure. Many spent a sizable portion of their careers dedicated to perfecting the telescope, its instruments, and its launch vehicle, knowing that they had only one chance to get it right. Unlike the Hubble Space Telescope—which is in low-earth orbit and within reach of servicing (and famously flawed, needing post-launch correction)—Webb will be in orbit four times farther than the Moon. Had anything gone wrong with the launch or instruments, billions of dollars would have been wasted . . . and thousands, if not millions, of dreams crushed.

We have only begun to glimpse at the wonders of the universe. Webb is poised to engage the public on a cosmic journey into the unknown. Let's then meet the scientists and engineers who stood on the verge of the impossible and delivered the greatest telescope ever flown.

Introduction

A Telescope Thirty Years in the Making

Grand Beginnings

In September 1989, six months before the launching of the famed NASA Hubble Space Telescope, more than a hundred astronomers and engineers gathered near Johns Hopkins University in Baltimore, Maryland, to brainstorm about what great thing to build next. Initiating this Hubble successor activity a few years prior was Riccardo Giacconi, an immensely respected astrophysicist and director of the Space Telescope Science Institute (STScI) who would win the Nobel Prize in Physics in 2002 for his decades of work in pioneering the field of X-ray astronomy. Giacconi understood that building a space-based observatory could take decades. Hubble, after all, was begun in the 1970s. Now, with Hubble nearing delivery to the Space Shuttle Discovery to launch it into low-earth orbit, Giacconi fretted that nothing was even on NASA's radar screen for a successor come 2005, the end of Hubble's expected fifteen-year lifespan. "Start working on the next big mission," he told his deputy at STScI, Garth Illingworth, in 1986. "It will take a very long time."

Ideas had been kicking around for a few years. Engineers at NASA Marshall Space Flight Center, circa 1980, had studied the possibility of launching an 8-meter telescope on the tip of the external tank of the space shuttle. Note that Hubble's optical telescope mirror, by far the most massive ever placed in space at the time, was *only* 2.4 meters and could fit in the space shuttle bay. In the mid-1980s, the Space Science Board, comprising members of the prestigious National

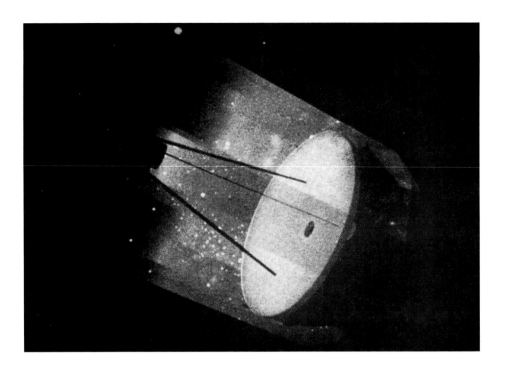

The first sketch of the Next Generation Space Telescope, in *Workshop Proceedings: Technologies for Large Filled-Aperture Telescopes in Space*, 1991, courtesy Garth Illingworth (coeditor).

Academies of Sciences, Engineering, and Medicine, were thinking about going big, too. They recommended that Hubble's successor should be a large-area, high-throughput, infrared-ultraviolet telescope with an 8- to 16-meter mirror. STScI engineer Pierre Bely also described a 10-meter telescope successor to Hubble in a paper in 1986.[1] Mind you, such a diameter is staggering, larger than the size of world-class ground-based telescopes at that time.

These lofty concepts peppered the Baltimore workshop, called "The Next Generation: A 10 m Class UV-Visible-IR Successor to HST," hosted jointly by STScI and NASA and organized by Illingworth and Bely. Fantastic ideas batted around included a 10-meter telescope in geosynchronous high-earth orbit some 36,000 kilometers from Earth, compared to Hubble's distance of 500 kilometers, and a 16-meter telescope on the Moon. The workshop participants concluded that these both were realistic goals. Optimistically, they hoped this Next Generation Space Telescope (NGST), as they were calling it, could launch by 2010, which they assumed then to be a regrettable five-year gap after the end of Hubble but better late than never. They also saw the necessity for international partnerships to help pay for the creation.

As far as the science was concerned, the workshop participants had some understanding of the limits of Hubble. Primarily an optical observatory, Hubble would not be able to observe the first generations of stars and galaxies. The reason is because these objects are now so distant from us and receding so quickly

from our view with the expansion of the universe that their light—once dominant in the optical and ultraviolet range, like our Sun's—has stretched into the infrared range. Thus, NGST would need to be an infrared observatory if we hoped to "go deeper" than Hubble.

Quickly came the first delay to their plan. Hubble launched successfully in 1990, but its primary mirror was seriously flawed. Ground improperly, the mirror had a spherical aberration that produced blurry images, a remarkably sloppy error for such an expensive and high-profile mission. STScI, which operated Hubble for NASA, needed to focus on fixing this problem. Fortunately, NASA HQ was still interested and funded NGST technology development studies and a major workshop through a program called Astrotech21 until national budget issues circa 1991–1992 led to cuts to NASA. At that point NGST was placed on a backburner for the next three years. Hubble—fortunately within reach by the space shuttle, per design—would be repaired during a 1993 servicing mission by NASA astronauts, the first space-based telescope repair of its kind.

The Hubble error, interestingly, demonstrated the relative ease with which Hubble could be upgraded. This took some pressure off the NGST development time, as Hubble's lifespan could be extended to 2010 with subsequent servicing missions. Also, by 1994, Hubble already was exceeding expectations. With its 2.4-meter mirror now corrected, Hubble could see deeper than astronomers had predicted. This meant that the NGST mirror could be smaller in diameter yet still meet some of its observational goals. Indeed, the recommendation of the 1996 HST and Beyond Study—the so-called Dressler Report, named after study chair Alan Dressler of the Carnegie Institution for Science—called for a space-based telescope with only a 4-meter mirror and simple near-infrared instrumentation, in a cost range between $500 million and $1 billion.

Ironically, that mirror recommendation almost immediately got boosted back to a more expensive, larger diameter as a result of the "faster, better, cheaper" mantra coined by NASA administrator Dan Goldin. Tied to Goldin's slogan was the notion of thinking big and taking chances, too. At the 1996 winter meeting of the American Astronomical Society, Goldin gave a major speech. He saw Dressler in the audience and teased him publicly about his recommendation. "Why do you ask for such a modest thing? Why not go after six or seven meters?" Goldin got a standing ovation with that line; and NGST stayed big and bold, with Goldin ultimately supporting an 8-meter telescope.

By this point, NGST was destined for high-earth orbit, not the Moon. That 16-meter lunar-based telescope was never seriously considered. Illingworth later confessed to discussing this at the Baltimore workshop to support NASA's response to President George H. W. Bush's plan articulated in 1989 to return humans to the Moon and then set off for Mars. You see, a telescope on the Moon

would provide a reason to have humans on the Moon. Bush's plan, known as the Space Exploration Initiative, was poorly conceived and poorly received. And NGST divorced itself from it soon after Bush left office.

By 1996, NGST was starting to take shape. John Mather had joined the project in the fall of 1995, recruited to lead a small team to advance the NGST mission concept. Mather was hot off the heels of the successful COBE mission, which provided evidence for the Big Bang. He would share the 2006 Nobel Prize in Physics for this. Mather's team included Pierre Bely, Peter Stockman, and Eric Smith, who later became the JWST Program Scientist. They and three companies enlisted for independent feasibility studies were reaching a similar conclusion: To see the very first galaxies and supernovae in the distant, high-redshift universe, NGST would require, as discussed in the 1980s, an 8-meter mirror passively cooled with a sunshield, placed in deep, cold space at the L2 orbit, 1.5 million kilometers from Earth. That's four times farther than the Moon. (Note that one mission concept circa 1996 placed NGST with a 4-meter mirror out past Mars!)

Reality Sets In

By the end of 1996, NASA had decided to fund additional studies to further define the technical and financial requirements. The next five years would bring together numerous working groups for a seemingly endless series of technical studies. In short, the NGST team needed to understand what science the mission should do and what engineering was needed to make it a reality, given a set budget. Arguably the greatest flaw of the mission design was introduced during this period, and that was the proposed construction budget: $500 million, circa 1997. That was absurdly low. This was adjusted to $1 billion by 1998, a cost repeated in the influential 2000 Decadal Survey published by the National Academy of Sciences, titled *Astronomy and Astrophysics in the New Millennium*, which gave NGST its "top-priority recommendation" for NASA to pursue for the coming decade.

The problem was that NGST could never have been built for $1 billion, or $1.7 billion in today's dollars. Most knew it, too. Some called this a "political price tag" just to get NASA and ultimately Congress to support the mission in the era of "faster, better, cheaper." Intentional or not, the underestimation would haunt the project team as the real mission cost expanded at a rate eerily comparable to the effect of cosmic inflation NGST was to study. Funnily enough, at that 1989 NGST workshop, George Field of the Harvard-Smithsonian Center for Astrophysics, citing mid-1980s calculations, estimated the likely cost of a 10-meter space-based telescope to be $3.8 billion, or $9.5 billion in current dollars, which is about what JWST did cost.[2] Another early estimate, by the 1990 Decadal Survey Panel that

Illingworth chaired, figured that a 6-meter NGST-like telescope would cost $2 billion, or $4.2 billion in today's dollars.

So, as the mission cost grew through the 2000s and 2010s, from $1 billion to nearly $10 billion, and as other important space science missions were canceled or scaled back, cries went up in the scientific community about the "telescope that ate astronomy." Much ink has been spilled on the topic, but ultimately this is a subjective critique of the mission. Bold ideas cost money. Yes, there were errors along the way and a good degree of poor management. Yet arguably, bigger blows to NASA's spending power to properly fund the mission from the get-go were the back-to-back budgetary boondoggles of the space shuttle program and the International Space Station (ISS). The former devolved from the bold promise of a cheap, biweekly, low-orbit ferry into a horrifically expensive fleet of rocket-dependent vehicles averaging only about four flights per year, with two of the five shuttles exploding and killing the crew. Each shuttle mission cost more than half a billion dollars, far more than a typical rocket launch. Meanwhile, the ISS would cost $150 billion to complete, quite an increase over the initial $8 billion estimate. And truth be told, Hubble, too, had been billions of dollars over budget.

Goldin stepped down in 2001 with the change in the US administration. His "faster, better, cheaper" mantra had led to some wonderful successes. The 1997 Mars Pathfinder and the 1998 Lunar Prospector missions come to mind. But there were spectacular failures, too, all in 1999: The Wide-Field Infrared Explorer telescope leaked most of its fuel shortly after launch; the Mars Polar Lander landed, that's for sure, but at a velocity so high that is exploded upon impact; and the Mars Climate Orbiter never achieved orbit because of a mismatch between NASA's metric units and a contractor's imperial units. This trio of sloppy errors, coupled with ISS delays, shook the nation's confidence in NASA and prompted the administration to shift back to its risk-averse strategy of exhaustive oversight, which of course comes at a price.

And NGST was ripe with complexity that needed oversight—and a more realistic budget. Nearly every element of the mission required new technology with little precedence to build on. And unlike with Hubble, errors could not be fixed after launch. Measure twice, cut once? No, measure thousands of times and *launch* once. The raw cost of the time and labor for this necessary oversight added hundreds of billions of dollars to the price tag. Then mission creep added more. Indeed, the NGST was being pulled in two directions in the early 2000s. Part of the team was scaling down the design to lower the cost. For example, in 2001, the 8-meter mirror design would shrink to the 6.5 meters now in orbit. Yet simultaneously, the mission was accepting new science objectives that would require the inclusion of complex, state-of-the-art, and highly ambitious instrumentation.

This, itself, is not unnatural for flagship astronomy missions. The period from 1996 to 2002 was the concept-development phase, a time when instrument ideas were to be considered for feasibility. The 1997 NGST proposal to NASA, edited by Peter Stockman of STScI, kept only to the generics: orbital location, mass budget, ultra-lightweight mirror material, segmented mirror design, passive cooling, fine guidance, near- and mid-infrared detectors, and the framework to hold it all together. By 2002, the astronomy community was deciding on—or shall we say salivating over—how sensitive those detectors could be in instruments with a huge range of capabilities. Why squander all that light focused from such a massive mirror by using garden-variety detectors and instruments? So, the instrumentation and the untested technology to support the instrumentation became additional drivers of the mission cost. Despite this, NASA was still eyeing a 2010 launch.

A New Name and Refined Look

NASA renamed the NGST the James Webb Space Telescope in 2002 in honor of NASA's second administrator, James Edwin Webb, who served from 1961 to 1968. That naming decision has garnered a bit of controversy. Why Webb? many wondered. On one level, the naming was apt. Webb led NASA through its initial glory years, primarily the Apollo era, which culminated in the 1969 Moon landing. He was an astute administrator. Lesser known about Webb, but now highlighted as a result of JWST's naming, is the fact that he helped to establish astronomy and astrophysics as core to NASA's mission. NASA might have been a pure extension of the US military without this scientific core.

That said, NASA had maintained a tradition of naming large space science missions after scientists: Albert Einstein, Edwin Hubble, Subrahmanyan Chandrasekhar, Lyman Spitzer, Arthur Compton, and David Wilkinson, to name a few. Moreover, the naming usually came just before the launch or after the mission was operational. Otherwise, that name could be tainted by failure if something goes wrong at launch. JWST was not close to launch in 2002; the expected launch date at that time was at least eight years away. This was a curious decision indeed, made by NASA administrator Sean O'Keefe, whose own tenure at NASA was brief and tumultuous. More recently, some members of the public have learned of and taken offence to Webb's alleged involvement in the Lavender Scare, a so-called moral movement in the early 1950s prior to the creation of NASA that led to the dismissal of hundreds of homosexual personnel from the State Department, as they were considered a security threat. Most of them lived closeted lives back then, leaving them vulnerable to blackmail.

We cannot get into the heart and mind of James Webb, who died in 1992. Moreover, we must be careful when judging someone's character from what we feel is a more enlightened stance seventy years later. What we do know is that Webb was not a primary perpetrator of the homosexual purge; that dubious honor goes to Senator Joseph McCarthy, as this was tied to the Red Scare. We also know that Webb worked with Presidents John F. Kennedy and Lyndon B. Johnson to openly and deliberately use NASA facilities in the then-segregated US southern states to promote equal opportunity and racial integration. Webb's views on homosexuality, whatever they were, may have been a relic of a bygone era.

The James Webb Space Telescope began to attain the trappings of its current form in 2003. This was the year the mission moved from Phase A (detailed feasibility studies) to Phase B (definition studies). STScI had been designated the Science and Operations Center in 2000. The NASA Jet Propulsion Lab (JPL) was selected as the implementing center for the Mid-Infrared Instrument (MIRI) in 2001. The European Space Agency (ESA) and several European institutions built MIRI, making it an ESA contribution to JWST, but needed US involvement for the detector package. The University of Arizona was chosen to build the Near Infrared Camera (NIRCam) with Lockheed Martin in 2002. And NASA selected TRW as the prime contractor to design and fabricate the telescope, the sunshield, and the spacecraft, also in 2002. (TRW was acquired by Northrop Grumman shortly after, and subcontractor Ball Aerospace & Technologies Corporation would fabricate the mirror segments, reduced from 36 to 18.) By the end of 2003, the NIRCam and NIRSpec teams decided on HgCdTe Rockwell technology for their detectors. ESA committed itself to providing its Ariane 5 launch vehicle as a further contribution to JWST, albeit to the consternation of some US-based rocket builders. Nevertheless, the Webb team felt confident entering 2004 that they could launch by 2011.

But 2005 brought a major sticker shock. NASA finally signed off on the use of ESA's Ariane 5, although a delay in that approval resulted in a $300 million cost increase. Not knowing which rocket was to be used had impacted many design issues. With a better-defined observatory now in place, the project team discovered that the total mass was too high. One fix was to change the cooling system from a larger cryostat to a smaller cryocooler, now feasible because that technology had improved in recent years, as demonstrated in a 2002 Hubble servicing mission. Concurrently, Northrop Grumman and the NASA Integrated Science Instrument Module (ISIM) team calculated cost-to-complete estimates. The development cost had almost doubled, from approximately $2 billion to $3.5 billion. The project team scrambled to find significant savings. They saw a way to shave $100 million by altering how they would perform their final optical testing before launch, while still making certain that Hubble's optical disaster was not repeated.

Yet a now-realized launch delay, to 2013, added $250 million. The total cost was up to $4.5 billion for development, launch, and operations.

After that fateful year, 2006 started off promising. Both NIRCam and MIRI teams passed their critical design review and could proceed into fabrication. Northrop Grumman assembled a full-scale "traveling" model of the Webb Telescope at NASA Goddard Space Flight Center, providing NASA employees and later the public with a much-needed sense of tactical realness to what had been an abstract mission idea for the previous ten years. In 2007, NASA signed memoranda of agreement with ESA and the Canadian Space Agency (CSA). ESA, in full, would provide the rocket, the launch site in French Guiana, the NIRSpec instrument, and the Optics and Optical Bench Assembly of the MIRI instrument. CSA would provide the Fine Guidance Sensor and, originally, the Tunable Filter Imager, which later transmuted into the Near Infrared Imager Slitless Spectrograph. The project team successfully passed the preliminary design review in 2008 and transitioned into Phase C/D (implementation and testing). All systems were go, although the launch had now slipped to 2014 and the cost inched up to $5.1 billion.

Cancellation Threat

In 2010, Webb passed its critical design review. On the technical front, the project received excellent grades. The mission had struggled to keep within budget, however, partly because of the unforeseen development costs of cutting-edge technology. NASA administrator Michael Griffin noted that the mission was chronically underfunded during the early years. With the launch date slipping to 2015, and the rising price, the optics were not good. Maryland Senator Barbara Mikulski—a perennial advocate for NASA—called for an independent review of the project to get to the core reason for the never-ending slips and cost overruns. The final report of this Independent Comprehensive Review Panel (ICRP), led by John Casani of JPL, highlighted the crux of the problem. "Rather than change its management paradigm after Confirmation, the Project continued the practice of deferring work into future years to stay within annual budget commitments," which were too low, the report stated.[3] The report also noted that the earliest possible launch date would be September 2015 and that the final cost would need to be in the range of at least $6.2–$6.8 billion.

By 2011, following a thorough cost and schedule reassessment by NASA in response to the ICRP recommendations, the launch was looking more like happening in 2018 and with a total construction cost of $8 billion. Some members of Congress were not too pleased. In July 2011, the Chair of the US House Appropriations Committee on Commerce, Justice, and Science moved to cancel

the Webb project, arguably about 75 percent built. This was no idle threat. The Superconducting Super Collider had been canceled in 1993 after the US government had spent nearly $2 billion on it; Congress then cited a similar concern of never-ending cost overruns and poor management. To counter this, a band of astronomers—though certainly not the full community, as some were delighted by the cancellation, thinking it would free up money (it would not; funding for NASA didn't work that way)—lobbied intensely to save the project. They were joined by an outpouring of support from the public, such as schoolteachers and planetarium members, as well as Senator Mikulski and other members of Congress. By November, after five scary months, Webb beat the cancellation threat. However, Congress capped its prelaunch development and testing budget at the $8 billion construction cost derived by NASA.

More Frustrations

Steady progress was made through the next several years as the development was progressing neatly, with instruments integrated and attached to the telescope. Webb looked on target for 2018. NASA had put a new management structure in place, as proposed by the ICRP report and instructed by Congress. The cryocooler had been a major problem for many years, but with pressure from NASA, the contractor, Northrop Grumman, finally delivered. Nevertheless, as 2018 neared, the team understood they still would not be ready in time. That congressionally set $8 billion budget cap seemed impossible to maintain. (By 2018, NASA had spent $7.3 billion of it.) The integration and testing of the now-combined telescope and instrument package were taking longer than expected. Human errors were creeping in. Faulty fasteners on the sunshield shook loose and took months to find. Independent of this, technicians discovered seven tears in the sunshield likely due to poor workmanship. Testing also revealed that 8 of the 16 valves in the spacecraft's thrusters were leaking beyond acceptable levels, again likely due to a poor cleaning decision during storage. On one level, that's what testing is for. But each tiny slip led to backups in the testing schedule. These human errors, circa 2017, cost the mission a 1.5-year delay and an extra $600 million, according to an independent review board led by Tom Young, a retired aerospace executive.[4] In 2017, the launch was pushed back to 2019. In 2018, it was pushed back to 2020.

Every extra day was costing the mission an extra $1 million. In late 2018, Congress agreed to a funding increase once more, to $8.8 for development costs, but not after a grilling of NASA administrator Jim Bridenstine and Northrop Grumman CEO Wesley Bush. That last bit of support helped Webb cross the finish line.

Remove before Flight

The final stretch proved interesting, too, of course. The COVID-19 pandemic hit in March 2020, significantly limiting in-person collaborative work and access to the telescope. This resulted in another launch date slip, first to March 2021 and then to October 2021. Availability of ESA's Ariane 5 rocket delayed the launch slightly more, to December 18, 2021.

The last task before packing up the fully integrated, fully tested Webb Telescope was . . . wait for it . . . removing the lens cap. Now, wouldn't that have been a colossal error if forgotten! The lens cap was on the front of the Aft-Optics System to prevent any stray light or debris from getting inside. This was flagged with a red sign that literally read REMOVE BEFORE FLIGHT. Optical engineer Larkin Carey, who had lovingly cared for the mirrors for more than fifteen years, was raised up by a tall forklift while lying belly-flat on a diving board to remove the cap and perform a final inspection.

Transporting Webb from Northrop Grumman Space Park facility in Redondo Beach, California, to the launch site at Europe's Spaceport, at the Guiana Space Centre in Kourou, French Guiana, went remarkably smoothly despite the challenging logistics. The business end of the telescope—the Optical Telescope Element (OTE) and the Integrated Science Instrument Module (ISIM), together known as the "OTIS"—had been tested at NASA Johnson Space Center in 2017 and then flown out to Northrop Grumman in a massive US Air Force C-5 cargo plane in a custom-made travel pod named the Space Telescope Transporter for Air, Road, and Sea (with the appropriate acronym STTARS). But now, the fully completed telescope with its sunshield and spacecraft bus attached to the OTIS was too large for any cargo plane and, actually, too heavy to cross the bridges to get to the airport. All of this was known in advance, naturally. NASA needed to pack up Webb in an expanded "Super STTARS" and tow it down to the docks, 26 miles through the streets of Los Angeles—fittingly, the length of a marathon—to Naval Weapons Station Seal Beach. There, it was loaded onto the MN Colibri, a French-flagged cargo ship, and sailed to French Guiana, a 16-day, 5,800-mile sea voyage through the Panama Canal to Port de Pariacabo on the Kourou River.

The Internet lit up with chatter about NASA's concern about a pirate heist. This was never a serious worry for NASA, but nevertheless the space agency employed some tricky security measures to obfuscate the ship's route once through the Panama Canal. The two months in Kourou were not without incident. In early November, as technicians were preparing to attach the telescope to the launch vehicle, the clamp band that was to secure the telescope in place suddenly popped, sending vibrations throughout the observatory. No damage was detected, but the incident was enough to delay the launch for several days. At long last, the James

Webb Space Telescope launched on the dot at 7:20 a.m. East Coast time on Christmas Day, December 25, 2021, from the Guiana Space Centre. Like clockwork, following an absolutely flawless launch, in space parlance known as "nominal," the telescope detached from the Ariane 5's second stage to begin its deployment about 10,000 kilometers from Earth. First, the solar panels unfolded to provide power. Twelve hours into the launch, thrusters fired to finetune the spacecraft's trajectory to L2. Ariane and the ESA-led team had so precisely launched Webb toward L2 that the thrusters used far less fuel than originally planned, resulting in the telescope now having a usable life of over twenty years at L2 instead of the hoped-for ten years. It was simply remarkable.

Whew. But then began the next round of terror.

Over the ensuing month, while en route to L2, the Webb team needed to deploy the telescope in a series of delicate maneuvers comprising 300 single-point failure items, constituting the most complicated spacecraft activity that NASA and its partners had ever undertaken. On day 3, the sunshield began to unfurl, not unlike a shipping sail, with cables and pulleys to pull it taut, simultaneously employing ancient and futuristic technology. The sunshield alone entailed 140 release mechanisms. On day 10, with the sunshield fully employed, the secondary mirror was extended; on days 12–13, the primary mirror unfolded. The Webb team could breathe a little easier now. But the mission was far from ready for science. The next two weeks were comparably critical because all 18 mirror segments and the secondary had to be moved from their launch positions without a single failure of the 138 actuators over a distance nearly one million times the tiny and typical motions needed when operating. After about a month, the Webb Telescope arrived at L2, where it underwent five months of aligning its precision optics, turning on its complex instruments, and calibrating and fine-tuning them before its first light.

Webb's first images were glorious to behold, simultaneously capturing the success of a twenty-year engineering odyssey and the incredible promise of this future mission. President Joe Biden unveiled the first image on July 11, 2022, a field of distant galaxies, some more than 13 billion years old. NASA Goddard followed up the next day with the release of four more jaw droppers showcasing the diversity of Webb's instrumentation: a star-forming region called NGC 3324 in the Carina Nebula; a visual grouping of five galaxies, called Stephan's Quintet; the vibrant remains of an ancient star explosion called the Southern Ring Nebula; and a spectrum of the atmosphere of a giant planet outside our solar system named WASP-96b.

As Webb project manager Phil Ochs put it, "Webb is the perfect example of science desire driving engineering capability to new frontier." Now the time has come to reap the scientific dividends of this remarkable investment.

Notes

1. P. Y. Bely, "A Ten-Meter Optical Telescope in Space," Proc. SPIE 0628, Advanced Technology Optical Telescopes III (August 20, 1986), https://doi.org/10.1117/12.963528.
2. George Field, Summary of Space Science Board 1995–2015 Study, in *The Next Generation Space Telescope Workshop Proceedings*, STScI, NASA, 1989.
3. James Webb Space Telescope (JWST) Independent Comprehensive Review Panel (ICRP) Final Report, October 29, 2010.
4. Mike Wall, "NASA Delays Launch of James Webb Space Telescope Again—This Time to 2021," Space.com, June 27, 2018.

The Science of the James Webb Space Telescope

A Trip through Space and Time

A time machine. That's what senior project scientist John Mather calls the Webb Telescope in his public talks. Through Webb, we are seeing the universe not as it is but rather as it was. This is the reality of all space observations, as information can travel only as fast as the speed of light. Light is fast but it is not instantaneous. Traveling at 300,000 kilometers per second, light from the Sun takes about 8 minutes to reach us on Earth. So, when you look at the Sun, you are seeing it as it was 8 minutes ago. If it burned out at this very moment, went poof, you wouldn't know for another 8 minutes.

But the Sun is relatively close and stable, and this time-travel trip isn't that significant. The closest star to us beyond the Sun is Proxima Centauri, 4.2 light-years away. Any creature there staring at the Earth won't see our light emitted today for another 4 years. Yet go farther into the universe, and the time machine concept really comes alive. Trappist-1 is a star system with seven terrestrial planets about 40 light-years away. Any creature there spying on us today would see life on Earth in the 1980s. Zoom out to the Virgo Cluster, millions of light-years away. Any civilization there watching the Earth today would come to the conclusion that our planet is inhabited by dinosaurs.

Similarly, when Webb detects the first galaxies, we will be seeing the universe as it was about 13.5 billion years ago. Those galaxies "today" aren't there anymore, in the same way the dinosaurs aren't here anymore. They have moved on, so to

speak. They have accelerated away beyond our view. Perhaps they burned out; perhaps they merged with other galaxies and recycled their material into new stars. We will never know. The deeper we look into the universe, the further back in time we are seeing, all based on this concept of a constant, finite speed of light. As a result, Webb enables us to map out the entire history of the universe. By observing galaxies at set distances—13 billion light-years, 12 billion light-years, 11 billion light-years, and so on—we can create snapshots of the structure and evolution of the universe. This, in turn, provides clues about the future because we can learn about the rate and dynamics of the expanding universe.

All telescopes take us back in time. The Webb Telescope is unique, however, in that it can detect such a range of epochs, from the era of first star and galaxy formation to the present. The reason is its exceptionally large mirror and sensitive infrared detectors.

Why an Infrared Telescope?

Perhaps the concept "infrared" conjures up thoughts of night-vision goggles and those eerie, blurry images of a world active after dark—nocturnal animals foraging for food, an enemy camp just over the ridge. This is partly the type of infrared energy that Webb will detect. Nearly all objects radiate infrared, whether they are deep in space or here on Earth—galaxies and stars, planets and people, even ice. In essence, infrared radiation is heat. Humans don't emit visible light; we don't glow in the dark. But we do radiate heat, and that's what an infrared camera detects.

The universe is filled with energy, most of it unknown to us. Let's first just focus on the light energy. When most people speak of light, they mean what is visible, what we see with our own eyes, aptly named visible or optical light. To most astrophysicists, light tends to mean the entire electromagnetic spectrum, a range of energy from radio waves and microwaves to ultraviolet light, X-rays, and gamma rays. Visible light is but a tiny sliver of the electromagnetic spectrum. This is merely the range of energy that human eyes can detect. Put another way, our eyes are telescopes that are rather similar to Webb. Light enters our eyes; a certain range of energies is detected; and our brain forms an image of the object producing or reflecting that light. Similarly, light enters Webb's eye (the aperture) and gets focused onto detectors, and a machine converts the detected energies into an image. The difference is the range of energies that our eyes are detecting compared to what Webb detects. It cannot detect visible light aside from a little bit of red; and we cannot see infrared light.

Light travels through the universe in waves. The speed is always the same, about 300,000 kilometers per second, but the waves travel at different frequencies,

called wavelengths. Light with a wavelength between 625 and 700 nanometers is visible, and our brain calls this red. Light with a slightly shorter wavelength, between 500 and 565 nanometers, we detect as green. Shorter yet, between 380 and 450 nanometers, we see as violet. Shorter than 380 nanometers? We don't see this at all. This is the ultraviolet range of the electromagnetic spectrum, and that's beyond the detection sensitivity of our instrument called the eyeball. Ultraviolet radiation is real, for sure. Many insects can see into the ultraviolet. Ultraviolet light, emitted by the Sun along with visible light, causes sunburn and retinal damage.

On the opposite side of the visible spectrum lies infrared radiation, with wavelengths longer than 700 nanometers. So, as with ultraviolet light, any light with a wavelength longer than 700 nanometers simply can't be detected by our eyeball detectors. Our skin can detect it as heat. Some snakes have organs that enable them to detect the heat of their prey and possibly form a mental image.

Light is more than meets the eye. The universe is aglow in a range of electromagnetic energy, from low-energy radio waves to the highest-energy gamma rays. Visible light but only some radio, infrared, and ultraviolet waves penetrate the atmosphere. Illustration courtesy NASA.

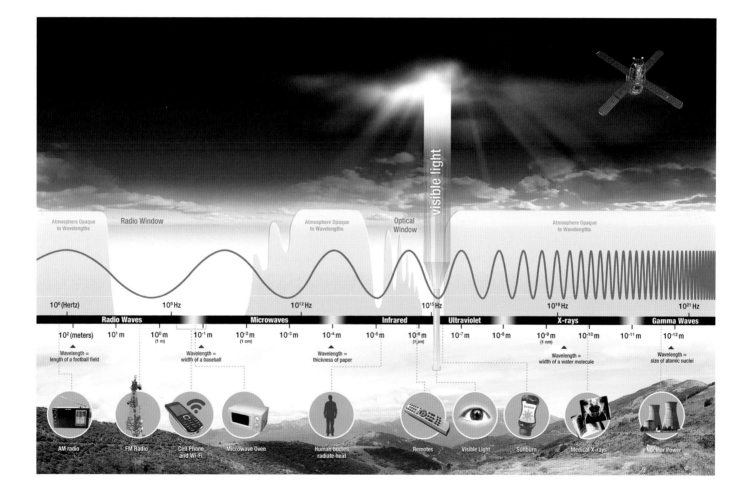

The Sun actually radiates more than half its energy in the infrared; the other half is mostly visible and ultraviolet radiation.

The longer the wavelength, the lower the energy. Compared to visible light, what we call infrared light constitutes a huge range of energies, with wavelengths from 700 nanometers to 1,000,000 nanometers. So wide is this swath that we divide the infrared spectrum into near-infrared (i.e., "near" the visible color red), mid-infrared, and far-infrared. The near-infrared spectrum ranges from 700 to 1,400 nanometers; the mid-infrared ranges from 1,400 to 15,000 nanometers; and the far-infrared ranges from 15,000 nanometers to 1 million nanometers. (Some metric to keep in mind: Infrared astronomers measure wavelength in micrometers, or microns. A micron, abbreviated μm, is 1,000 nanometers. The Webb detector range is between 0.6 μm and 27 μm.)

So, back to our original question: Why an infrared telescope? The Hubble Space Telescope mostly detects visible light, with a little bit near-infrared and near-ultraviolet. If Hubble were bigger—if it had a 6.5-meter telescope, like Webb's—it would be able to see with greater resolution and produce sharper images, but it wouldn't necessarily be able to see deeper into the universe because those more distant objects are primarily in infrared, beyond Hubble's range. Here's why. The universe is expanding. Nearly every object we can detect beyond our galaxy is moving away from us, caught up in this expanding universe. And as objects move away, the light they emit from our perspective loses a little energy. The light is redshifted—shifted toward the red and infrared part of the electromagnetic spectrum. This is similar to the sound of a moving siren. As the siren approaches, the sound has a higher frequency; as it passes and moves away, the sound to our ears has a lower frequency.

The farther the object beyond our galaxy, the faster it is receding from us in the expanding universe, and the greater its light is redshifted. The reason why is that the light is sort of like a fish swimming upstream, going against the current of the universe. It struggles to reach us because the expanding universe is tugging it back a bit.

Now for the punchline: The first stars and galaxies to form in the universe once glowed strongly in visible, ultraviolet, and even X-ray light when they exploded. But now their distant light, weary from travel across 13.5 billion light-years, has shifted into the infrared. Regardless of Hubble's mirror size, its optical and near-infrared detectors, as excellent as they are, can hardly register the light from those first objects now reaching us primarily in the infrared spectrum. But this light will be smack in the middle of one of Webb's detector's sweet spot, at a wavelength of 1.9 μm.

To be clear, an infrared telescope isn't inherently better than an optical telescope. The universe speaks to us in a range of wavelengths. The regions around

black holes, for example, radiate strongly in X-rays. The afterglow of the Big Bang forms a diffuse veil of microwave light all around us. Astronomers tune to specific wavelengths to learn of specific cosmic phenomena. The primary goal of Webb is to see those first objects, and a sensitive, ultra-cooled telescope tuned to infrared is the best way to do that.

But Webb is no one-trick pony. Its infrared detectors will reveal other kinds of cosmic phenomena. This includes the secrets of star creation in stellar nurseries in our own galaxy. Stars form within great clouds of dust and gas. Consider the iconic Hubble image of the Eagle Nebula known as the "Pillars of Creation." There are newborn stars in there. The cloud obscures visible light and thus limits our view in optical wavelengths. However, the cloud does not block infrared light. With infrared, we can see through the dust veil. And with Webb 100 times more sensitive than Hubble, we will be able to resolve infant stars in these stellar nurseries. This same sensitivity also will enable us to directly image planets around other stars. Webb will be able to tune out the bright optical light of a star and focus instead on the infrared heat of the planet(s) orbiting it.

We discussed the universe being filled with matter and energy. Remarkably, only 5 percent is known to us. We call this ordinary matter: stars, planets, people, atoms, and so on. Another 25 percent of the universe appears to be some undetectable substance with mass that serves as a scaffolding or gravitational glue holding galaxies together. This is called dark matter. The other 70 percent of the universe appears to constitute a force that is accelerating the expansion of the universe, sort of like anti-gravity. We call this dark energy. The Webb Telescope will not be able to directly detect dark matter or dark energy. But its infrared surveys of the structure and evolution of the universe over cosmic time will trace the relationship between dark matter and galaxies and provide clues to the location and distribution of dark matter as well as the era in which dark energy became the dominant force in the universe.

Why Place It in Space?

Space-based telescopes have the advantage of being above Earth's atmosphere, the ultimate mountaintop. You can observe continuously, not just at nighttime, the limitation of ground-based optical telescopes. There are no clouds in space to obscure your view, either. The trade-off is size and accessibility. Ground-based telescopes can be much larger and can be repaired or upgraded as needed. The great twin telescopes of the W. M. Keck Observatory on Mauna Kea in Hawai'i are each 10 meters wide. The Gran Telescopio Canarias on the island of La Palma is 10.4 meters, the largest single-aperture optical telescope in operation as of 2023.

The Extremely Large Telescope under construction on Cerro Armazones in the Atacama Desert of northern Chile will have a 39.3-meter mirror. Wow.

These all are magnificent and indispensable observatories. Despite being on the ground, they often can produce higher-resolution images and spectra compared to Hubble in space. But, consequently, these gigantic telescopes weigh hundreds of metric tons, compared to Webb's 6 metric tons. Our current rocket technology limits not only the amount of mass we can launch but also the telescope size. Webb's 6.5-meter mirror, the largest ever placed in space, needed to be folded carefully to fit into a rocket, after all. Astronomers can dream of a 30-meter telescope in space, or maybe on the Moon, but such an instrument is decades away from reality because of the engineering difficulties of deploying something so large.

That said, Keck and these other grand observatories on mountaintops, regardless of their size, cannot easily detect infrared wavelengths because much of this light is absorbed by water vapor in our atmosphere before it reaches their detectors. Also, both the telescope and our atmosphere itself are bright in infrared radiation, being so warm. So, for an infrared astronomer struck on the ground, all day is like high noon. Just as you cannot easily see the stars in the daytime from the ground—the bright sunlight filling the atmosphere washes out their faint optical signal—you cannot easily detect faint infrared signals from the ground, particularly in the mid-infrared range. Keck can detect a little near-infrared radiation. So can Hubble. But they are not optimized for this. Even Hubble in space, above the watery atmosphere, is compromised by being warmed (it's heated to a balmy 20°C) by the heat of the Earth, which acts like an infrared lightbulb. For Webb to meet its observational goals—faint infrared signals from the early universe, and faint infrared signals from exoplanets, that is, planets beyond our solar system—the observatory needs to be in space, not only above the Earth's atmosphere but also far from our planet's residual heat, and then shielded from the sun, so that it can be cooled by the universe to close to absolute zero.

And that chosen location is the L2 orbit. That's one of five Lagrangian points for the Sun-Earth system, and it refers to orbital locations in which the gravitational forces of the Sun and Earth and a satellite are balanced. The satellite won't fall back to Earth or drift farther away but rather will orbit the Sun along with the Earth. L2 is four times more distant than the Moon, about 1.5 million kilometers, or 1 million miles, away. We've placed many satellites in orbit here. Most recently, there was ESA's Herschel Space Observatory, an infrared observatory with a 3.5-meter telescope—a meter wider than Hubble's—that was active from 2009 to 2013, when it ran out of coolant. Nevertheless, the Webb team needed a perfect launch to insert the satellite precisely into the L2 orbit. A less-than-perfect

launch would require a large orbital correction, that is, the burning of the space-craft propellant to get to the right place. Any fuel squandered in orbital correction results in less fuel available for day-to-day mission operations, which would result in a shorter lifespan for the mission, perhaps stealing several years. But ESA nailed the launch with its Ariane 5, inserting Webb into such a precise trajectory that it wasted no fuel.

Out of the Darkness

Webb's primary mission objective, its raison d'être, is to observe the dawn of the universe, that moment of sunrise after the Big Bang. We now have overwhelming evidence that the visible universe began with the Big Bang, approximately 13.77 billion years ago. We know this because the faint afterglow of the Big Bang is all around us in the form of a cosmic microwave background. The properties of this light provide important clues about what happened so long ago. The time machine at work again.

The Big Bang is perhaps less like an explosion and more like a moment in time at which the universe began to expand into itself—a phase transition, as some physicists say, in which the universe transitioned from a state of nearly infinite density and temperature to the far less dense and much cooler universe we see today. And it is cold out there. The average temperature of the universe today is about 3 Kelvin, or −270°C. After the Big Bang, the universe was very dark. There were no stars, no galaxies, and no way for any light to shine through the dense, hot soup of protons, neutrons, and electrons created in the Big Bang. As the universe expanded and cooled, these particles combined to form the first atoms: hydrogen, helium, and a tiny bit of lithium. This era, which physicists call recombination, took place about 250,000 to 300,000 years after the Big Bang. The universe now was no longer a dark, opaque fog of subatomic particles. That veil had been lifted, and light created by the Big Bang itself could at last shine. Indeed, this light is the cosmic microwave background detected today, so distant and primordial that it has been redshifted all the way to the microwave part of the electromagnetic spectrum.

But then the universe fell dark for a very long time, as there were no stars and galaxies to generate new light. This so-called dark age, before the cosmic dawn, lasted tens to hundreds of millions of years. Ever so slowly, stars and galaxies began to form. Precisely when, precisely how, is what Webb aims to establish. All we have now to guide us are theories and a few tantalizing observations. The Hubble Deep Field observation of 1995, for example, found a surprisingly large number of tiny but growing galaxies at least a billion years after the Big Bang. The Hubble

eXtreme Deep Field, published in 2012, found such galaxies 13.2 billion light-years away, or about 500 million years after the Big Bang.

Theory suggests that stars may have first formed in protogalaxies of swirling matter 100 million to 250 million years after the Big Bang. The stars themselves were likely hundreds of times as massive as our Sun and millions of times as bright; they would burn for only a few million years before exploding as supernovae. Their light would have been primarily ultraviolet, so powerful that the radiation would split hydrogen atoms back to their constituent protons and electrons. This period is called the era of reionization. Ionization is the process of an atom losing an electron; and now, these primordial atoms, once just protons, later joined by electrons, were being "reionized" back into protons. These ionized hydrogen atoms are important because they signal the era of the first stars, the cosmic dawn. This is what Webb hopes to detect.

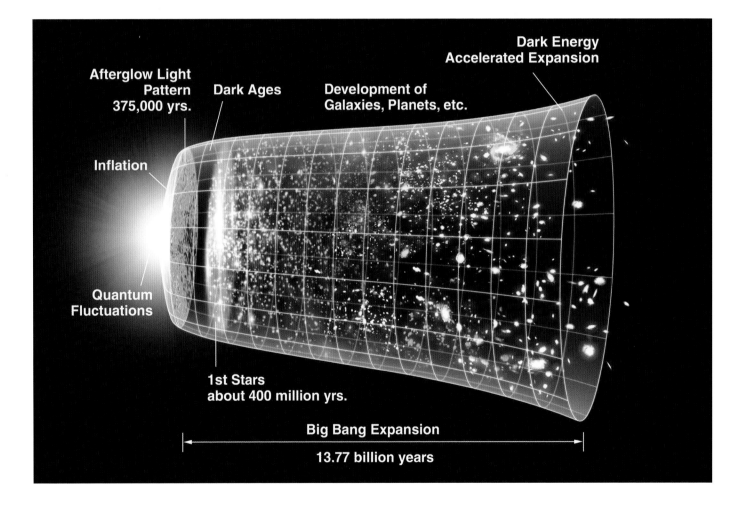

These early, massive stars likely collapsed into black holes, which then could have sunk to the cores of the protogalaxies, merged, and created even larger black holes that shaped the growth of the galaxies. Gravity is the great attractor. And black holes, points of infinite density, may have been the deep gravitational wells that attracted more and more matter into protogalaxies, triggering new star creation along the way.

Into the Light

A secondary goal for Webb is to answer the question, Well, how did we get here? How did the formless early universe evolve into the structure we see today of galaxies, stars, planets, and, on at least one of those trillions of planets, life?

Today we see stars and galaxies in every direction. Yet as thick as the universe is in galaxies—more than 100,000 in each view through a drinking straw—there are still plenty of voids of empty space. Cosmological models based on theory and observation provide us with a vision of a universe in a box, in which we see a cosmic web of galaxies threaded upon invisible strings of dark matter. Where threads meet, we have galaxy clusters. Our Milky Way galaxy is part of a local group of 54 "nearby" galaxies, on the fringe of the Virgo Supercluster comprising more than 100 galaxy groups and clusters spanning 110 million light-years. Between the threads lies seemingly nothing. The theory is that, in the early universe, when structure was forming, regions with slightly more matter grew denser, attracted

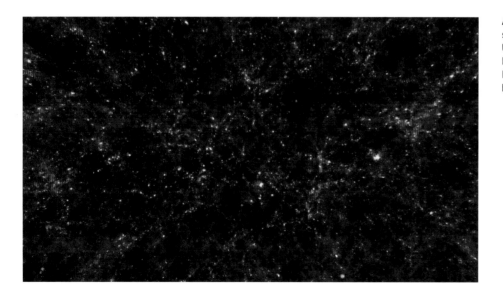

A simulation of the cosmic web, with strings of galaxies. Credit: NASA/NCSA University of Illinois. Visualization by Frank Summers, Space Telescope Science Institute. Simulation by Martin White and Lars Hernquist, Harvard University.

by the force of gravity. Regions with less matter grew sparser. The rich grew richer; the poor grew poorer. Those denser regions coalesced into stars and galaxies, leaving empty voids.

Webb will provide observational evidence of this theory by mapping regions of galaxy formation over time, to see how well the observations fit this model. Webb will tackle this goal in two ways. First, its sensitive infrared detectors will be able to resolve the faint light from early galaxies, light so distant that it has shifted primarily in the infrared range. Today we see a variety of galaxy shapes, from the classic spiral to the featureless ellipticals and everything in between. Such large galaxies would have undergone many mergers from the tiny ones seen already in the first billion years. Indeed, we have caught a few in the act. Optical telescopes by themselves cannot discern what is happening here because many galaxies are dominated by dusty regions of gas, which block their more central light. This same dust is transparent to infrared radiation. So, with Webb, we will be able to see into galaxies and galaxy mergers to observe their inner mechanics.

By comparing farther (older) to closer galaxies, we will understand how cosmic structure has changed over time. Tied to this is understanding the chemical composition of those galaxies, which we can ascertain through spectral analysis. Each element—such as hydrogen, helium, carbon, or oxygen—produces a unique fingerprint when light passes through or is emitted by it. Webb instruments include spectrometers that record these signatures. In the earliest galaxies, we expect the signature to be mostly hydrogen and helium, which were created in the Big Bang. All other heavier elements, such as carbon and oxygen, were made in stars and star explosions. With Webb, we can trace the creation of the elements necessary for life.

A Star Is Born

Stars are created continuously in the modern universe, a form of cosmic recycling. They form when clouds of cold hydrogen gas coalesce under the force of gravity and become denser and hotter. If there's enough gas, the pressure and temperature in the core of this now-spherical cloud will trigger hydrogen fusion. When that happens, a star is born. The fusion radiates tremendous energy we experience as heat and light. Hydrogen fusion is the fusing of two hydrogen atoms into a helium atom. Stars can burn this fuel for millions to billions of years. When the hydrogen is used up, the star might turn to helium fusion, fusing two helium atoms into carbon. Carbon fusion, in turn, creates even heavier elements, which themselves can fuse. The technical name for this creation of elements is nucleosynthesis.

As a star burns through all its nuclear fuel, its core begins to collapse and its outer layers expand outward and shed gas into the surrounding space. For low-mass stars, this is a slow process of generating stellar winds that form a wispy nebula that ultimately becomes material for new stars. For high-mass stars, ten times or so more massive than the Sun, the depletion of fusion fuel will result in a catastrophic and fantastic supernova. The largest supernovas give birth to neutron stars or black holes. In either scenario, though, low mass or high mass, these dying stars shed copious amounts of gas, which enters the interstellar medium to trigger new star formation.

Star formation is understood at a theoretical level but is poorly observed because stars are born in stellar nurseries defined by their veil of dust and gas. As alluded to earlier, the Eagle Nebula, also called Messier 16, contains the quintessential stellar nursery, nicknamed the "Pillars of Creation." Those pillars are massive; each stretches about 4–5 light-years. Within the pillars are several stars literally turning on, igniting their hydrogen fuel. The iconic Hubble image, as beautiful as it is, cannot show us what's happening inside the clouds, in the nursery. A lesser-seen image of the same region produced by Hubble's near-infrared camera does indeed get under this veil for a glimpse, although the resolution is not as sharp as the optical. With Webb 100 times more sensitive than the Hubble's infrared camera, we will be able to study star formation within the Eagle Nebula

The "Pillars of Creation" star-forming region in the Eagle Nebula, as seen by Hubble in optical (left) and infrared (right). The infrared image reveals star formation in these massive dust clouds. Credit: NASA, ESA/Hubble, and the Hubble Heritage Team.

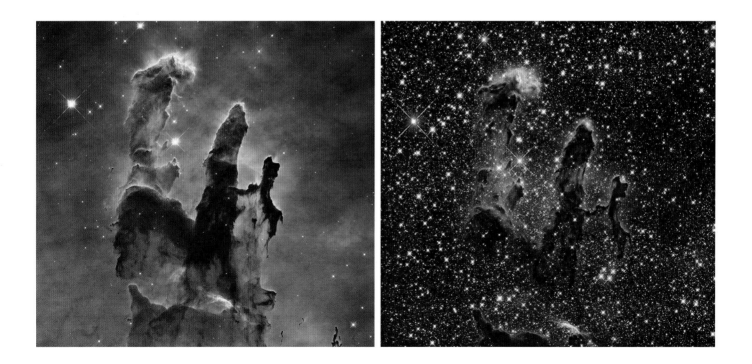

and elsewhere with far greater precision. Such detail will reveal how the leftover debris from star formation, rich in heavier elements, forms planets.

Discovering New Worlds

With billions of stars in our galaxy, and with most harboring planets, surely the chances are high that we soon will discover ones resembling Earth in temperature and other life-sustaining properties. We have long assumed that other stars must have planets, but it was only in 1992 that the first extrasolar planet, or exoplanet, was confirmed. Since then, approximately 5,000 others have been identified. Most are large, gaseous planets like Jupiter; it's easiest to detect the largest, after all. Yet a multitude of terrestrial, Earth-sized planets have been discovered in recent years. Among the most important tools for discovering exoplanets was the NASA Kepler Space Telescope, launched in 2009 and dedicated to the task of spotting Earth-sized planets orbiting other stars. Another, still active as of 2023, is Transiting Exoplanet Survey Satellite (TESS).

Webb won't set out to identify new exoplanets; that's a time-consuming endeavor. However, both Kepler and TESS provide Webb with targets. Webb's sensitive infrared instruments are ideal for studying the properties of known exoplanets in unprecedented detail. This may include direct imaging of these planets and the identification of biosignatures, that is, signs of alien life.

Exoplanets are challenging to observe because they are so tiny in comparison to their host star. In our solar system, Jupiter, the most massive planet by far, is one-thousandth the size of the Sun. Earth is one-millionth the size of the Sun. So, the light we see from stars tends to wash out any diminutive light from a planet in its orbit. The most common trick to observe them, and one that Webb will utilize, is to follow transits of planets across the face of their stars during their orbits. When that tiny planet crosses its star, the star's light diminishes ever so slightly, from our vantage point. So, we can ascertain the mass and temperature of the planet from the degree to which the star dims and the time it takes for the planet to transit.

Webb is so sensitive that it may be able to detect a planet's atmosphere, if it exists. The light from the star will pass through those atmospheric gases, and through the process of spectroscopy, Webb can perform a chemical analysis to detect molecules such as water, methane, carbon dioxide, and oxygen—the biosignatures of habitability and biology on Earth. One star system topping the list of Webb's targets is that of TRAPPIST-1, a red dwarf star with seven terrestrial planets detected so far. At least three of these planets are in a habitable zone, with surface temperatures that can allow for liquid water given sufficient

atmospheric pressure. Additionally, two of Webb's instruments include a coronagraph, a device that occludes light from a star so that we can see planets nearby, much like how you can see more clearly around a lightbulb by covering the sight of the bulb with your hand. The direct image of a planet could reveal information such as temperature and weather differences from day to night and year to year.

Closer to home, Webb can observe planets and moons from Mars outward. Targets include the icy bodies of the Kuiper Belt, far beyond Pluto, and the rings of not only Saturn but also Jupiter, Uranus, and Neptune. There's more, much more, that Webb will do, too: Observe through our galactic plane, famously enshrouded in dust (that's what the Milky Way is named for); hunt for brown dwarfs, mysterious cold orbs far more massive than Jupiter yet not massive enough to turn into stars; and examine cold, dark objects passing through our solar system, such as errant extrasolar asteroids. And then there's the unknown. A telescope this powerful is bound to stumble upon the unexpected. This is what thrills astronomers the most about Webb—astronomers such as Webb team members Garth Illingworth and John Mather.

★

Garth Illingworth, Advisor
—Guiding light, invisible hand

Garth Illingworth bore witness to Webb from conception through launch, a nearly thirty-five-year gestation. No one has been involved in the project longer. "It's been an interesting, long haul," he said, putting it mildly. Sure, more than three decades of toil, community animosity, a near cancellation, significant restructuring, engineering mishaps, and a coronary-inducing deployment while en route to a distant orbit 1.5 million kilometers from Earth. Interesting indeed.

Garth's direct participation began in 1987 when his boss, Riccardo Giacconi, director of the Space Telescope Science Institute (STScI), challenged him, the deputy director, along with two others at STScI—Peter Stockman and Pierre Bely—to start thinking about the next major mission beyond Hubble. Giacconi called on the right people. Pierre Bely was an imaginative engineer; Peter Stockman, a physicist by training, had sharp organizational skills. And Garth, then interested in relatively nearby ellipticals and globular clusters, would soon make a name for himself as codiscoverer of the most distant galaxies ever observed, a line of research that culminated in the eXtreme Deep Field and the Hubble Legacy Field, the latter being a "history book" of galaxies stretching across 13.3 billion light years, from modern to ancient. Together, the three formulated designs for an 8-meter, multi-instrument, passively cooled infrared telescope. Two years later,

they highlighted their concept at the 1989 STScI conference that would introduce to the astronomy community the name Next Generation Space Telescope.

Garth was just entering his mid-career at this time. He had grown up under the Southern Cross in Australia and attained his PhD in astrophysics from Australian National University in 1973. He arrived in the United States soon after as a postdoctoral fellow at Kitt Peak National Observatory in Arizona. After a fellowship at University of California, Berkeley, he returned to Kitt Peak as an astronomer

from 1978 to 1984. Among his earliest observations at Kitt Peak were those globular clusters, tightly packed spheres of hundreds of stars present in most galaxies. Some of them appear to be nearly as old as the universe itself, even those in the Milky Way galaxy. Garth moved to STScI in 1984 to begin work on Hubble, which like Webb was more than a little delayed and over budget.

Although he left STScI in 1988 for a dream job, a professorship at the Department of Astronomy and Astrophysics at the University of California, Santa Cruz, and an appointment at the associated Lick Observatory, Garth remained tied to both Hubble and NGST/JWST. He chaired the influential "UV-Optical in Space Panel" of the 1990 Decadal Survey, which recommended a 6-meter passively cooled infrared space telescope estimated to be ready for launch by 2009 for $2 billion. But Garth's focus by the mid-1990s had turned to leading important Hubble observations and supporting the Keck telescope instrument program. He was deputy principal investigator for Hubble's Advanced Camera for Surveys and cochair of the Keck Science Steering Committee. Nevertheless, for NGST/JWST, Garth became the man behind the scenes helping to keep the mission moving forward. Although not officially on the team—he joked about not even being able to get guaranteed observation time—he was a crucial player, lending an honest, independent voice and coordinating negotiations to keep the mission funded through its darkest times. His work on Hubble and Keck had taught him about the troubles of big missions and, more important, the solutions.

Garth's insights and negotiating skills proved most useful in 2010 and 2011, when animosity over the mission's delays was growing and when Congress nearly pulled the funding on Webb. Garth was the only astronomer on the JWST Independent Comprehensive Review Panel (ICRP) in 2010, and with panel chair John Casani he represented its findings to NASA leadership and US Congress. This is the report that pinpointed the causes of the budget overruns and set the first reasonable, minimum cost-to-launch price of $6.5 billion. "When a problem arises, you really need the reserves to fix it then and there," Garth explained about the rising costs. "If you have to start delaying [repairs of] major issues into the future, it drives the cost of the program up dramatically. And every year they had a crisis. . . . To NASA's credit, they really took a lot of interest in our assessment and said we'll accept your recommendations and do a serious replanning."

NASA did its replan in early 2011 and came up with a cost to launch of $8 billion, well over what the ICRP estimated. This didn't sit well with some members of Congress, and in July, the House Appropriations committee voted to terminate JWST's funding. Garth had heard from past congressional staffers about how serious the threat was. With many others, he set out to rally the science community for support while simultaneously diffusing dissent. "We were countering, as much as we could, the astronomers who were opposed to JWST," he said. The

next four months were harrowing, but after Senate and House negotiations, and with strong support from Senator Barbara Mikulski, Congress in November 2011 ultimately agreed to fund JWST but set a strong cap on the new budget. Garth was an invited witness during the Congressional House Science Committee Hearing on Webb that December. Despite his deep knowledge and amiable personality, he did not win over all the members of the House science committee. But budget stability eventually came to Webb—for a few years, at least.

Garth maintained a strong role into Webb's third decade of development, as well. NASA Goddard Director Chris Scolese had asked Garth to stay involved in the project as an "independent eye." He also chaired the JWST Science Advisory Committee from 2009 to 2017. Here, he helped to establish an early data release program to enable swift public open access to JWST data. And he lobbied NASA to allocate $60 million per year for observation grants, which is twice that of Hubble's allocation.

Now that Webb is finally in orbit, Garth is just one of the regulars, anxiously awaiting observation time he proposed. You guessed it: a deep early galaxy survey in search of the first galaxies. Although Webb took about ten years longer to build than originally estimated, the mission has still exceeded his expectations. "There is no doubt that the capabilities of the instruments are far beyond what we could conceive of doing in the '89–'90 time range, particularly in the infrared," he said. "The infrared camera technology, particularly mid-infrared, was really immature in those days."

As for the cost of the mission, "This is an activity of cultural significance, not only for the United States but worldwide," he said. "The mission strikes at the heart of questions that everybody has about our origins. Where did we come from at the deepest levels? How did the first stars and galaxies form and grow? How did stars like the Sun form? How do planets like Earth form and come to harbor life and ultimately self-aware analytical beings? It's a bargain given what Webb's insights into our origins will do for human society."

★

John Mather, Project Scientist
—The steady hand in control

John Mather is a patient man. His 2006 Nobel Prize in Physics was thirty years in the making. That award, for unswerving evidence of the Big Bang, was based on a bus-sized machine called COBE—yet another NASA mission that almost didn't happen. Design drama? Been there. Navigate unforeseen delays? Done that. For NASA to choose Mather as JWST Project Scientist was pure prescience.

Like Webb, COBE—the Cosmic Background Explorer—was to be a time machine to reveal a snapshot of the early universe. The target era was just 370,000 years after the Big Bang, when the universe was still a fog of elementary particles with no discernable structure. This is called the epoch of recombination, when the hot universe cooled to a point to allow protons to bind with electrons to form the very first atoms, mostly hydrogen with a sprinkling of helium and lithium. As the atoms formed, the fog lifted, and the universe became clear. Light broke

through. That ancient light, from the Big Bang itself, is with us today as remnant microwave radiation called the cosmic microwave background.

Tall but never imposing, demanding but never mean, Mather is a study in contrasts. His childhood was spent just a mile from the Appalachian Trail in rural Sussex County, New Jersey, where his friends were consumed by earthly matters such as farm chores. Yet Mather, whose father was a specialist in animal husbandry and statistics, was more intrigued by science and math. At age six he grasped the concept of infinity when he filled up a page in his notebook with a very large number and realized he could go on forever. He loaded himself up with books from a mobile library that visited the farms every couple of weeks. His dad worked for Rutgers University Agriculture Experiment Station and had a laboratory on the farm with radioisotope equipment for studying metabolism and liquid nitrogen tanks with frozen bull semen. His dad also was one of the earliest users of computers in the area, circa 1960, maintaining milk production records of 10,000 cows on punched IBM cards. His mother, an elementary school teacher, was quite learned, as well, and fostered young John's interest in science.

A chance for some warm, year-round weather ultimately brought Mather in 1968 to University of California, Berkeley, for graduate studies in physics. He would fall in with a crowd intrigued by the newly detected cosmic microwave background, discovered by accident in 1965 by radio astronomers Arno Penzias and Robert Wilson. His thesis advisor devised a balloon experiment to measure the spectrum, or color, of this radiation to see if it really came from the Big Bang. (It does.) The next obvious thing was to make a map of this light to see, as theory suggested, whether the temperature varied ever so slightly across the sky. And years later, that's just what he and his COBE team found: anisotropy, an unequal distribution of energy. These micro-degree temperature fluctuations imply matter density fluctuations, sufficient to stop the expansion, at least locally. Through the influence of gravity, matter would pool into cosmic lakes to form stars and galaxies hundreds of millions of years later. In essence, Mather and his team captured a sonogram of the infant universe.

Yet the COBE mission, like Webb, was plagued with setbacks. Mather and the team proposed the mission concept (for a second time) in 1976. NASA accepted the proposal but, that year, declared that this satellite and most others from then on would be delivered to orbit by the Space Shuttle, which itself was still in development. History would reveal the foolishness of such a plan. Mather understood immediately. This wedded the design of COBE to the cargo bay of the unbuilt Shuttle. Engineers would need to meet precise mass and volume requirements of a vessel not yet flown. More troublesome, COBE required a polar orbit, difficult for the Space Shuttle to deliver. The COBE team was next saddled with budget cuts and compromises in COBE's design as a result of cost overruns of another

pioneering space science mission, the Infrared Astronomical Satellite, or IRAS. Still, the tedious work continued of designing instruments sensitive enough to detect variations of temperatures just a few degrees above absolute zero, about −270°C. From 1980 onward, Mather was consumed by the creation of COBE all day every day. The team needed to cut corners and make risky decisions to stay within budget. News came that COBE was to be launched on the Space Shuttle mission STS-82-B in 1988 from Vandenberg Air Force Base. All systems go.

Then the Space Shuttle Challenger exploded in 1986, killing all seven of its crew. NASA grounded Shuttle flights indefinitely. COBE, now locked to Shuttle specifications, couldn't launch on just any other rocket system. COBE was too large for a Delta rocket at this point; ironically, Mather had the Delta in mind in his first sketch in 1974. The team looked to Europe for a launch vehicle, but this was hardly an option for NASA. Instead, the project managers led a redesign to shave off hundreds of pounds, to slim down to a 5,000-pound launch mass, with fuel, which would just make it within the limits of a Delta by a few pounds. Oh, and Mc-Donnell Douglas had to build a Delta rocket from spare parts, having been forced to discontinue the series in favor of the Space Shuttle.

The team worked around the clock over the next two years. The final design challenge was . . . wait for it . . . a sunshield that now needed to be folded into the rocket and spring-released once in orbit, a novel approach. COBE got the greenlight to launch from Vandenberg Air Force Base in California, the originally desired site because it would provide easier access to a polar orbit compared to launching a Shuttle from Florida. Launch was set for November 1989. COBE was delivered several months before.

Then, on October 17, the California ground shook hard. A 6.9-magnitude earthquake struck Santa Cruz County, causing widespread damage to structures. Vandenberg, some 200 miles south, felt the jolt. As pure luck would have it, COBE was securely fastened only because two of the engineers minding it secured it that day before going off to get married. The instrument suffered no damage and launched successfully on November 18. More drama came with the high winds on launch day. Myriad worries followed in the first weeks of operation: the cryostat cooled too quickly; sunlight reflecting off of Antarctic ice played havoc with the power system; trapped electrons and protons in the Van Allen belts disrupted the functioning of the electronics; and so on.

All the delays, all the drama, faded into a distant memory for Mather as the results of the COBE experiment came in. Data would take four years to compile. But the results were mind-blowing. The first result came weeks after launch, when Mather showed the spectrum to the American Astronomical Society and received a standing ovation. The Big Bang was safe as a theory. Two years later, at an April 1992 meeting of the American Physical Society, the team showed their

first map. Data matched theory perfectly. This was the afterglow of the Big Bang revealing the seeds that would grow into stars and galaxies. Physicist Stephen Hawking called it "the most important discovery of the century, if not of all time."

Mather spoke humbly of the discovery at his Nobel acceptance speech in 2006, fully crediting his remarkable team and his colleague George Smoot, who shared the prize with him that year. But he didn't downplay the achievement. He noted that he was thrilled with the now broader "recognition that our work was as important as people in the professional astronomy world have known for so long."

Mather maintains that realism today. While concerned about delays, threats of cancellation, cost overruns, and not-too-subtle animosity in the broader science community over the "telescope that ate astronomy," he didn't let this consume him or his team. "There's no point in trying to manage other people's feelings," he said. "Quite a lot of the community opinion is, 'well, if it were my nickel, I'd spend it differently.' But it isn't their nickel; and the reason why we have the nickel in the first place is because NASA takes on incredibly great challenges. Congress approved of us taking on great challenges. And great challenges aren't free. My feeling is that the only reason why we have an astronomy program at NASA for anyone to enjoy—or complain about—is that we do astonishingly difficult projects. We are pushing to the edge of what is possible."

Webb isn't just a little better than the Hubble Space Telescope, Mather added; it's a hundred times more powerful. Yet his biggest worry through mission design was not the advanced astronomy instruments but rather the massive sunshield, which needed to unfold. All instruments and all the deployment mechanisms had redundancy engineered into them; there are two or more ways to make them work if the primary method fails. But that's not the issue with a sunshield. It would either work or not work.

Now Mather can focus completely on the science to be had. He expects surprises; he'd be surprised if there were no surprises. "Just about everything in astronomy comes as a surprise," he said. "When you have new equipment, you will get a surprise." His hunch is that Webb might reveal something weird about the early universe, perhaps an abundance of short-lived objects never before seen that say something about dark energy, the mysterious force that seems to be accelerating the expansion of the universe, or the equally mysterious dark matter. He also can't wait until Webb turns its cameras to Alpha Centauri, the closest star system to Earth. What if there's a planet there suitable for life? Webb should have the sensitivity to detect molecules in its atmosphere, if present.

"That would be cool," Mather said. Hints of life from the closest star system? Yes, cool, indeed.

Meet the Team

Thousands of machinists, engineers, scientists, and communication specialists made Webb a reality. We profile nine here.

Amber Straughn, Deputy Project Scientist for Science Communications
—*Drawn to the sky*

Amber Straughn cannot remember a time when her head wasn't in the stars. Raised in a green, rural patch in central Arkansas, far from city lights, Straughn would gaze nightly at the immense celestial sphere above her. "Some of my earliest memories are of looking up at that beautiful dark sky and wondering what was out there," she said. She could easily discern that hazy band of light cutting through the center of the sky that we call the Milky Way, a sight now lost to most of us living in urban settings, and this made a lasting imprint on her young mind. "I often wonder, if I had grown up in a big city, if I would have become an astronomer." And so, Straughn's childhood experiences "in the middle of nowhere," as she described it—where her family raised steer cattle and grew watermelon for a living, and where her high school had only twenty-nine students in its graduating class—would propel her to the University of Arkansas and then Arizona State University to earn undergraduate and graduate degrees in physics.

Straughn continues to wonder "what's out there." Her scientific expertise is in galaxy formation. She arrived at NASA Goddard Space Flight Center in 2008, first as a postdoctoral fellow. With data from the NASA Hubble Space Telescope and other observatories, both in orbit and on dark-sky mountaintops, she has probed some of the deepest patches of the visible universe to witness the physical processes of galaxy mergers, star formation, and black hole growth—essentially

Amber Straughn

cosmic evolution. Webb is the ideal platform to take such observations to the next level, as it is 100 times more powerful than Hubble and 1,000 times more powerful than the NASA Spitzer Space Telescope, an infrared observatory.

Infrared is key here. The earliest objects to appear in the universe are so distant that their ultraviolet and optical light has been redshifted, or stretched, into the infrared region of the electromagnetic spectrum. Spitzer, as fine a machine as it is, lacks the collecting power to see the very early universe. And Hubble's reach

doesn't extend much into the infrared. "The reason why Webb was designed the way it was is to push past that limit that Hubble has reached, to see the very first epoch of stars and galaxies that formed after the Big Bang—a part of space we have never seen before," Straughn said.

This will be the fun part for Straughn, the observations. As Webb deputy project scientist, Straughn has served as technical liaison between the science team who shaped and built this incredible observatory and, in essence, the public who have paid for it. This includes the communications and legislative affairs teams tasked with maintaining public support and congressional funding. With Webb infamously over budget and behind schedule, and with so much pressure to launch with no errors, that task wasn't easy. "I *love* my work," Straughn said with emphasis. "I am grateful to work at NASA. It's a dream come true." Nevertheless, there were many stressful periods, made less stressful by . . . yoga.

"I practice yoga every day. It's more than a hobby; it's a big part of my life. I started yoga in grad school, when I was stressed to the max, and it helped me immediately." Straughn also flies. She and her husband attained their pilot licenses in 2013 and purchased a four-seater, single-engine plane, another stress-reliever. They fly often from Maryland back home to Arkansas and even once took a cross-country trip, an ideal way to see America from an altitude of about 5,000 feet.

"Stars are up in the sky. Planes are up in the sky. I guess I've always been drawn to the 'up there,'" she said. Except for the yoga. "That keeps me grounded and sane." Namaste.

★

Scott Willoughby, James Webb Space Telescope Vice President and Program Manager at Northrop Grumman
—Problem-solver-at-large

Scott Willoughby describes himself as a puzzle guy. He does word puzzles before going to sleep each night and takes sudoku squares with him on long plane rides. His penchant for problem solving indeed is what nudged him into the field of engineering. And it's what kept him laser focused for more than twelve years as a lead on the Webb project.

Scott was the top person at Northrop Grumman for Webb, assigned to that role in 2009. He soon found himself in a game of three-dimensional chess—mitigating risk in a world of engineering firsts, managing a budget that granted little room for error, reassuring an at-times skeptical Congress of the project's continued progress, coordinating delivery of parts and whole instruments, designing tests, and finding the best talent to address critical design issues. He's

Scott Willoughby

darn proud of that talent, too, a team of hundreds of engineers and mechanics. "Every day this team came up with ideas on how to do some incredibly difficult technology," he said.

He also likes to set the record straight about the task that was at hand: Webb is no mere extension of Hubble. "Webb was a first-of-its-kind design" for space

astronomy, Scott said. He estimates that 100 million person-hours went into the invention of the Webb Telescope. And he uses that word "invention" with specific intent, because this project was beyond "building" or even "creating," in his mind. Nearly every aspect of the mission required novel engineering, a journey into uncharted territory.

Scott himself has had quite the journey. He grew up in East Rutherford, New Jersey, in a solidly blue-collar environment. The glow of neighboring New York City obfuscated most stars in the sky, and astronomy was on few people's minds. The biggest employer in town was the Meadowlands Sports Complex, which opened when Scott was a kid in the mid-1970s. Little surprise, then, that Scott never expected to find himself in the space telescope business, let alone managing a $10 billion project, the greatest telescope ever placed in space. "I envisioned myself being a bartender," he said. "My uncle was a bartender; my grandfather was a bartender. I didn't apply for college until a friend put an application in my hands."

Scott had assumed he was from too poor of a background to attend college. But he learned that he could apply for financial aid, and he was accepted into Lehigh University in Bethlehem, Pennsylvania—uncharted territory. He joked that he never took an AP class in high school and that the Lehigh admissions office must have pitied him. Nevertheless, he excelled there—90 miles due west from his hometown, in a blue-collar city on a decline with the slow collapse of its steel industry—and received a degree in electrical engineering summa cum laude. He then earned a master's degree in communication systems from the University of Southern California.

Scott credits his immigrant grandfather, who had no formal education, for giving him a key skill he has needed to succeed: listening. That's what bartenders do: listen. Scott spent nearly every weekday of his early life hanging out in his grandfather's bar, after school, doing homework and just absorbing the dialogue among the diverse patrons: lawyers and accountants, office workers and manual laborers. He developed a knack of being able to relate to all walks of life and to describe complex ideas in ordinary words. These skills proved invaluable for Scott as a Northrop Grumman vice president as he traversed the United States monthly to visit with NASA personnel at headquarters in Washington and at Goddard Space Flight Center in Greenbelt, Maryland. Several times a year he would meet with Congress members and their staff, too, listening to problems and translating the importance of the mission.

Scott remembers the best years in Webb's development, which came soon after the major project overhaul in 2011. "Between 2011 and 2018 . . . we were in stride," he said. "For seven years of that program, we hit nearly every milestone." Although he witnessed myriad engineering firsts, he laments the issue of loose

fasteners in the sunshield design, circa 2018, which grabbed some headlines. It clearly pains him to this day to retell the story, despite the success of the mission.

Yet Scott is being too hard on himself. By his own admission, risk management does not imply that you can eliminate all risks. The project was defined by making hard, calculated decisions every day; and, by and large, crisis was averted more often than crisis arose and needed to be addressed, all as a result of Scott's prudent risk management. And now with Webb working as designed, any engineering mishap that happened along the way will be an entry in the lesson book for the next great project.

"How could a kid from East Rutherford do this?" wondered Scott, reflecting on his uncommon path. "I didn't think about being a business major because I thought that Wall Street was just for rich people. If you had a country club membership, you go work there. I thought engineering was agnostic to wealth. I literally picked engineering because I felt that if you can get the right answer by an equation, then you're right. You don't have to be in the club. You just had to be right."

With Webb now fully operational 1.5 million kilometers from Earth, it looks like the Webb team got it right.

★

Amy Lo, James Webb Space Telescope Deputy Space Vehicle Director
—Contains multitudes

Amy Lo wanted to be all sorts of things growing up: a poet, an architect, or maybe a neurosurgeon. In college at Brown University, she started out as a chemistry major, flirted with being a math major, and thought about space geology before settling on physics simply because "that's about as foundational as one gets," she said.

She delved into this field for nearly a decade, earning a PhD in astrophysics from the University of California, Los Angeles, and studied the early universe, particularly the cosmic microwave background and the earliest structures that could form after the Big Bang. But much like that early universe, Amy wanted to expand. Perhaps to satisfy her itch to build things—note, one of her hobbies is turning junked cars into racers—she joined Northrop Grumman in 2005 to work on optical design and simulation projects with large deployables and turned herself into a card-carrying engineer. Quickly she rose to become one of Northrop Grumman's top engineers, assigned to Webb, their most prized contract, in 2012.

Amy's upbringing was equally as varied. She was born in Southeast Asia, immigrated to the United States at age twelve, and moved about North America to New York, Vancouver, San Francisco, and Seattle before her family settled down in Los

Amy Lo

Angeles. How curious, then, that her role on Webb as a systems engineer was to work with a global partnership in overseeing the integration of spacecraft instrumentation with its telescope and sunshield—a little poetry, architecture, neurosurgery, and physics rolled into one.

The challenges of Webb were immense and many. For starters, constructing that sunshield constituted novel engineering, and Amy's team needed to precisely align its five layers to maximize the cooling capability within narrow constraints

of size, mass, and foldability. Similarly, there's never been a space-based telescope with a primary mirror that needed to be unfolded. Amy's team was tasked with thinking through myriad testing regimes to guarantee the mirror would unfold in a zero-gravity vacuum environment.

Packing up Webb for French Guiana in September 2021 was by no means the end of her labor; rather, it was the prelude to a new adventure, that post-launch 29 days of terror, as the Webb team called it. After the launch, Amy and her team were at mission operations center at the Space Telescope Science Institute in Baltimore. She was on the night shift—"the party crew," she said sarcastically—to make sure that everything they built and integrated deployed flawlessly.

Now, with Webb safely at L2, Amy's work for this mission has come to a close. She said she is most interested in Webb's observations of the first stars and galaxies, a nod to her astrophysics research. She also noted how during her nine years on the Webb project she was keenly aware that this may be the biggest thing she does with her life, an experience to treasure. Along these lines, she also looks forward to finally spending much more time with her daughter and husband, as well as continuing her passion for refurbishing cars. She owns a 1984 Lotus Esprit, like the one in the James Bond film *The Spy Who Loved Me* that converts into a submarine, albeit minus the missile system. Then again, with a few weeks of tinkering, who knows what Amy could do with it.

★

Larkin Carey, Optical Engineer
—*Mystic of the mirrors*

Larkin Carey got hooked on "big universe" questions at an early age. "The meat of my homeschooling was just asking questions," he said. "How did things begin? What is all this?" Raised in rural, southern Oregon—way out there, in a cabin with an outhouse—the clear, night sky was an open book, and his parents encouraged him to ask, observe, build, and learn. His mother was an obstetrics nurse; his father, a botanist. For many months of the year, the family would camp in the woods, following Larkin's dad as he climbed trees to shake loose pine cones, which they'd bundle for reforestation projects for the US Forest Service.

Now nearly two decades out of college, Larkin hasn't lost that sense of being a nature child. He earned a degree from Oregon Institute of Technology in laser engineering, attracted to both the power—so impressed by a demonstration of a CO_2 laser boring a hole through wood—and the beauty. "Light is interesting because it is like the dividing line between science and mysticism."

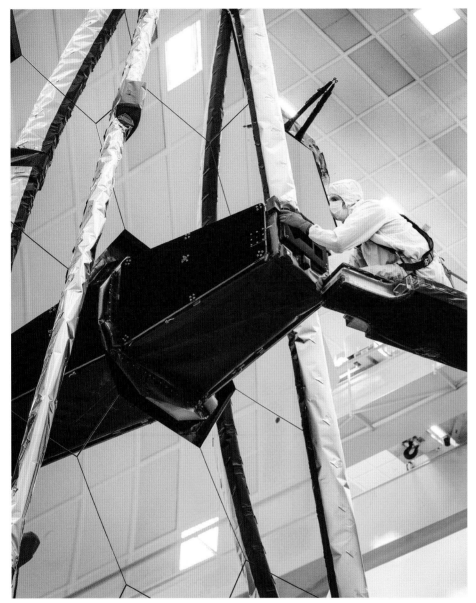

Larkin Carey

Larkin took a position at Ball Aerospace in 2004, knowing the company was working with NASA on the optics for Webb. It was his first major project, and his first task was to help build a one-fifth scale model of the 18-hexagonal-mirror observatory, from bare metal to finish, ultimately used to develop the alignment algorithms used for commissioning the telescope. He stayed on, constructing the gold-plated beryllium mirrors at the heart of the observatory. Over the years he

became intimate with the surface, having learned subtle differences across each segment. That's Larkin you see in the photograph, removing the protective "lens cap" before launch, his last major task.

One unexpected challenge was keeping the mirrors clean for so long. The mirrors weren't intended to be earthbound for fifteen years. Larkin needed to find novel ways to keep them pristine, applying wipes and puffs of air at first. But repeated cleaning had the potential to damage the mirrors and introduce dust elsewhere on the massive observatory. Larkin and his team ultimately developed a technique using a fine-haired brush used in art restoration.

His mirrors will direct infrared light onto Webb's detectors. There's a bit of irony here: Larkin is color blind; he can't see red. Yet for Larkin, this gets back to the mystic qualities of light. "I came into this world with the understanding that we all see it differently," he said. "Being color blind has taught me that my perspective isn't necessarily right or wrong, just a different one." Similarly, Webb's infrared-only perspective will reveal phenomena never before seen. That infrared light is magical, capturing a frozen moment in time from upward of 13.5 billion years ago, when stars and galaxies first formed.

With Webb safely operating at L2, Larkin's eighteen-year project has come to an end. There will be a well-deserved break before the next one. One of Larkin's pastimes is paragliding. Just as he hovered over the Webb Telescope's mirrors, he will glide over golden valleys around his home in Colorado, no doubt pondering "big universe" questions.

★

Kenneth Harris II, Integration Engineer
—Making connections within and beyond

Kenny Harris was only fifteen years old when he first started working at NASA Goddard Space Flight Center as an intern. This wasn't his first time at the facility, though. He had visited countless times before as a kid, tagging along with his father, also a NASA mechanical engineer of some renown. Kenny remembers napping under his dad's desk on a piece of foam left over from the Mars Pathfinder mission, doodling and otherwise absorbing all the engineering jabber around him.

That first internship was a nice gig. Kenny would walk over to Goddard after school to spend long afternoons learning the trade, working on projects such as the Global Precipitation Measurement Satellite and, coincidentally, some electronics for the Webb Telescope circa 2010. But engineering can't be learned

Kenneth Harris II

through osmosis from napping on Pathfinder foam, he soon learned. Acing high school and ultimately accepted into the prestigious Meyerhoff Scholars Program at the University of Maryland, Baltimore County, Kenny nevertheless found several courses quite challenging. Materials science was nearly his downfall; he failed twice. His advisor told him he wasn't cut out for engineering, and Kenny initially believed him, searching that very night for a new major that would allow him to graduate on time.

But fortunately, Kenny fell back on his connections. His first mentor at NASA, engineer Alphonso Stewart, had given him a bit of advice years prior: fail early, fail often, and then learn from those mistakes. Armed with mentors such as Stewart and others willing to coach and tutor him, Kenny persevered. He graduated

UMBC with a degree in mechanical engineering and eventually earned his master's degree in project management from Johns Hopkins University.

Kenny was back at NASA Goddard in conjunction with his Hopkins studies in 2014 and worked on several projects before being pulled into the Webb mission. Stewart was the Webb deployment systems lead, so the two could work together again. Kenny's role as an integration engineer under lead Matthew Stephens was to integrate the electronic components between the Optical Telescope Element (OTE) and the Integrated Science Instrument Module (ISIM), what the team called the OTIS, grabbing the first two letters of each acronym in typical NASA style. In short, Kenny was creating connections, ensuring that all the instruments had power, could communicate with each other, and could function properly in frigid orbit.

The challenges kept piling up, although not unexpectedly. "There is nothing routine about integrating a 10-billion-dollar satellite," Kenny said. He spent hours in the clean room with colleagues from Northrop Grumman working through the testing—failing early, failing often, all long before integration so that lessons learned would make that integration go smoothly. He helped develop the drawings for the harnesses that would be used to secure all the connections, and he saw that through its fruition. He stayed with the OTIS all the way through the successful testing down at NASA Johnson Space Center in the famed Chamber A thermal-vacuum test facility in 2017. Then his job was done.

Much of Kenny's passion is in enabling lasting connections, acknowledging the many people who have helped him succeed—he made the Forbes "30 Under 30" List of Innovators in the science category in 2020 for being one of the youngest African Americans in NASA's history to lead an integration—and inspiring others to become mentors and to seek mentorship to secure the next generation of engineering excellence. He frequently delivers public lectures, many aimed at high school students of color, in which he imparts the wisdom of Martin Luther King Jr., who wrote: "Intelligence plus character—that is the goal of true education." He tells them that they won't have all the answers and that mentorship is essential to be successful, particularly in the STEM fields.

Kenny noted that the Webb mission taught him "an amazing sense of teamwork and an appreciation of what goes into something this large," an experience he now brings to his current NASA project, the Gateway, the proposed outpost that would orbit the Moon and support a long-term human return to the lunar surface. This is part of the Artemis Program, which Kenny calls the Apollo Program of his generation. The Gateway could serve as a staging point for deep space exploration, too. Once again, Kenny is hoping to make connections.

★

Stefanie Milam, Deputy Project Scientist for Planetary Science
—Chemist in a galactic lab

Stefanie Milam caught the astronomy bug at an early age. She guesses she was only about six years old when she took her first field trip to the NASA Johnson Space Center in her hometown of Houston, Texas. "I came home that day and told my mom I was going to work for NASA and be an astronaut," she recalled with a laugh. In high school, that dream remained strong, and she began training to enter into the Air Force Academy to become a pilot. Alas, genetics intervened. Stefanie's final adult height left her an inch shy of the NASA space shuttle's minimum height requirement of 64 inches for a pilot.

Dejected, Stefanie applied herself to her studies at the Kansas Wesleyan University in Salina. She chose the field of chemistry with hopes, still, that she could work for NASA, maybe even be sent to the International Space Station to perform a chemistry experiment. On a practical level, she also knew she could find work as a chemist anywhere should this NASA dream crumble altogether. The first in her family to attain a bachelor's degree, she was driven and self-conscious about doing well in school. She earned her degree in only three years and graduated summa cum laude.

But her nascent chemistry career couldn't have been further from her dreams. She did have a fun side job as an assistant winemaker, measuring the alcohol content in the wine. But her day job was in an environmental wet lab measuring metal concentrations in paint samples and such. "Basically, my job was to wash beakers," she said. "Robots could do that." Frustrated, Stefanie turned to her college advisor, who suggested combining her chemistry training with her love of astronomy in the growing field of astrochemistry. This led Stefanie to the University of Arizona in Tucson for a PhD program. Suddenly she was using radio telescopes to perform chemical analyses in space. "This was the most eye-opening and revolutionary part of my career," she said. "My laboratory grew from a room, washing beakers at a sink, to the entire galaxy."

Soon after receiving her doctorate in 2007, Stefanie became a principal investigator at the SETI Institute, working at NASA Ames Research Center in California. In 2009, she took a position at NASA Goddard Space Flight Center in Maryland. Her specialty included studying the chemical enrichment of the interstellar medium, and she developed a particular passion for comets. In 2012, she got the call to join the Webb team. This was just after the 2011 cancellation threat, and NASA needed to better understand what kind of planetary science Webb could do. This,

Stefanie Milam

in turn, required the expertise of someone like Stefanie to ascertain how much interest the planetary science community would have in the mission and what kind of testing was needed of the Webb instruments from a planetary perspective concerning object luminosity and other parameters, such as tracking moving targets.

Stefanie rose to the challenge, first tapping into the network she had forged in her mostly radio-based observations and then reaching out more broadly to

planetary and solar system scientists who, for the most part, were not previously engaged in a mission billed as Hubble's successor to study the early universe. This was another period of incredible growth for Stefanie, as she learned of new science possibilities enabled by Webb, such as tracing the change in atmospheric conditions at nightfall on Mars and identifying planets around our neighboring star system, Alpha Centauri.

The dream of going into space is not off the table, either. More and more people are rocketing off each year. Stefanie still hopes to fly in orbit, one way or another.

★

Maurice te Plate, European Space Agency Webb Systems Integration and Test Manager
—One team, one goal

Maurice te Plate recalls the atmosphere at the Guiana Space Centre in Kourou in October 2021, where he was performing the final functional tests on the Webb Telescope before its December launch. Webb had arrived by boat from Redondo Beach, California, on a twelve-day journey to French Guiana that took it through the Panama Canal and into the Caribbean Sea, a cargo more precious than treasure chests of gold that passed through these waters centuries ago. The Webb spacecraft was tightly folded up in its launch configuration. Nevertheless, Maurice and his fellow team members could remotely switch on and test their instruments to confirm one last time that everything was in tiptop shape. Then, one by one, they shut down those instruments.

"It was quite emotional," Maurice said. "I was there with two of my close German colleagues from Airbus. And we had been doing these tests for years and years. When we switched it all off after we had done a very smooth test, we said to each other: Guys, this is the end of an era. We thought about how the next time we switch it on, it will be a million miles away—and it will be for real."

The entire Webb engineering team was deeply committed to the success of the mission. But Maurice had been particularly vested. He became involved very early on, while in his native Netherlands working at the European Space Research and Technology Centre (ESTEC), ESA's primary technology development center for space technology. The year was 2002. As an optical engineer, Maurice had been supporting many high-precision ESA spacecraft, such as Gaia, Planck, and LISA Pathfinder.

One late Friday afternoon—close to quitting time and the approaching weekend, Maurice remembers well—Peter Jensen, who was then the ESA Webb Project

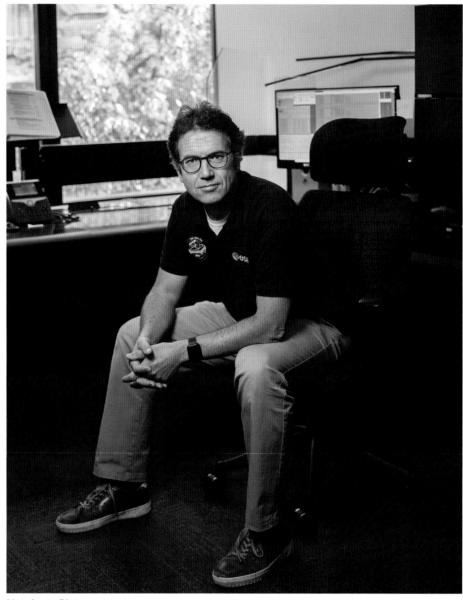

Maurice te Plate

Manager, came to Maurice's office with another colleague, unannounced, and began interviewing him to work on Webb. They were looking for an experienced optical engineer to help build the proposed European contributions to the mission. Reluctant at first, Maurice soon warmed to the idea and, within a few months, was working full-time on the Webb project. The proposed instruments weren't even

designed; they existed only as crude sketches. But he liked the blank-slate nature of the project.

Maurice was drawn to space exploration at an early age, inspired by a book his mother gave him about the Apollo astronauts. He read of their adventures countless times. With an inclination for math and a desire to build, he sought a master's degree in applied physics at University of Twente in Enschede, Netherlands, which was known for its optics group. His skills led to a job working on space technology at TNO, or Toegepast Natuurwetenschappelijk Onderzoek, a Netherlands research organization focused on applied sciences. And from there he moved to ESTEC, home to more than 2,000 engineers and scientists working hands-on with space mission designs.

Those blank-slate instruments that Maurice was assigned to would become NIRSpec and MIRI. NIRSpec was being built by ESA and a German-based team at the company Airbus Defence and Space, with the innovative microshutter design coming from NASA Goddard Space Flight Center. MIRI had contributions from ESA and from institutes in nearly a dozen European countries, as well as the University of Arizona and the NASA Jet Propulsion Laboratory. As work progressed, Maurice committed himself to the next big step: In 2012, he moved with his wife and three small boys to the United States so that, together with the delivery of NIRSpec and MIRI, he could embed himself in the Webb team at Goddard in Greenbelt, Maryland.

As in his playground at ESTEC, Maurice found himself at Goddard banging out designs, integrating instrument parts, and running tests in the high bay and clean room dedicated to Webb. This wasn't pure fun every day, though; the teams—plural—went through a multitude of trials, from Germany to Maryland and clear across the country to Redondo Beach, California. Maurice remembers Hurricane Harvey in Houston in 2017, which hit during an important test in the giant vacuum chamber at NASA Johnson. The team was forced to stay the night in sleeping bags to keep the cryo-vacuum testing on track, fretting that their helium and electrical supply might give out, as the winds howled outside and their cars were window-high in the flood waters.

But the teams remained one through it all, in part due to Maurice. Amiable and optimistic, Maurice had a talent curiously complementary to his ability to integrate instruments, and that was to integrate culturally diverse teams of engineers, machinists, and scientists. He served as a de facto ambassador, defusing divisiveness and securing unity not merely among a European team of many nations but also between the United States and Europe, NASA and ESA.

"We might be different entities, completely different cultures, completely different backgrounds," Maurice said. "But when it came to resolving technical problems, within a minute you're like one integrated team—one team with one goal: making the thing work."

★

Elaine Stewart, Contamination Control Engineer
—The next generation

The Webb project began in 1996 as the Next Generation Space Telescope. Elaine Stewart, born in 1995, wasn't even a year old yet. Who could have guessed that she'd come to represent part of the next generation of space systems engineers working on Webb?

Sure, maybe some odds were in her favor. Both of Elaine's parents were chemical engineers. Her older brother would pursue the field, too. Elaine studied chemical engineering at the University of Delaware as a matter of course. But her interest in aerospace was influenced by her work as an undergraduate researcher, when she investigated shear thickening fluids for astronaut space suits and studied ultracool brown dwarfs for the JWST Early Release Science program. Through a partnership with the Delaware Space Grant Consortium, she applied for a summer internship at NASA Kennedy Space Center after her freshman year of college because, well, it was NASA. Never mind what the work would be. She wound up on a team building the Resource Prospector, a lunar mission since reimagined as the Volatiles Investigating Polar Exploration Rover (VIPER), scheduled for launch in the mid-2020s.

That experience got her hooked on space. Having picked up valuable knowledge about working with materials in vacuum chambers, Elaine applied for an internship at NASA Goddard, and she was assigned to the Webb project under the tutelage of none other than senior project scientist John Mather. She returned each year until her graduation in 2019 and then was invited to join the team as a NASA employee.

As a Webb Telescope contamination control engineer, Elaine had the task of ensuring that the primary and secondary mirrors and all other sensitive surfaces met the requirements for cleanliness throughout the construction, testing, and transport of the telescope. The sheer size of the telescope and orientation of the components posed endless challenges. Just a speck of dust could compromise the integrity of the mirrors and thus the quality of the captured image, not unlike a smudge on a pair of eyeglasses. Yet wiping the mirrors clean with a cloth had the potential to smear; a blower had the potential to damage the delicate surface. After testing many approaches, Elaine's team decided on a fine-haired brush to remove any errant particle.

"We were really trying to prevent any problems from happening later," she said. "With Webb a million miles away, if there is an issue such as degradation

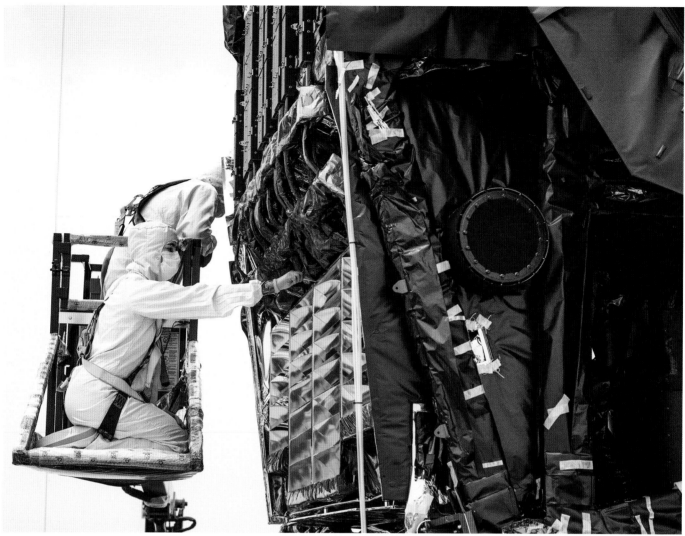

Elaine Stewart

loss or how much we are able to see with what's on the mirrors, we can't go up and clean it. It was all about the efforts we made while on the ground, because we knew there'd be no going back."

Elaine's role with Webb is largely behind her now. But as part of the new generation of engineers at NASA, she is moving on to other challenging projects. Once hooked on space systems engineering, there's no going back.

★

Gregory Robinson, Program Director
—Engineer of human motivation

Greg Robinson sometimes jokes that he could have been a psychiatrist. He's approachable, and most people are at ease talking to him. His vast team of engineers indeed were comfortable opening up to relay their problems and frustrations. Turns out that this quality, which comes naturally to Robinson, was instrumental in saving the Webb mission.

Robinson joined the Webb team late in the game, in 2018, when the mission was once again in peril. Human error and subsequent cost overruns and launch delays were steadily mounting to a point where, as in 2011, the risk of losing funding was becoming tangible. That's when Thomas Zurbuchen, NASA's associate administrator for science, asked him to step in to direct the Webb program.

Robinson was reluctant. He had an enjoyable job at NASA already, albeit challenging. As deputy associate administrator for programs, he oversaw more than 100 space and earth science missions, quite the diverse and exciting portfolio. He did, however, have a knack of getting projects back on track. One such project is the Joint Polar Satellite System (JPSS), a set of environmental satellites that NASA is developing for the National Oceanic and Atmospheric Administration (NOAA). Robinson described that project as being in "tough territory" circa 2011, much like the Webb project. As of 2023, two of the four planned JPSS satellites have been placed in orbit, with others on track to follow.

Robinson eventually yielded to Zurbuchen's request. Webb, the greatest observatory ever to be flown, certainly had its allure. When Robinson saw the telescope's extremely talented team of scientists, engineers, and technicians, he was confident the mission would fly and fly right. He was just less sure about when.

Sensitive to the criticism of launch delays, some team members were becoming reluctant to report potential problems, hoping they could work out the issues themselves. This was to be expected, as far as Robinson was concerned. "Humans make mistakes," he said. "If we don't want mistakes, we have to get rid of the humans. But then we won't have much innovation." As an engineer by training—he has a bachelor's degree in math from Virginia Union University and another in electrical engineering from Howard University—he understood human error innately. As an astute manager, with an MBA from Averett University and more than twenty years in leadership positions, he also knew ways to mitigate it. He applied key management skills to instill a culture of transparency that encouraged team leaders to report problems without fear. He also implemented better forward planning, for example, not simply knowing what testing was needed in

Gregory Robinson

six months but additionally what was needed for that testing, such as whether the testing facility needed to be cleaned in a unique way.

"The technologies in our systems are extremely complex; and Webb was complexity on steroids," Robinson said. "Often I say, let's not make the complex

complicated. Sometimes we do that," he said, by not communicating openly or not doing relatively simple forward planning. To wit, he saw his role as enabling his team to better manifest their talents.

Under Robinson's leadership, scheduling efficiency—that is, keeping to schedule for each element of the project—improved to near perfection. The first major setback came in May 2018 when an acoustics test shook loose screws and washers from the sunshield cover, a problem set in motion years prior but hiding in the shadows. This was "not terrible news," he said at the time in his typical calm manner, "but not good news, either." Indeed, the incident led to a ten-month launch delay and an additional $800 million. Robinson guided the team through it all. One more test of stamina came in November 2021, about a month before launch, when a high-tension clamp band that would secure the telescope within the rocket fairing unexpectedly released, sending vibrations through the tele-scope. The team worked through a tense two weeks of testing to be sure the instru-ment suffered no damage. "We dodged the bullet on that one," he said.

Robinson's has been quite the journey. Like many others on the Webb team, he grew up in a deeply rural setting, in southern Virginia near Danville. His parents were sharecroppers who grew tobacco, and Robinson was the ninth of eleven children. He began his education in the 1960s in a racially segregated elementary school. He found he had a proclivity for math, "one of those qualities that the good Lord gave me," he said. He was equally blessed with teachers who nourished that talent and encouraged him to earn a college degree. Robinson's athletic prowess helped, and he attended Virginia Union University on a football scholarship.

Now in his sixties, Robinson said he won't be coaxed into leading another big NASA project, although he amended that a bit, adding with a laugh, "but I guess it depends on what kind of mission it is." For now, he seems happy to have worked himself out of a job. Modest as he is, Robinson does understand that he can im-part extraordinary leadership skills to the multitude of mid-career NASA manag-ers and many others who have been inspired by his skills and accomplishments. So don't expect him to ride off into the sunset just yet.

The Webb Telescope's Engineering Odyssey

Photographs and Captions by Chris Gunn

And so the task begins: Contamination control engineer Zao Huang stands before the enormous filter wall of the high bay cleanroom, the world's largest, at NASA Goddard Space Flight Center in Greenbelt, Maryland. Webb Telescope mirrors and instruments would be integrated and tested here over a period of about ten years before being shipped to NASA Johnson Space Center in Houston for further testing in 2017. Seemingly as infinite as space itself, this wall is about 100 feet, or 35 meters tall; each square is a HEPA filter measuring about 2 × 2 feet.

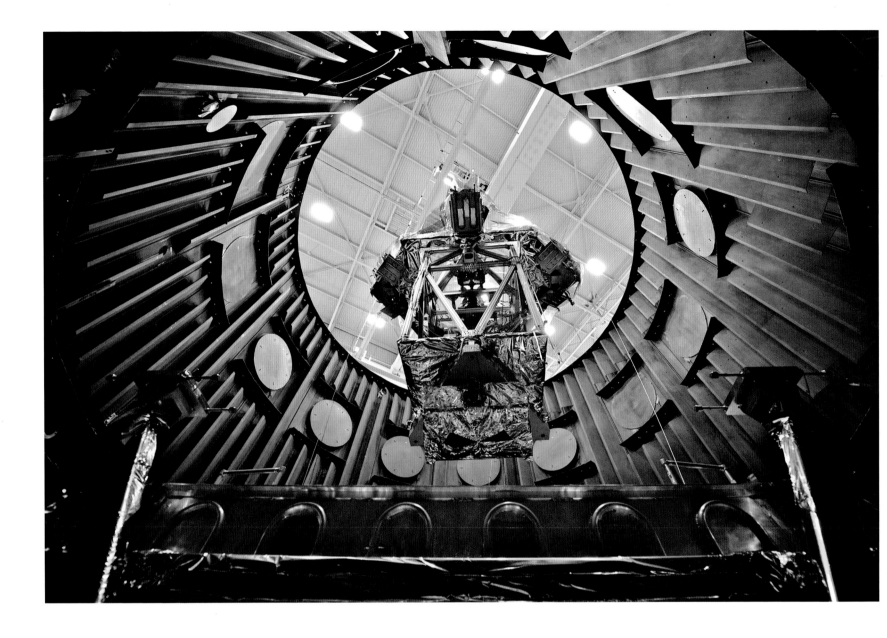

Before Webb's flight instruments were built, engineers constructed numerous prototypes to demonstrate they could meet the strict requirements for the mission. Here, circa 2012, the Optical Telescope Element Simulator (OSIM), wrapped in a silver blanket, enters the Space Environment Simulator, a thermal vacuum chamber, to see whether it can withstand the ultracold temperatures of space. The OSIM was needed in pretesting of the Optical Telescope Element (OTE) and its integration with the Integrated Science Instrument Module. OSIM contained no flight hardware. But still, images of it were very popular with news outlets. It revealed a real thirst for Webb images and energized my work.

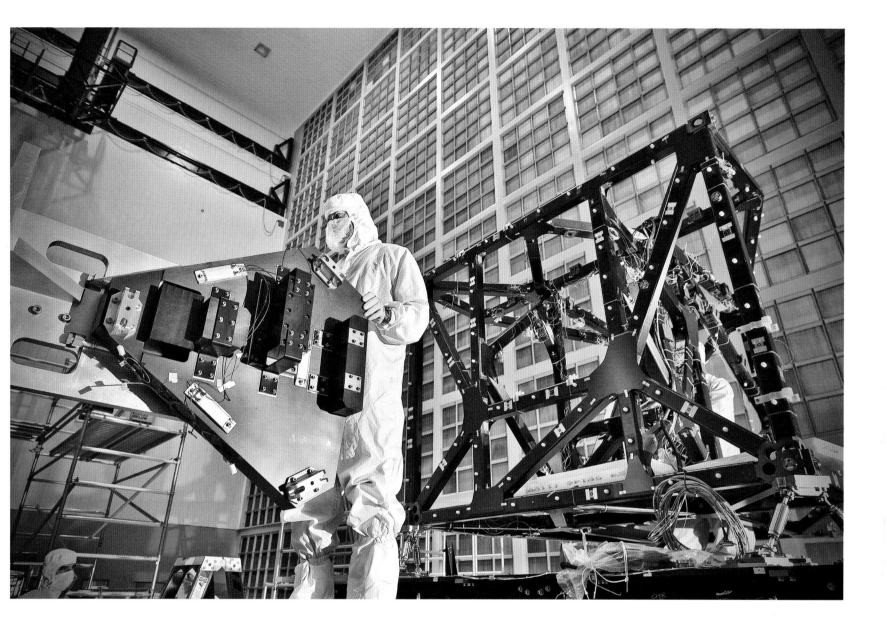

Hard to believe this bare black frame, the Integrated Science Instrument Module (ISIM), would become the heart of the Webb Telescope, housing the four main detector instruments. Here, NASA Goddard technicians install instrument mass simulators on an instrument-free ISIM in preparation for an early cryogenic test in September 2010. The ISIM is made of a composite material that is ultralight, durable, and barely contracts in the cold of space. I remember shooting this and becoming painfully aware this project had a long way to go.

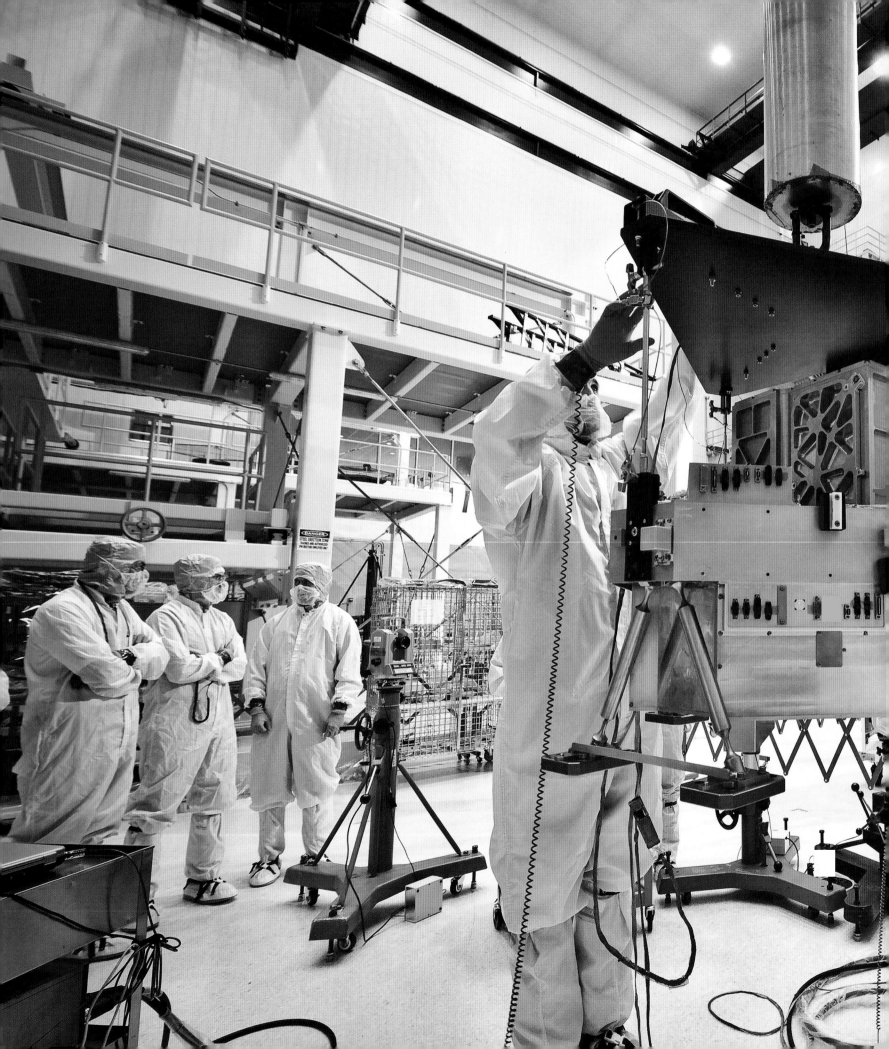

Teams across North America and Europe built the various components that would be integrated and tested at NASA Goddard before final assembly at Northrop Grumman in California. Among the first to arrive at Goddard, on July 30, 2012, was the Fine Guidance Sensor/Near InfraRed Imager and Slitless Spectrograph (FGS/NIRISS), seen here being lifted for placement on a master tool for key measurements prior to installation onto its flight structure. Designed by the Canadian Space Agency and built by Honeywell, the FGS enables the telescope to point at the intended objects for observation with astounding accuracy, and the NIRISS observes light from the wavelengths of 0.8 to 5.0 microns.

Webb's 18 mirror segments, each 1.32 meters wide, were sent by truck from its manufacturer, Ball Aerospace, in Colorado, to NASA Goddard in Maryland starting in September 2012—at first one by one and then in twos and threes, as they were manufactured over a period of about a year. Each segment is relatively light, about 20 kilograms, or 46 pounds, made from beryllium with a thin coating of gold only 4.3 grams, or 0.12 ounces. Here, Matt Macias of Northrop Grumman shines a light to assess and document any artifacts on the gold surface. Normally the clean room was noisy with activity, but there was a prolonged hush when the lid for the container came off and we all saw the mirrors for the first time. I remember standing in the glow of the gold and realizing that I had never stood next to something so precious.

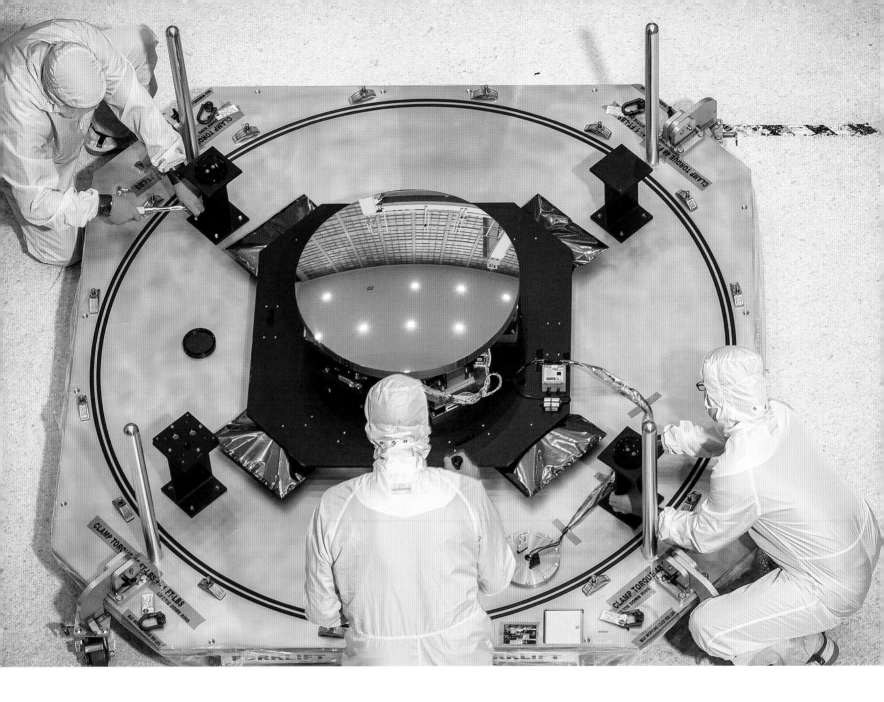

Lest we forget, Webb's secondary mirror is a wonder to behold, too. Captured here as a golden sun, this mirror is perfectly round, unlike the larger 18 hexagonal mirror segments that comprise the primary mirror on the telescope. It is convex, too, much like a bulging mirror in a parking garage that enables drivers to see around a corner. In this photograph, engineers at NASA Goddard examine the mirror from multiple angles to check for any surface imperfections.

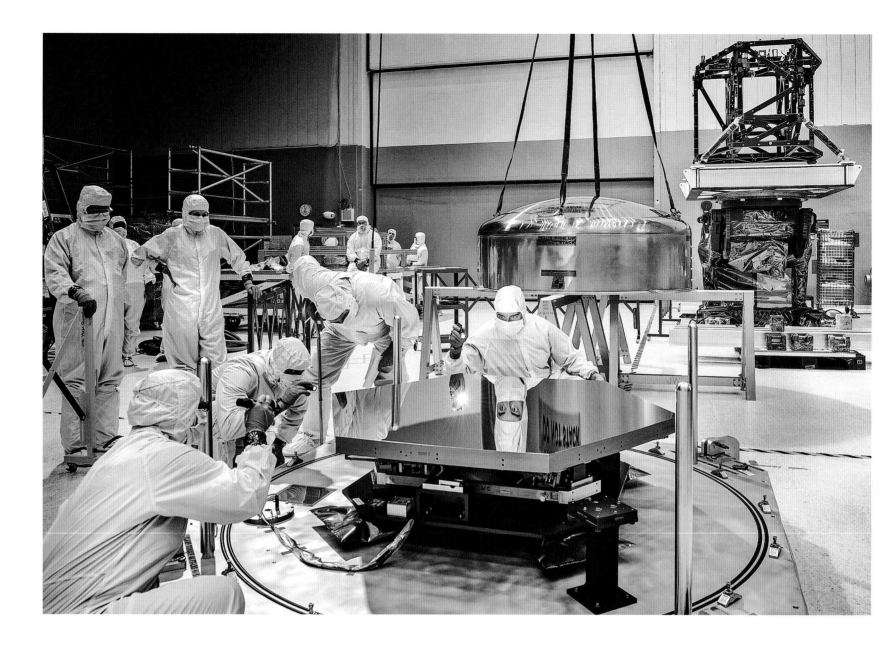

This was the very first mirror segment to arrive from Ball Aerospace to NASA Goddard, its concavity revealed in the distorted reflection of an engineer's face. The 18 segments must move independently to achieve perfect alignment for the entire primary mirror, to create a 6.5-meter-wide mirror with six times the collection area of the Hubble Telescope. Actuators that control the segment's micro-movements can be seen below this mirror segment. Seen in the back right, high on a platform, is the black ISIM frame that would hold all of Webb's detectors.

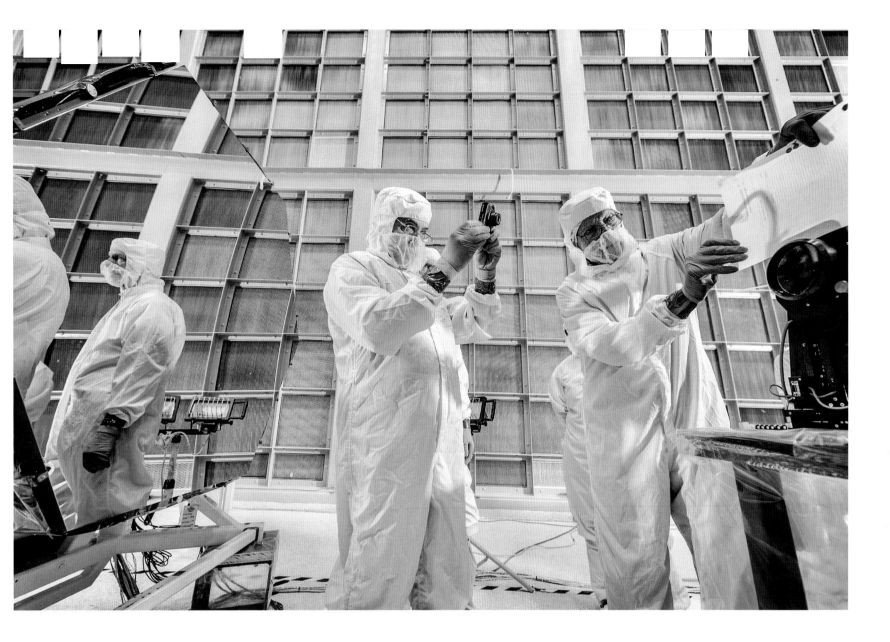

Optical Engineers verify the "prescription" of the mirror segment, as an optician would do with eyeglasses. The 18 segments have one of three prescriptions, or degree of curvature. This segment was not flown but rather used with one other segment in a simulation test.

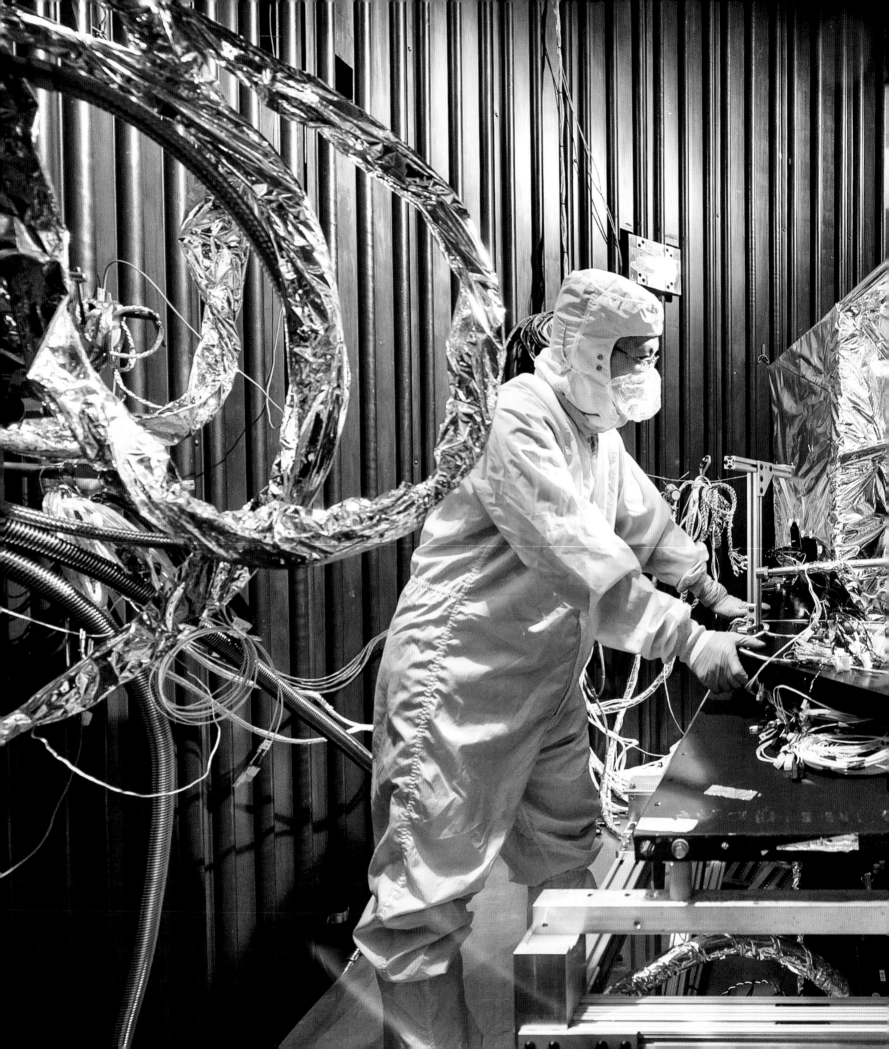

NASA Goddard engineer Acey Herrera examines wiring in the thermal shield of the Mid-Infrared Instrument (MIRI). MIRI needs to be 35 degrees colder than the other instruments, down to 7 Kelvin (−266°C, −447°F). The box-shaped shield helps achieve this lower temperature by blocking excess heat from the other detectors. As the MIRI shield lead, Herrera directed a team dedicated to the perfection of but one element of one instrument. He was one of hundreds of specialists on the Webb team.

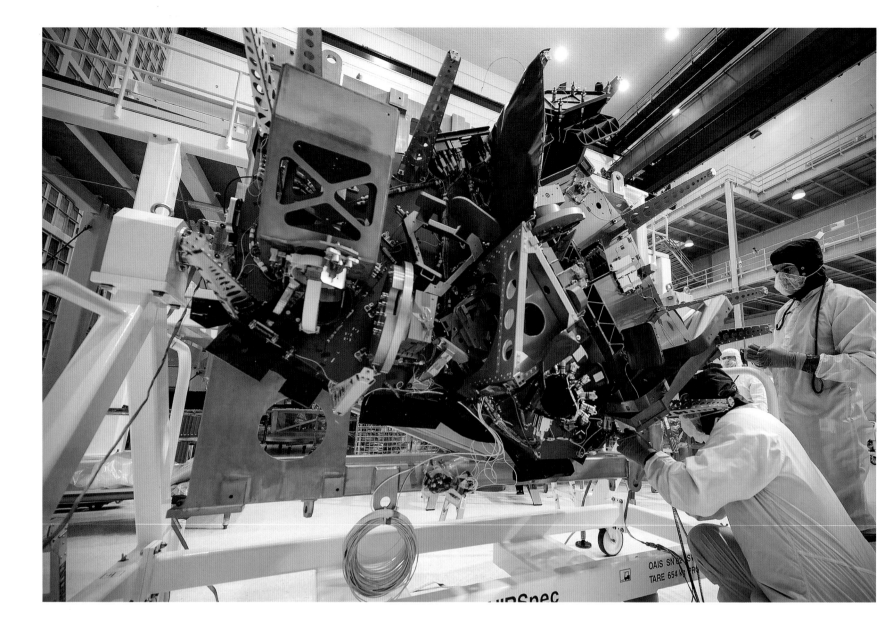

Engineers from Astrium, a subsidiary of the European Aeronautic Defense and Space Company, prepare the NIRSpec Engineering Test Unit at NASA Goddard. The unit would realistically replicate the thermal, mechanical, electrical, and optical characteristics of the Near Infrared Spectrograph.

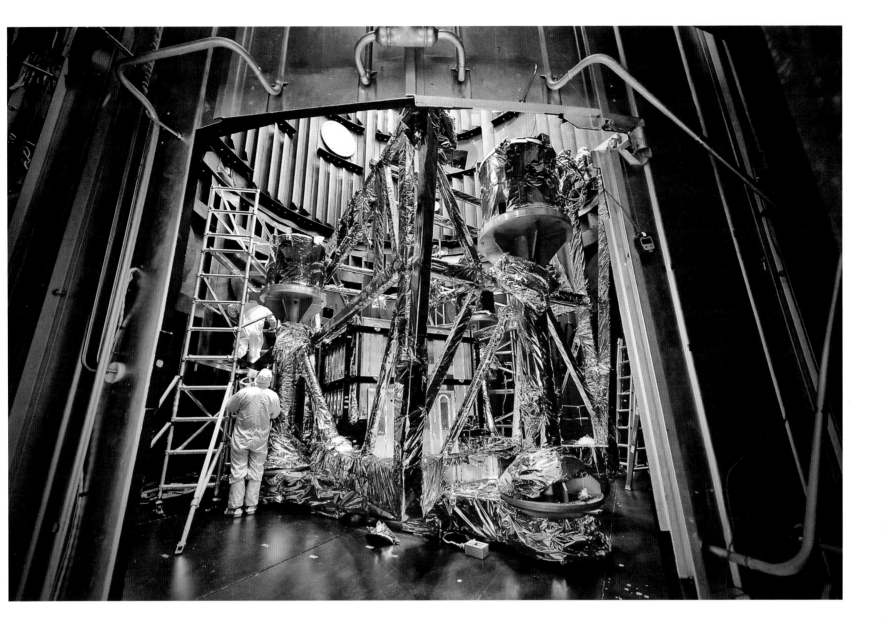

While Webb was in its earliest stages of construction, engineers needed to test the thermal properties of non-flight hardware similar to what was planned for the mission. Here, circa 2012, thermal engineers prepare the Optical Telescope Element Simulator for a test in a cryogenic vacuum chamber that was redesigned just for the telescope so that it could get colder than usual, down to 38 Kelvin (−235°C, −390°F).

NASA Goddard engineer Ed Shade is making last-second adjustments before an ultra-low-temperature test for non-flight hardware. This blanket of gold helps to maintain a delicate balance of minute temperature differences during the test.

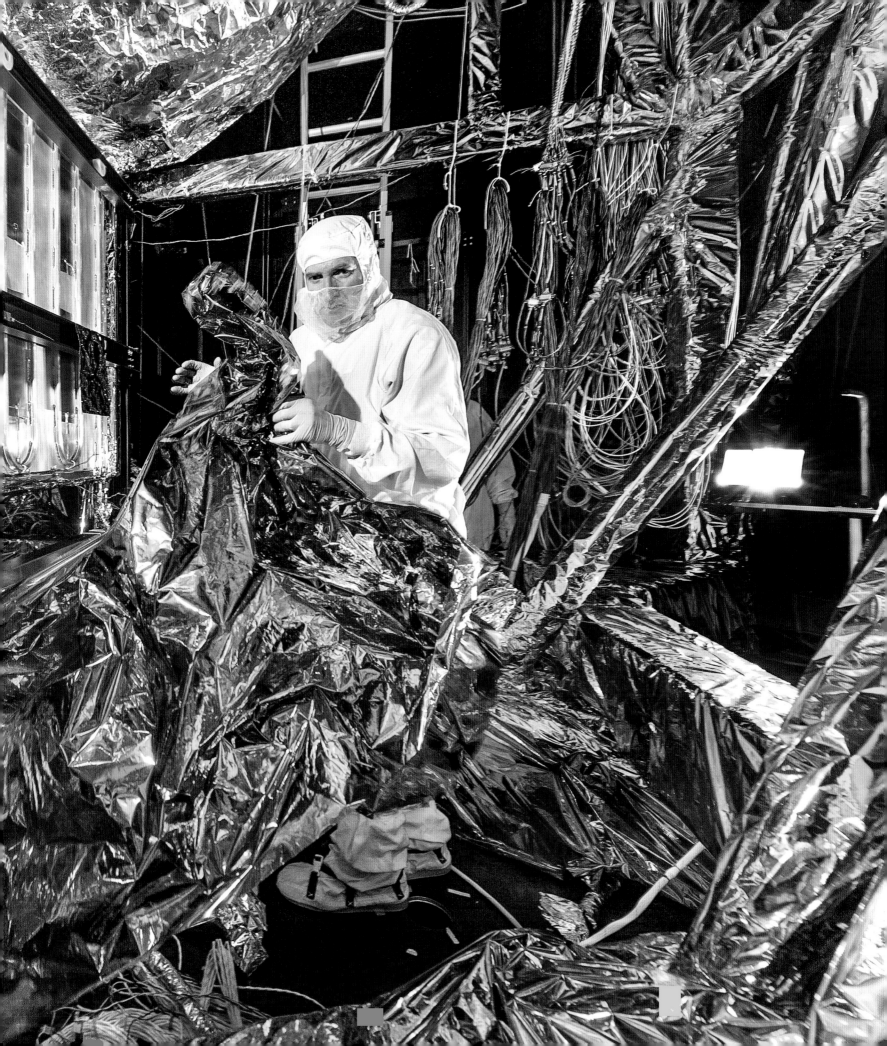

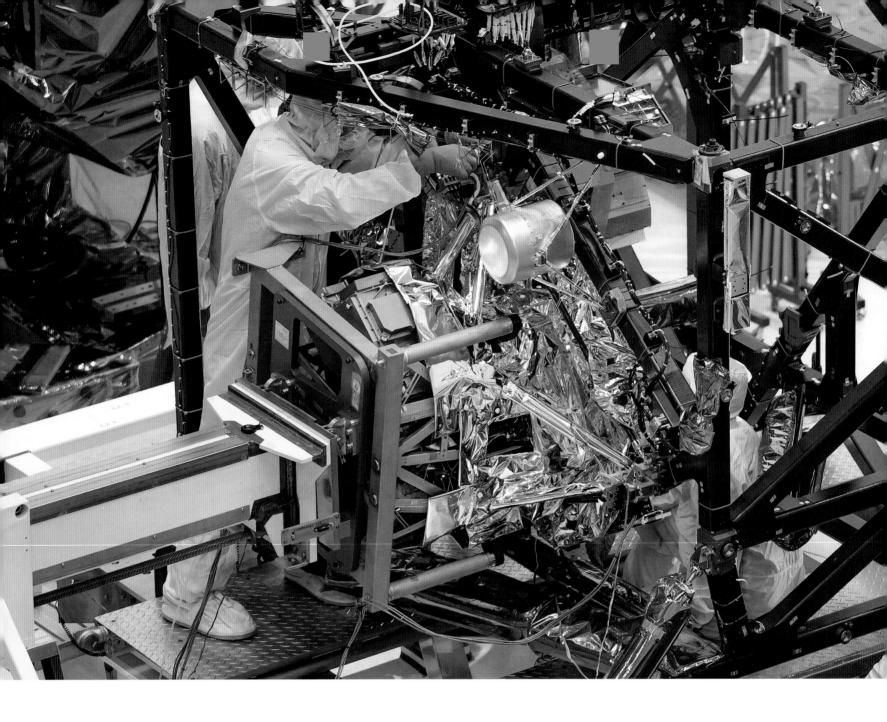

A technician installs bolts that will hold the MIRI to the black-framed ISIM. The gold-colored cylinder is a refrigeration unit that will lower the MIRI's temperature from about 40 Kelvin, the operating temperature of the other three instruments, to 7 Kelvin, just a few degrees above absolute zero. In this photo, the MIRI, wrapped in silver-colored foil, is attached to a balance beam, called the Horizontal Integration Tool, hanging from a precision overhead crane. This is the same tool that Hubble engineers used to prepare hardware for its servicing missions, also at NASA Goddard.

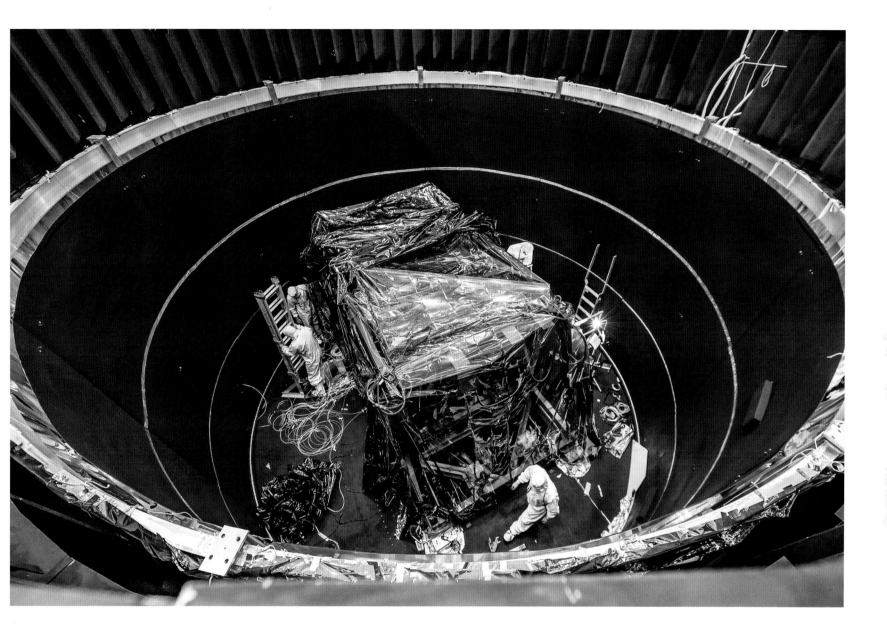

Down in the "vac." This view from above provides some spatial context, as engineers prepare the ISIM and ISIM Electronics Compartment (IEC) inside the thermal-vacuum chamber. The IEC houses computing and electrical resources for the instruments. Seen here are blankets partially pulled back; they would be removed during the testing. There are no doors to the chamber; engineers (and I) entered with ladders.

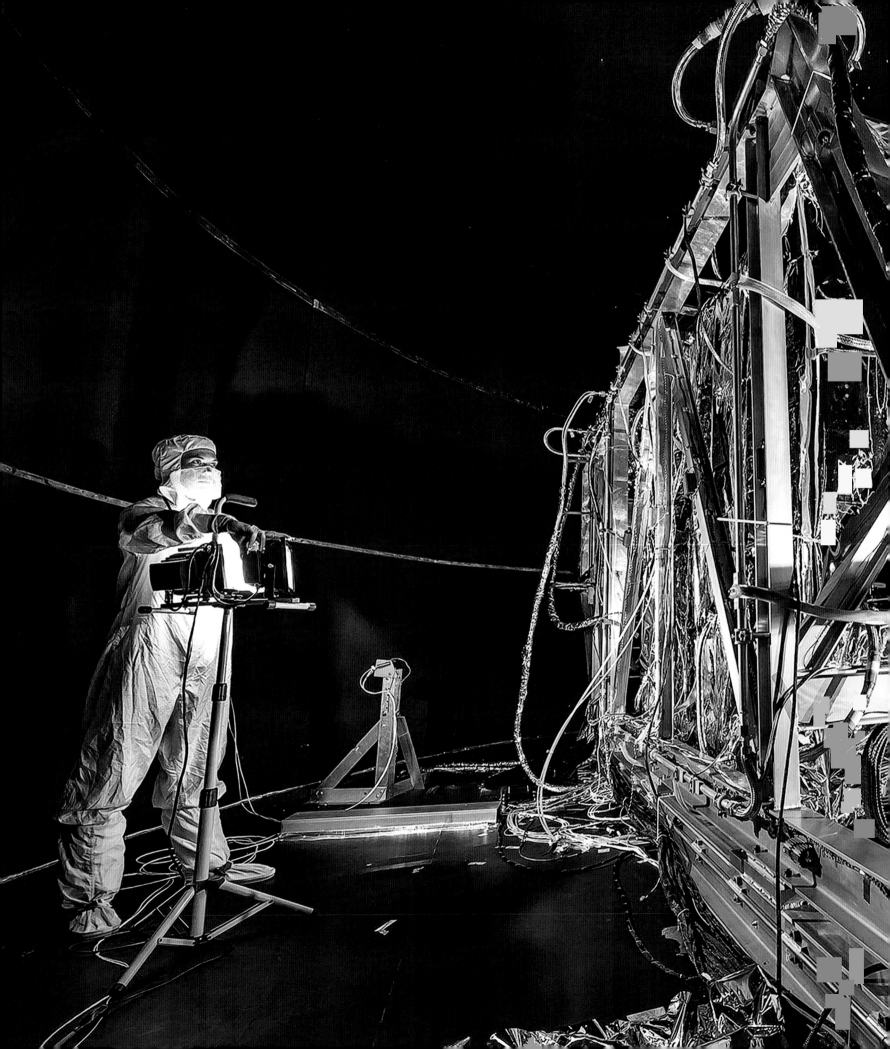

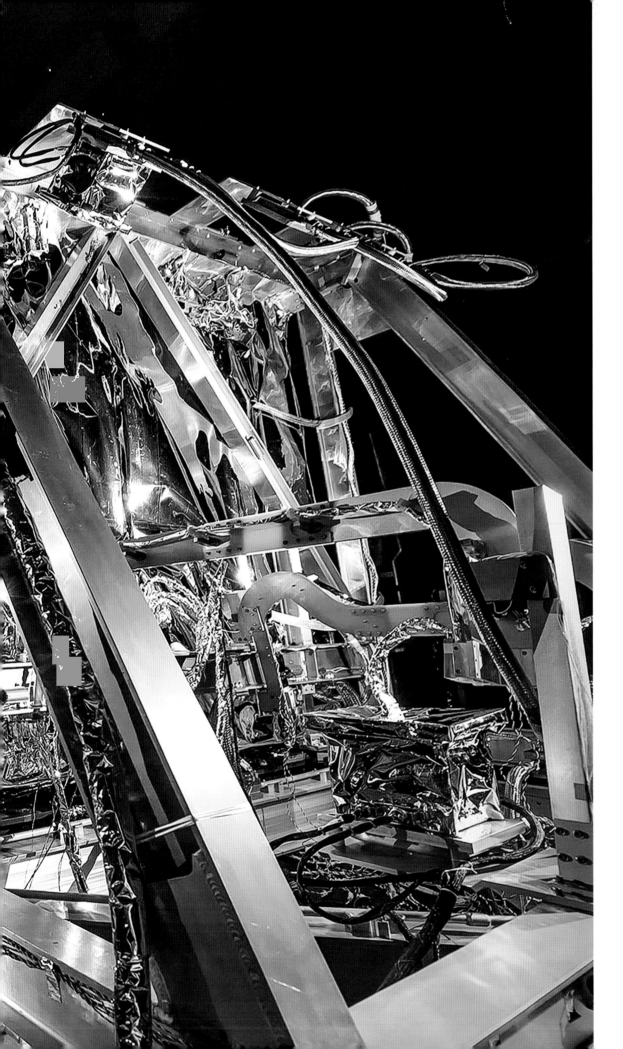

NASA photographer Desiree Stover shines a light on the golden frame holding the ISIM, which itself is holding the telescope's four detector instruments. Shortly after I took this photograph, this vacuum chamber, called the Space Environment Simulator, was sealed. Air pressure was removed, and the temperature slowly lowered to 40 Kelvin, the temperature the telescope would experience in space.

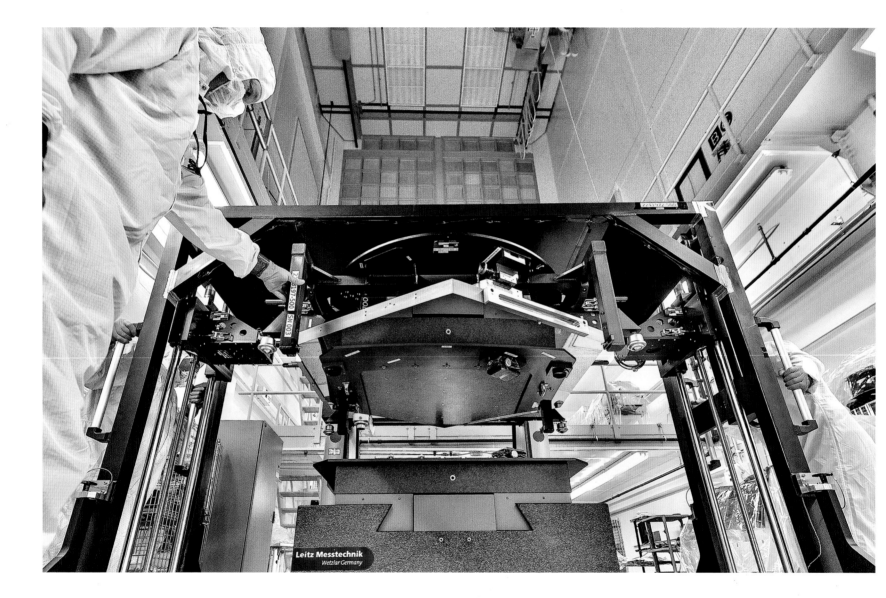

A James Webb Space Telescope primary mirror segment is loaded onto the Configuration Measurement Machine, made in Germany, used for precision measurements of the mirrors' surface to an accuracy of 0.1 micron, or 1/400th the thickness of a human hair, further assessing the mirror's prescription.

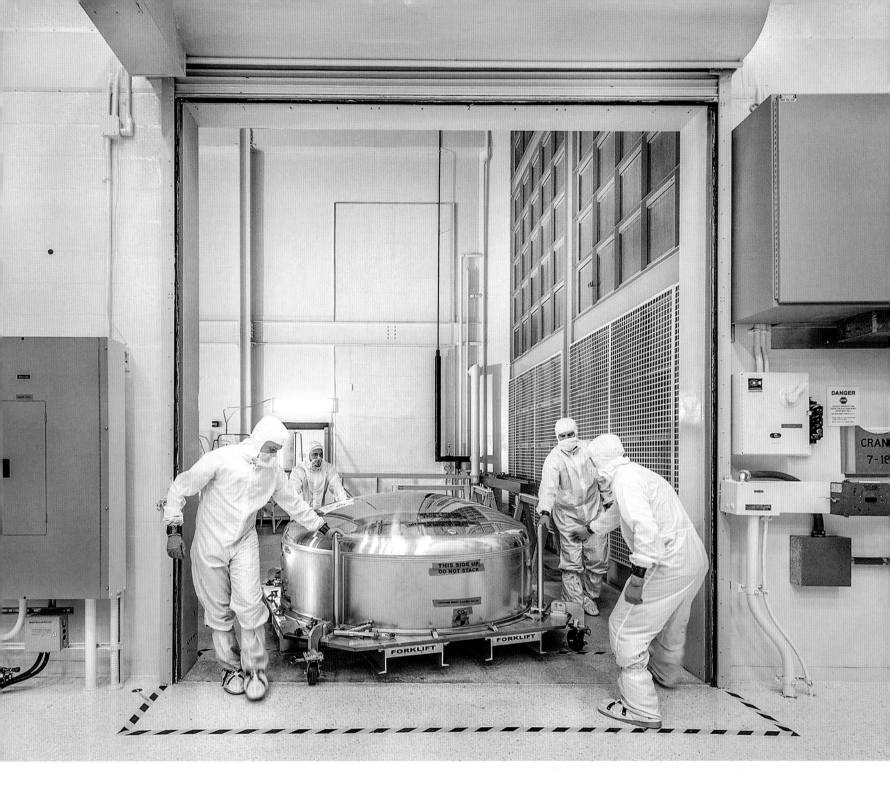

NASA Goddard personnel cautiously wheel into the cleanroom a vacuum-sealed capsule containing one of the 18 mirror segments that make up the primary mirror.

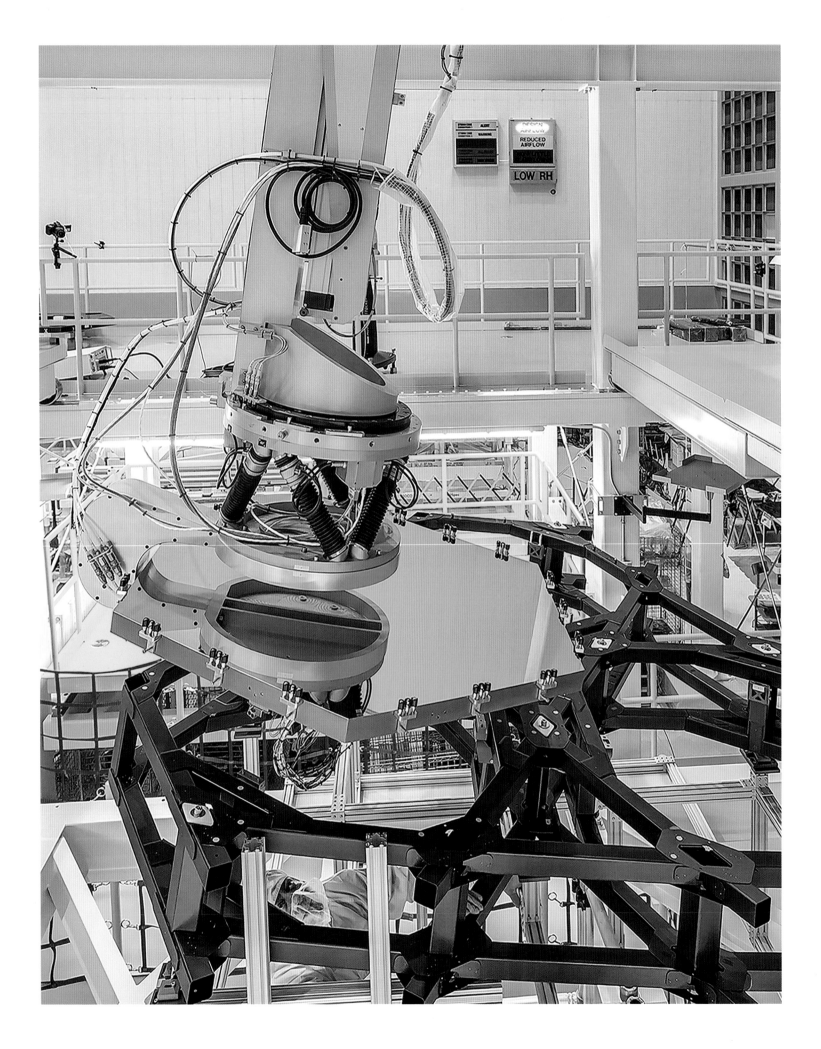

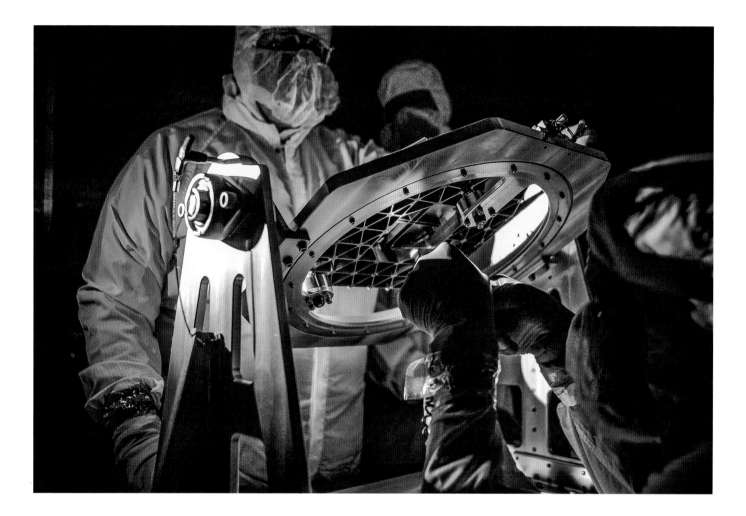

A robotic arm lowers a spare primary mirror segment onto a test piece of backplane at NASA Goddard. Dave Sime, an assembly crew chief, inspects the mirror placement from the underside of the backplane. This would prove to be good practice for the team to learn how to precisely position the flight mirrors later onto the actual telescope.

NASA engineers perform a "low light" test of the microshutter array, a revolutionary piece of novel technology designed and manufactured for the Webb Telescope at NASA Goddard to enable its Near Infrared Spectrograph to obtain spectra of more than 100 objects in the universe simultaneously. The microshutter array comprises thousands of tiny shutters only 100 × 200 microns, or about the size of a few strands of human hair, that open and shut to capture spectra from selected objects of interest in space and block out light from all other sources. I shot this in the natural low light of the test, as they were peering through the microshutters.

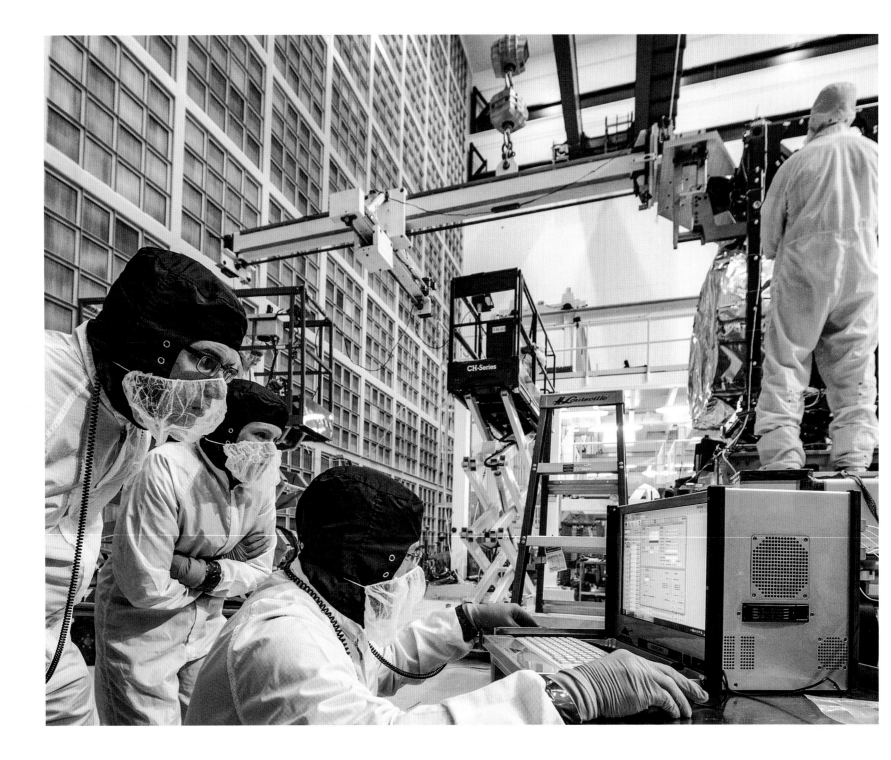

NIRSpec is in the upper right, wrapped in a thermal aluminum blanket, but all eyes are on the monitor assessing its integration onto the ISIM. Members of the German team who helped build NIRSpec are seen here with their designated blue hoods.

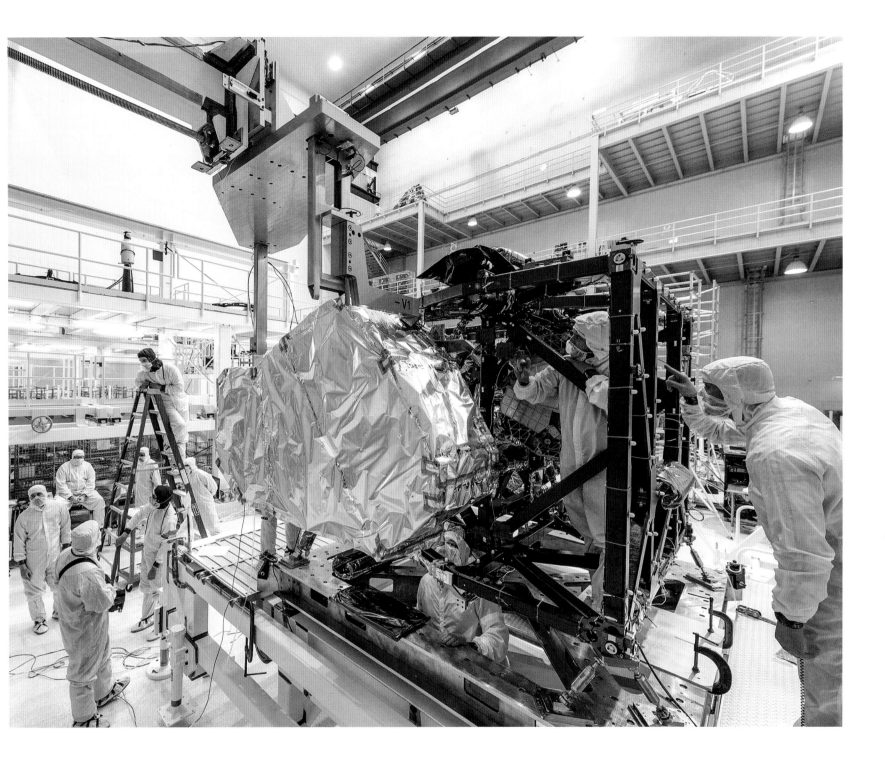

The European-built Near Infrared Spectrograph (NIRSpec), appearing somewhat triangular from this angle, was the first of four scientific instruments to begin integration testing at NASA Goddard yet the last to be fully integrated onto ISIM.

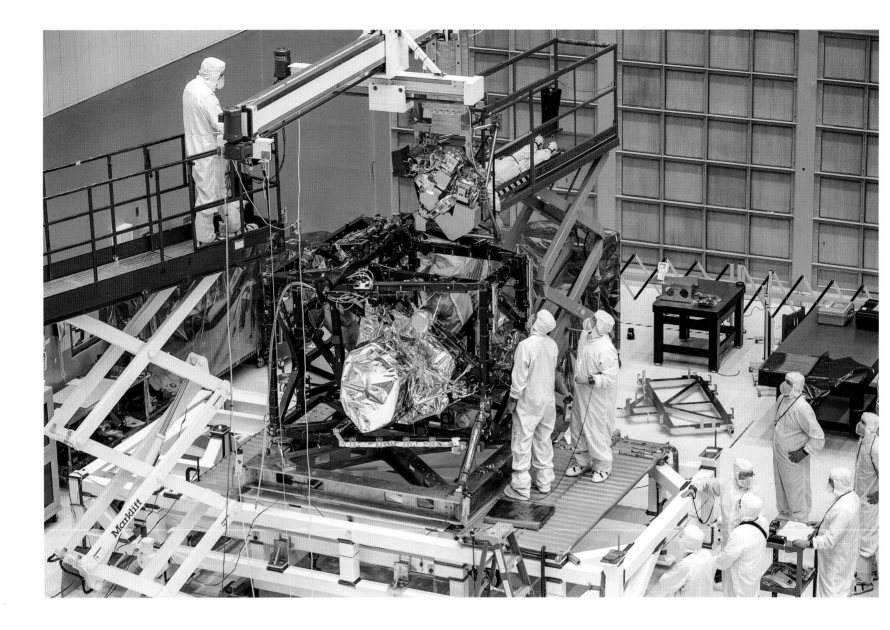

The Near Infrared Camera (NIRCam) is Webb's primary imager, the one behind most of
the stunning imagery. Here, circa 2014, NIRCam is integrated into ISIM, joining the
previously integrated Fine Guidance Sensor/Near Infrared Imager and Slitless Spectrograph
and Mid-Infrared Instrument. The Near Infrared Spectrograph would be integrated next.

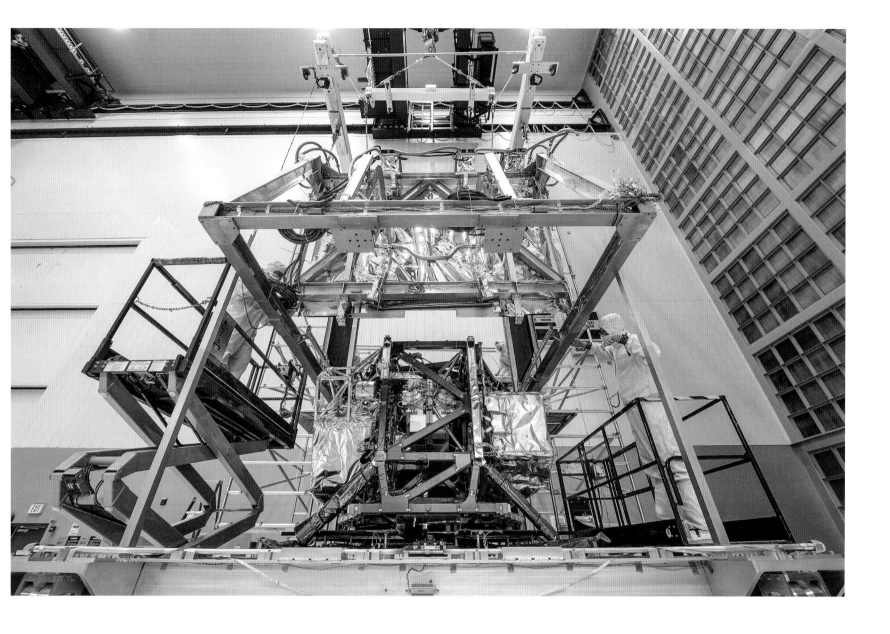

Engineers lower what looks like a golden cage, the Surrogate Thermal Management System (STMS), over the ISIM. The STMS would provide temperature balance as the ISIM is cooled to 40 Kelvin inside a vacuum chamber to simulate the harsh cold of space. Ironically, this was during a very hot Maryland summer in 2014.

Another view of the Surrogate Thermal Management System, the ISIM, and the ISIM Electronics Compartment, sitting in the NASA Goddard cleanroom after completion of a month-long cryogenic test in the Space Environment Simulator.

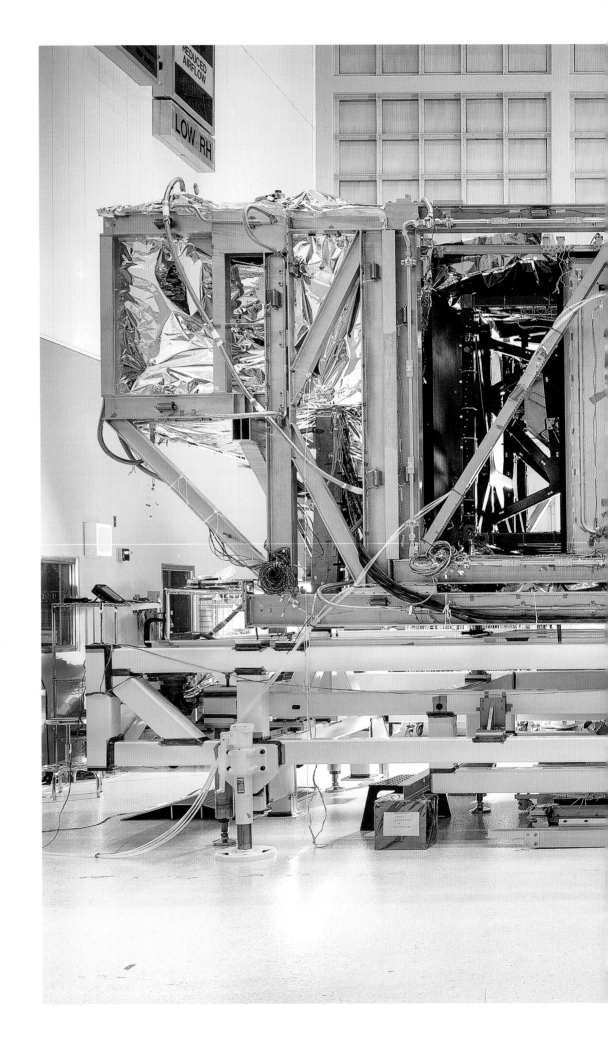

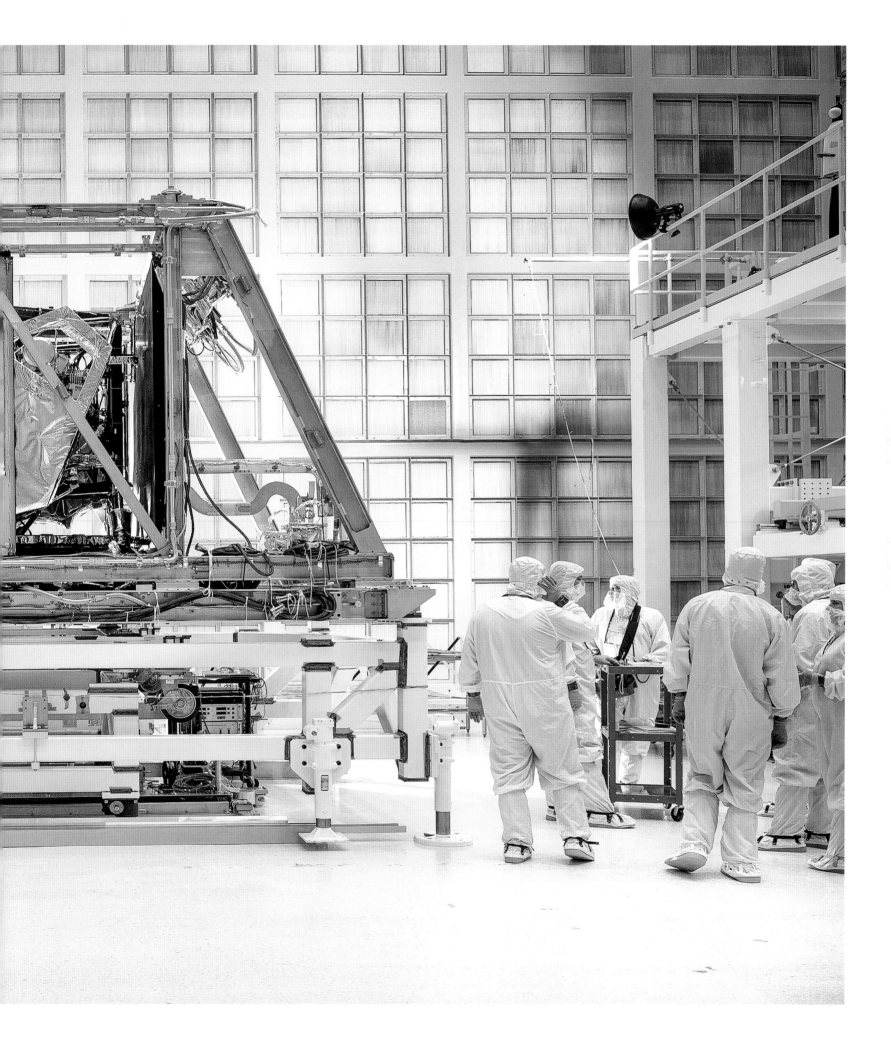

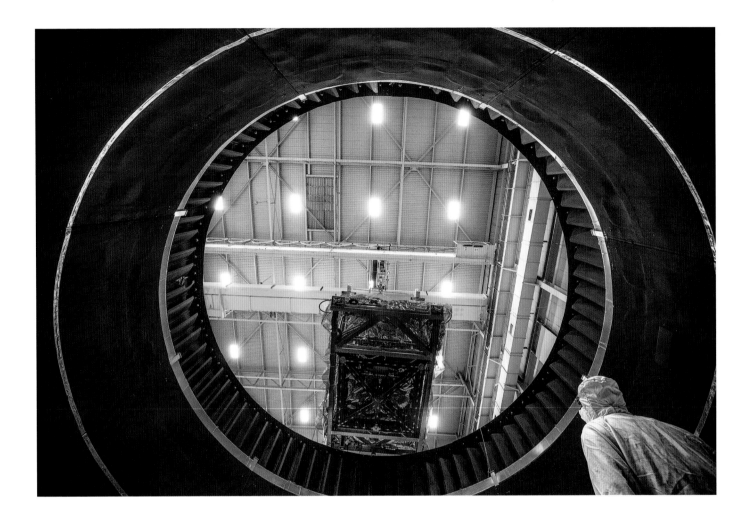

The ISIM is lowered into the chamber for yet more cryogenic testing. Visible here is thermal-control shroud protecting the ISIM components. The team would test and test again with such great care. They all were keenly aware that there would be no fixes after launch.

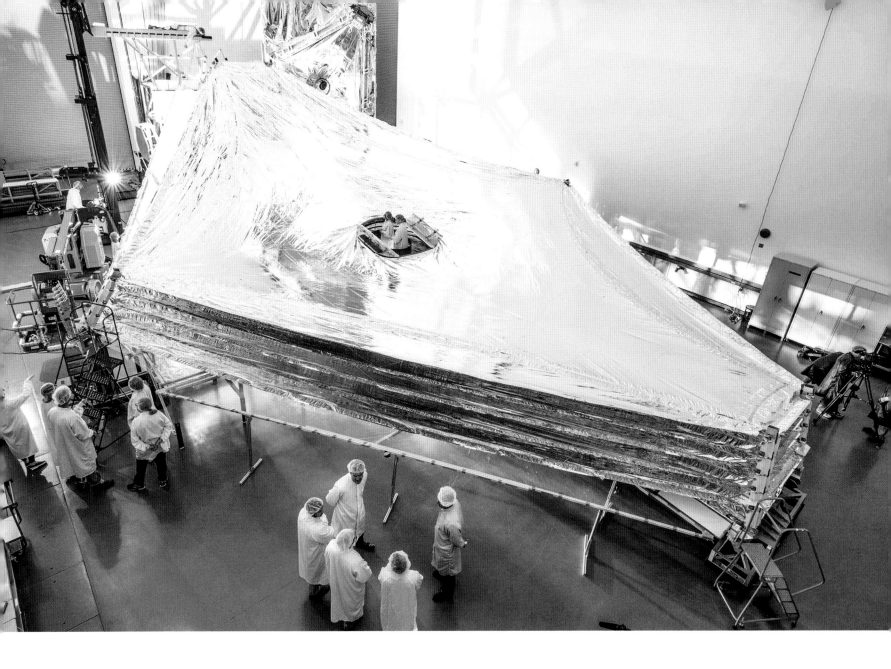

While engineers toiled at NASA Goddard, the Webb team at Northrop Grumman was busy on the other side of the country, in Redondo Beach, California, building the massive sunshield that would enable the telescope to passively cool to 40 Kelvin. I documented its early development seen here, a full-scale model circa 2014. Engineers were testing the elaborate pulley system that would be used to unfurl the shield in space.

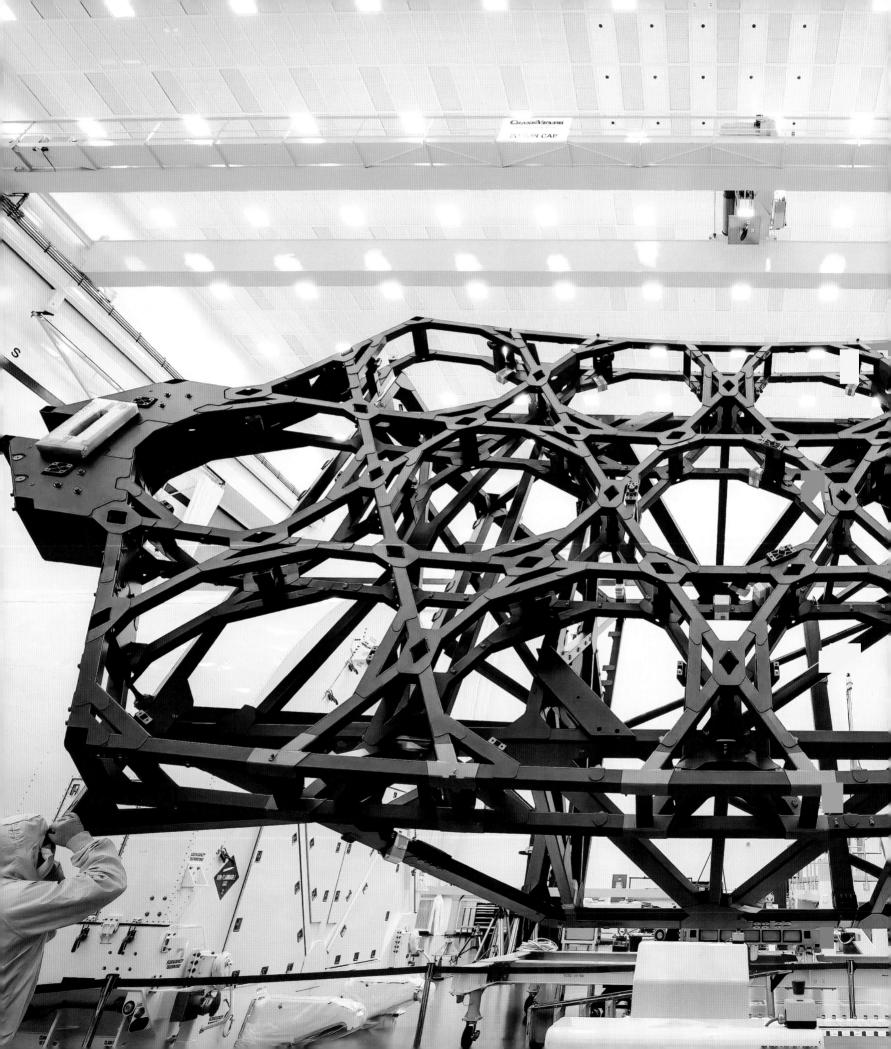

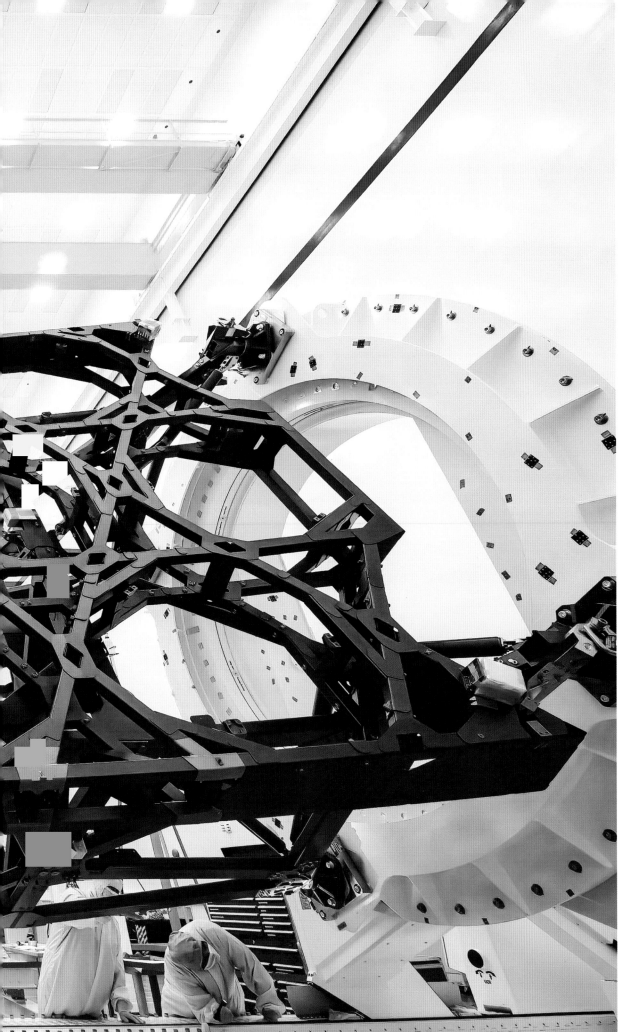

Webb's primary mirror may look like a single golden dish, but it comprises 18 hexagonal mirror segments fastened to a backplane. Pictured here is the center section of that flight backplane, with room for 12 mirrors. Not yet connected are the two "wings" that each hold 3 mirrors. I took this photograph in 2014 at Northrop Grumman's facility in Redondo Beach, before shipment to NASA Goddard.

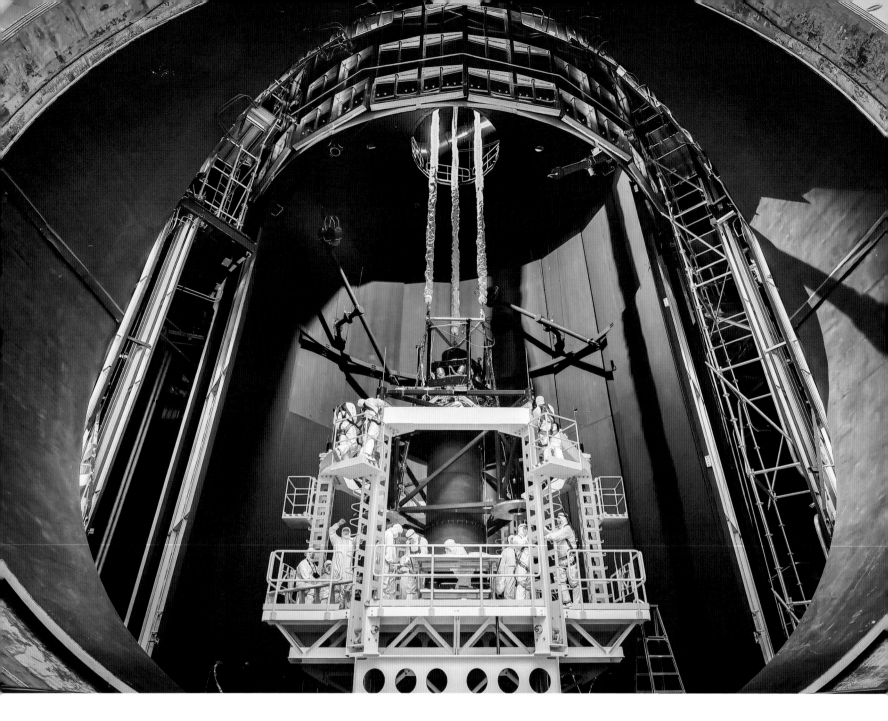

More prep work. Working in tandem on sunshield, mirror, and instrument construction and integration, a team at NASA Johnson Space Center in Houston prepares Chamber A for cryogenic testing of the telescope's larger elements. Famous for its use in the Apollo Moon missions, Chamber A is the world's largest thermal-vacuum chamber yet nevertheless needed significant redesign to receive and test Webb. Here, engineers and machinists work on a suspended platform designed specifically for testing the Webb Telescope to install the necessary photogrammetry cameras and other equipment.

The Webb Optical Telescope Element Pathfinder was a technology demonstrator comprising the frame for 12 mirror segments. The two segments I captured here—one gold-plated and one with exposed beryllium—were used in early optical testing at NASA Goddard and NASA Johnson. The Pathfinder now is part of the Smithsonian Air and Space Museum collection.

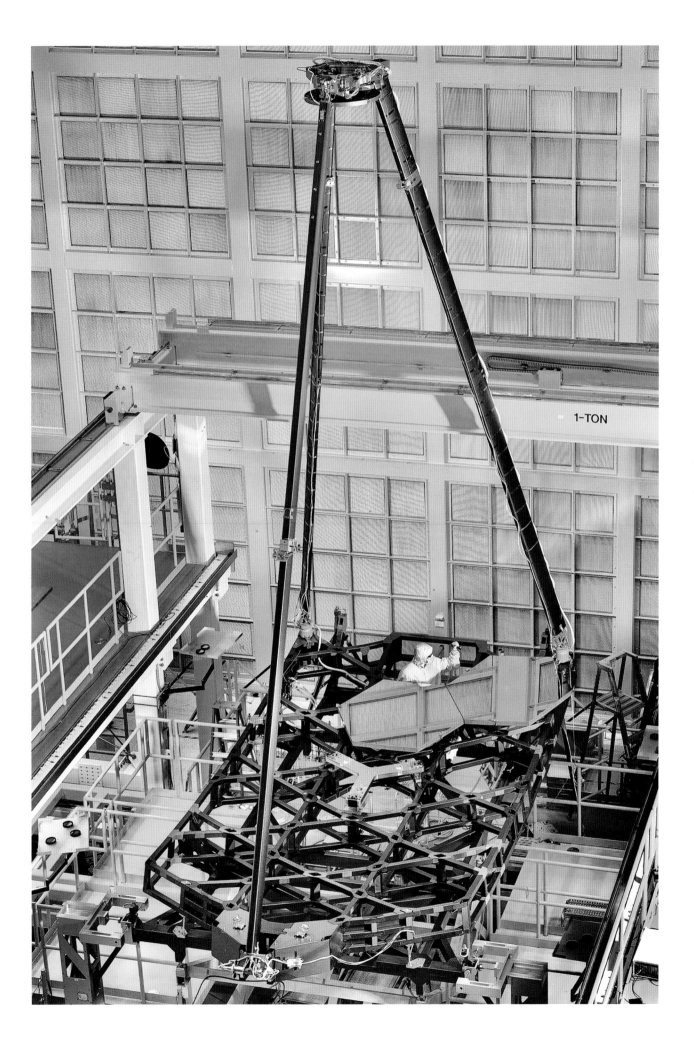

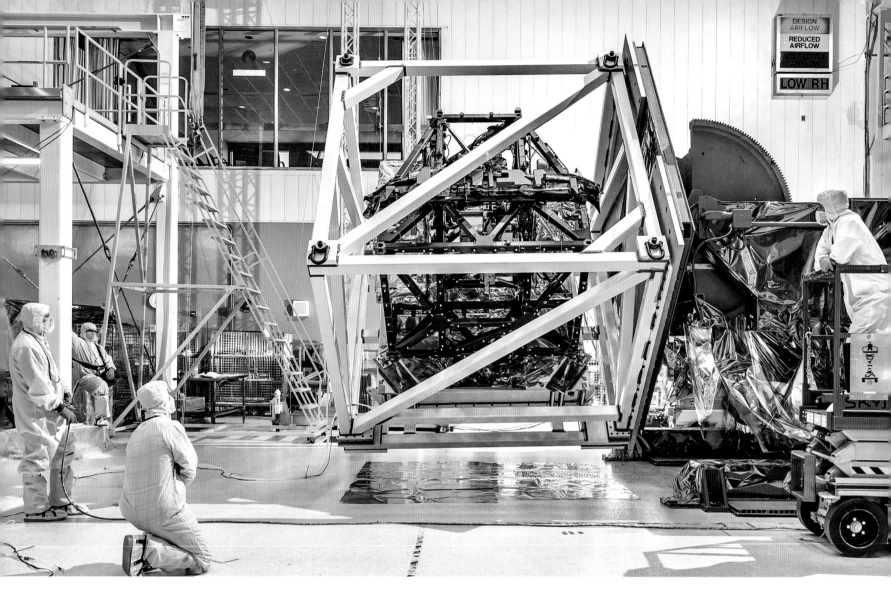

Back at NASA Goddard, engineers slowly rotate the ISIM to measure how the structure changes under the force of gravity when placed in various orientations. This gravity-sag test provides information about how ISIM will settle itself in the weightlessness of space, where there is no preferred orientation.

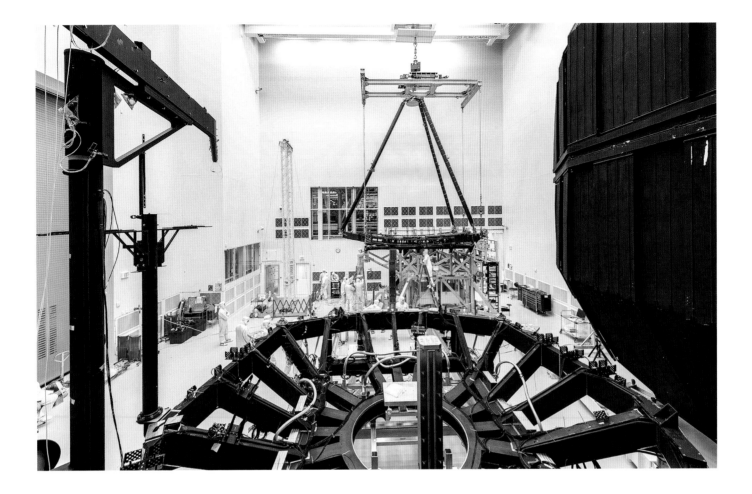

Back to NASA Johnson again. The Pathfinder, too big to undergo cryogenic testing at NASA Goddard, was shipped to NASA Johnson to be tested in Chamber A. I took this photograph from within Chamber A. The large black object in the foreground resembling a basket is a vehicle that will move the Pathfinder (in the back) into the chamber. And that large, rounded object on the right side of the photo? That's Chamber A's giant door.

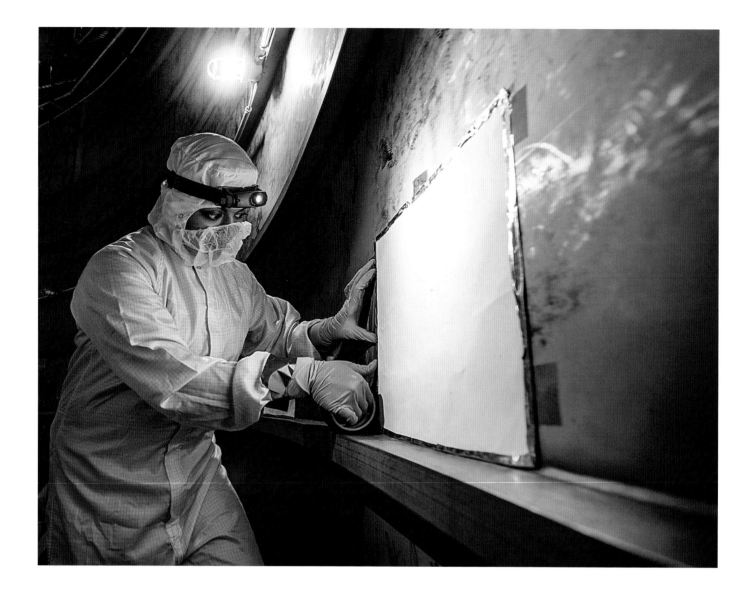

Nithin Abraham, a NASA coatings engineer, was the principal investigator of a team that developed and tested a highly porous material called molecular adsorber coating (MAC), which can be sprayed onto surfaces to passively capture contaminants that could harm the telescope's optics and science instruments. Here, she places a MAC panel in the plenum area below Chamber A at NASA Johnson. This was part of the intense prep work needed before Webb could be moved into the storied vacuum chamber for testing.

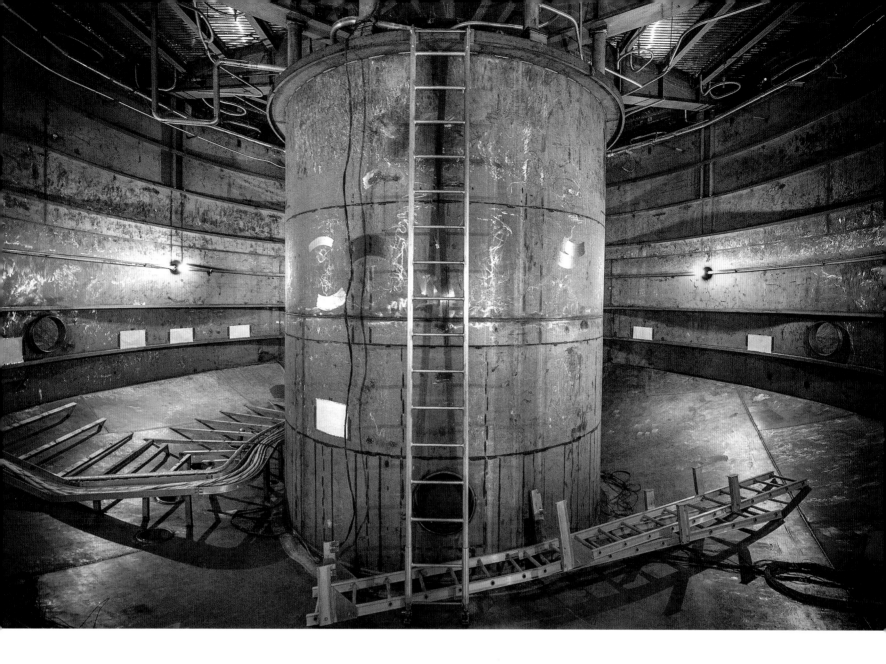

The Chamber A plenum in raw glory. The plenum sits below Chamber A, supports its weight, and regulates air flow. Engineers plunged the depths of the cavernous plenum to test technology designed to remove microscopic contaminants from the air. Even minute outgassing from adhesives and plastics on the telescope during the vacuum test could damage its sensitive mirrors and detectors. This is the gritty industrial side of space science. The plenum is eerie, unworldly, like something out of a sci-fi movie. We walked there in single file in dim light and bad air, like cave explores. I was down there for hours.

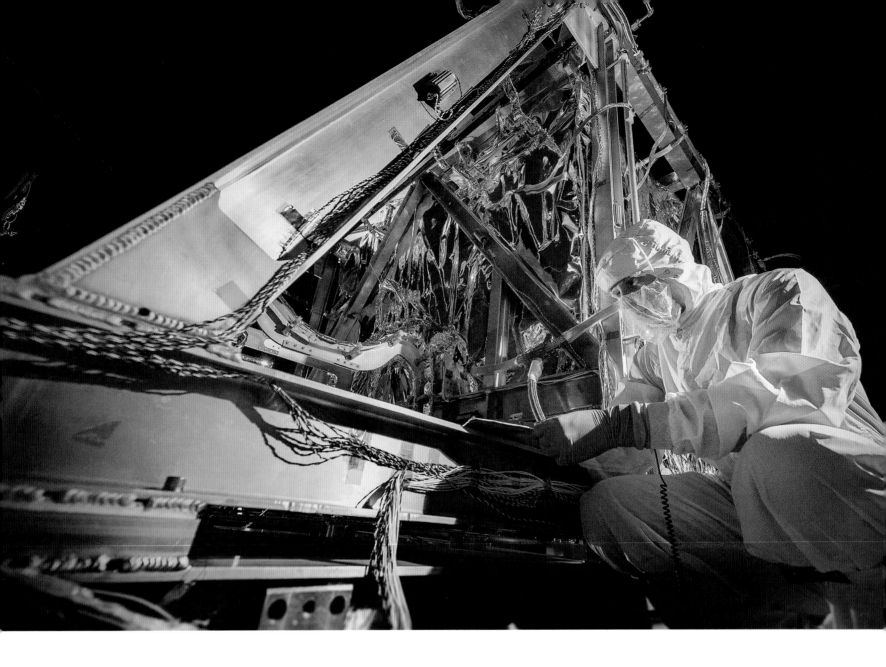

Back at NASA Goddard, contamination control engineer Alan Abeel conducts final inspections and applies contamination-protection foil before the start of another cryogenic test of the ISIM.

This is the skeletal backplane and frame that would hold all of Webb's mirrors, fully assembled at NASA Goddard circa 2014.

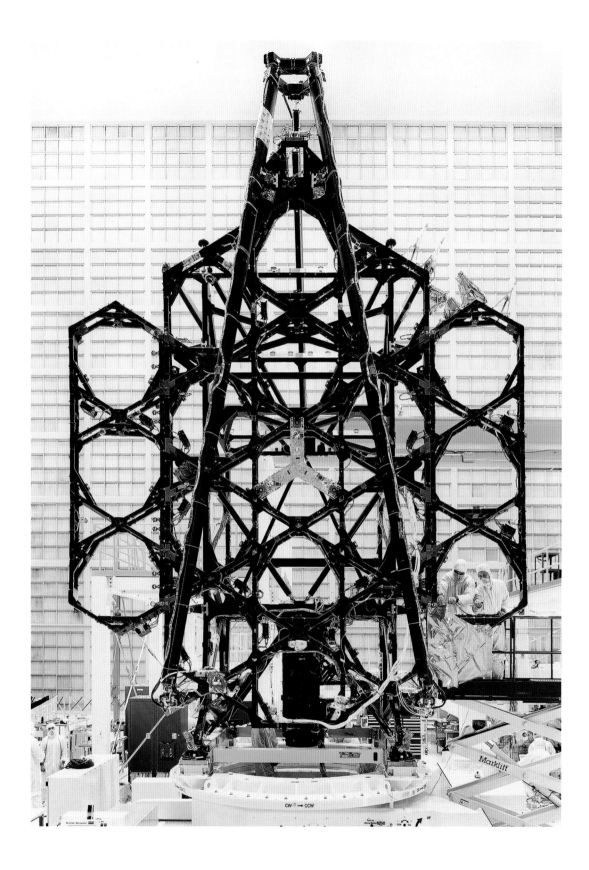

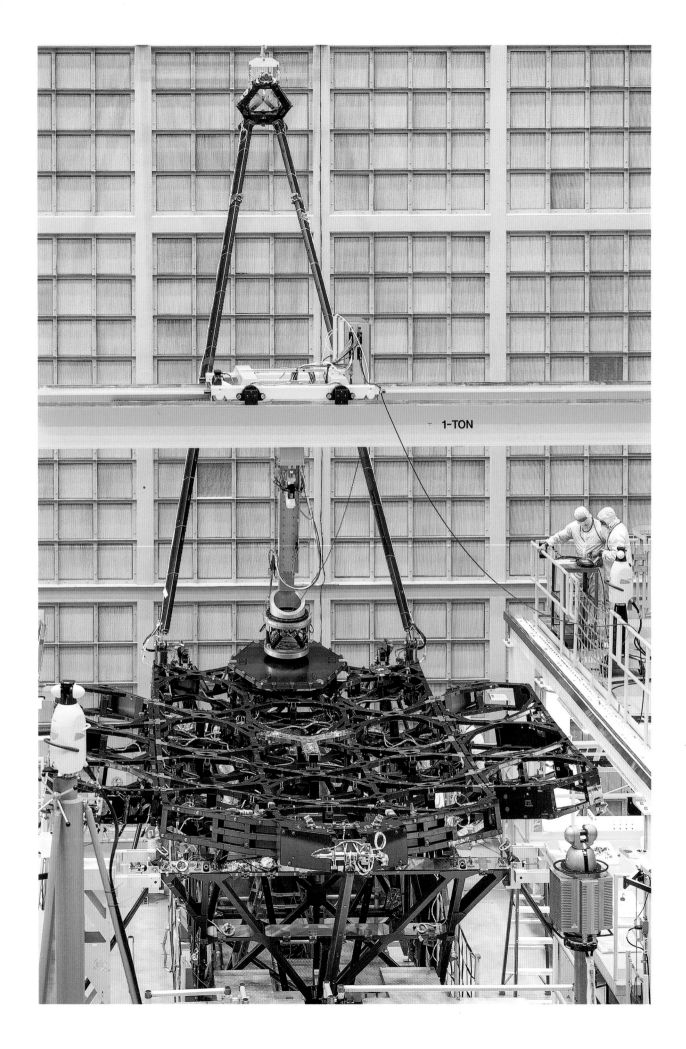

1-TON

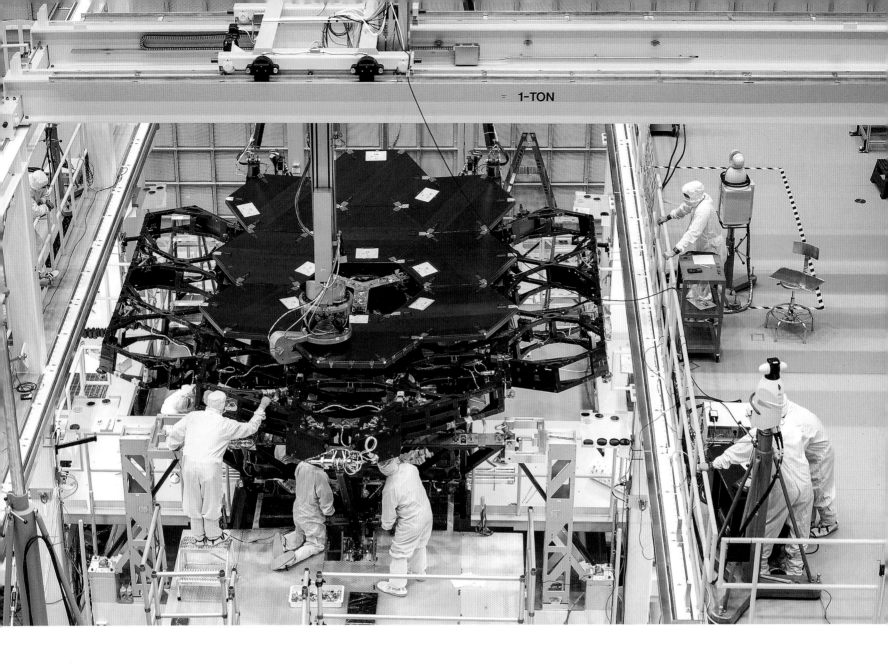

1-TON

Successful installation the first of 18 flight mirrors onto the James Webb Space Telescope in November 2015, the start of a critical piece of the observatory's construction. This photo captures one mirror, protected in a black covering, inserted with a special apparatus at the 12 o'clock position.

Nine down, nine to go.

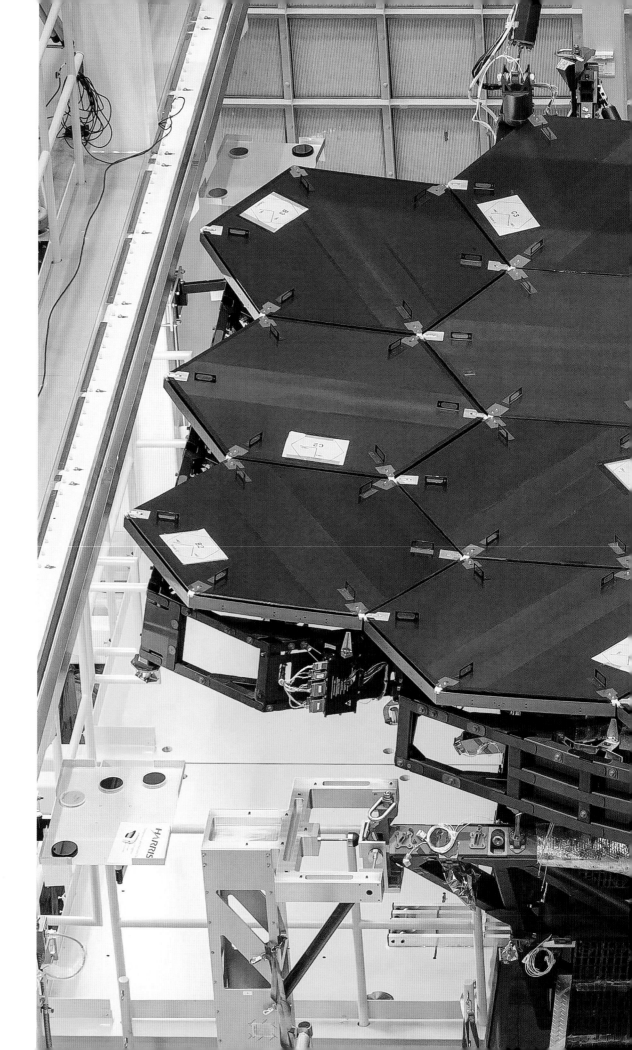

Webb's 18 mirrors, fully installed at NASA Goddard with protective covers, February 2016. The installation took nearly three months to complete.

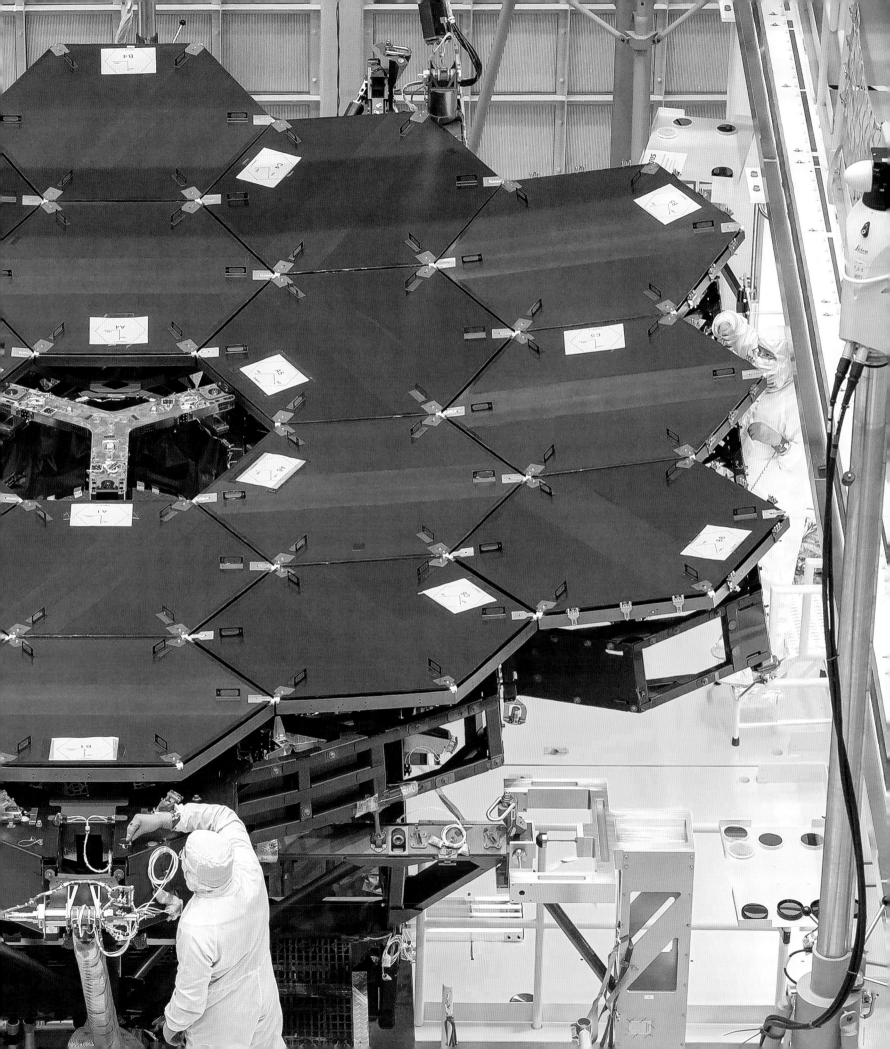

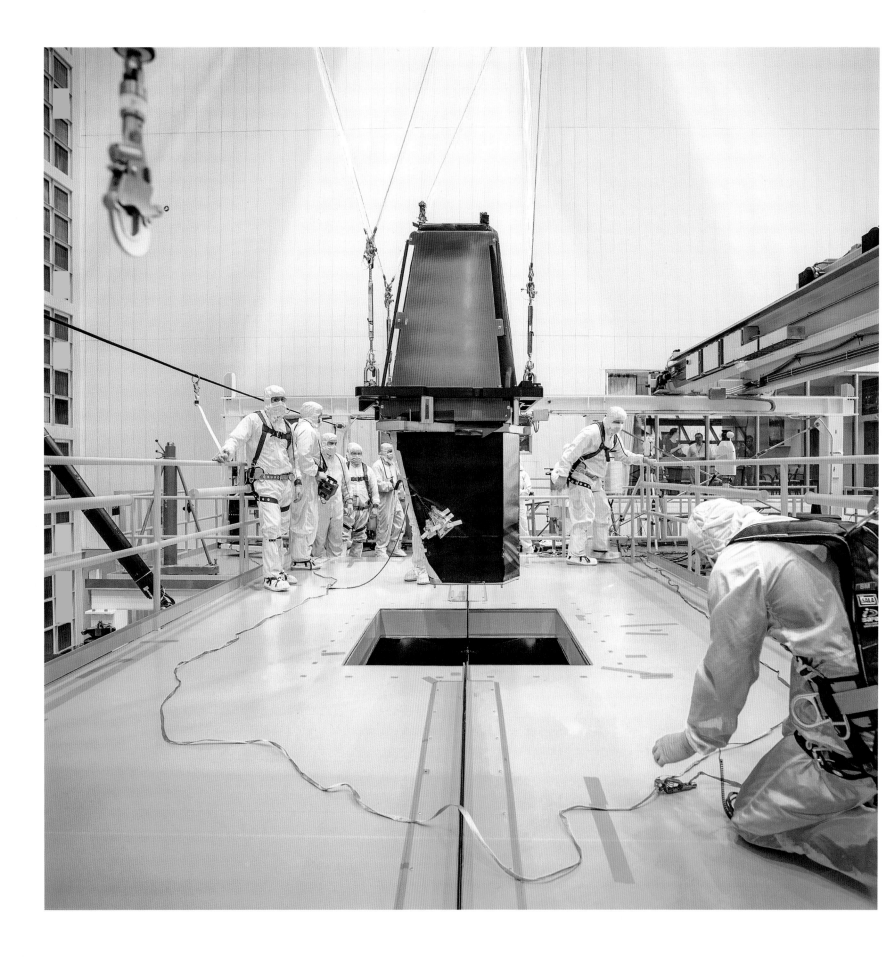

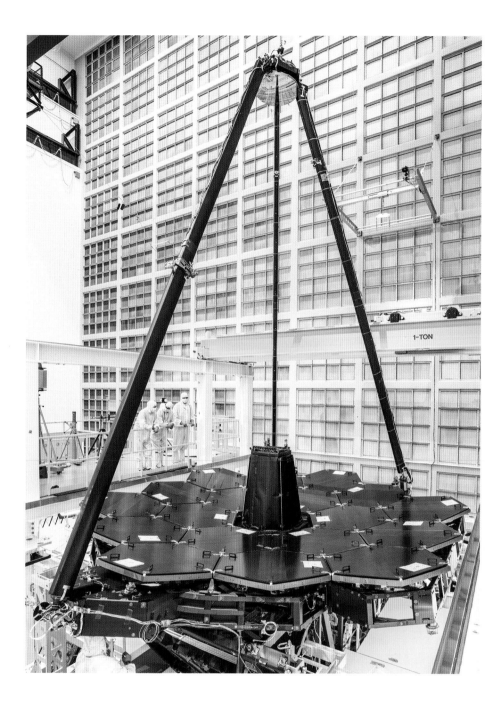

The Aft-Optics System is lowered to be integrated with the primary mirror, which is below a specially designed platform pictured here. Webb team members wear harnesses to prevent injury in case they fall from the platform. Aft to this, in the background to the right, can be seen visitors safely behind the observation window, a popular spot through the duration of assembly at NASA Goddard.

This extended deployment of the secondary mirror placed the primary mirror in a vulnerable position to collect dust, even in the cleanroom. So, engineers covered the mirrors.

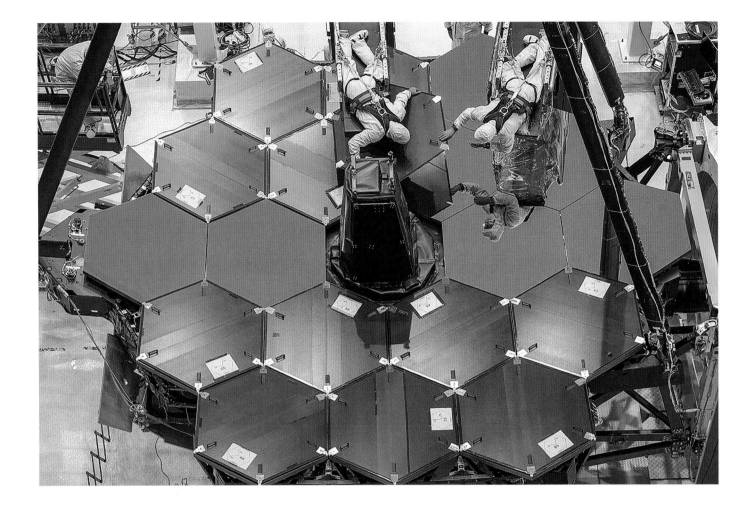

Covers protect the mirrors while they are face up, but they are just lightly fastened to the segments and could fall off if the mirrors are upright. On this afternoon at NASA Goddard on April 25, 2016, the engineering team were removing covers in preparation for instrument installation. The segments would be face-down during installation of the instruments behind the primary mirror. I had been watching them practice the choreography to accomplish this delicate task. Webb scientists were nervous, but these guys were absolute professionals. Incredible focus.

The Optical Telescope Element is shown here in a rare, unprotected "cup up" configuration, in preparation for the ISIM integration. The reflective surface of the mirror you see is polished to an average roughness of only 20 nanometers and is coated with a thin layer of gold to maximize its ability to reflect infrared light.

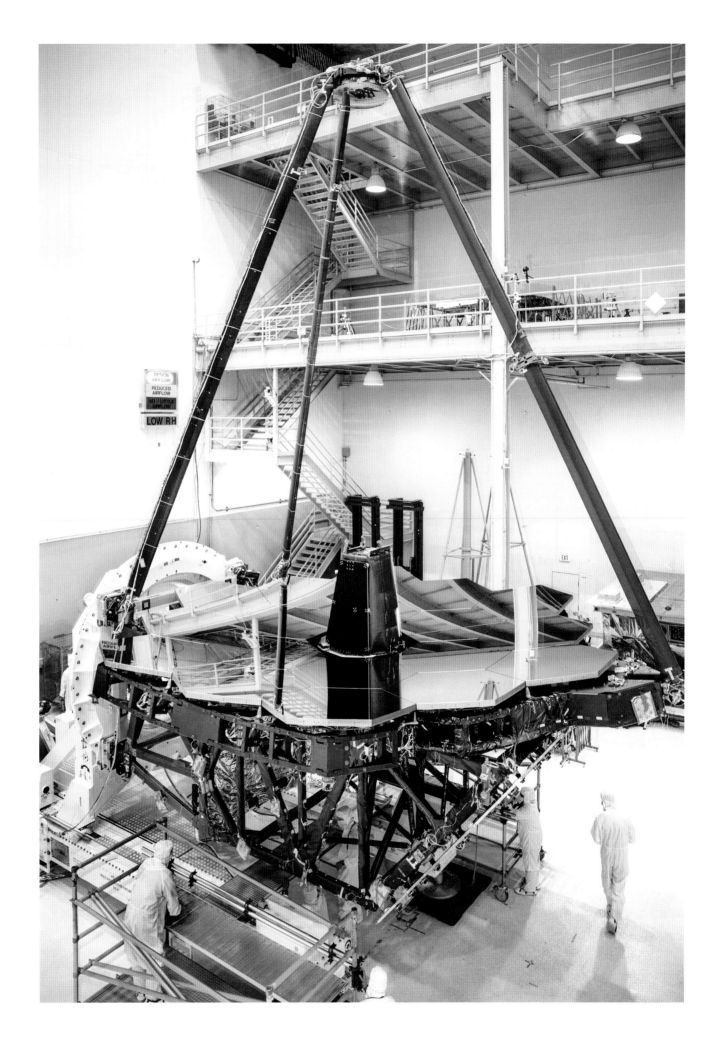

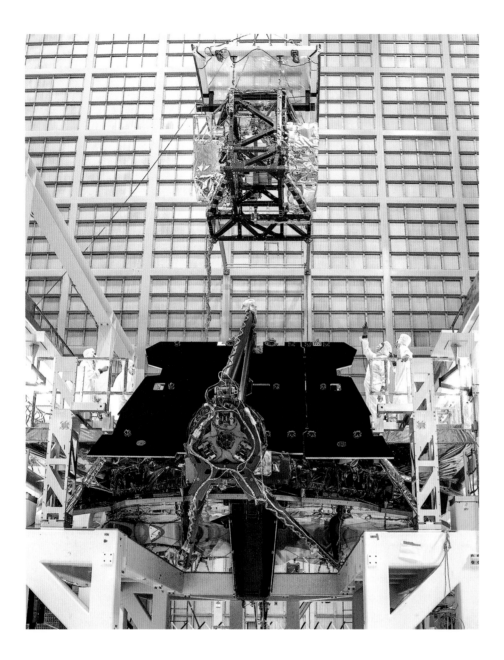

The Integrated Science Instrument Module (ISIM) is lowered onto the telescope at NASA Goddard in October 2016 with surgical precision. The primary mirror is facing downward.

Golden slumbers. The OTIS is seen here after a successful "center of curvature" test, undergoing a nighttime, lights-off inspection. The OTIS is what we called the combined Optical Telescope Element (OTE) and Integrated Science Instrument Module (ISIM).

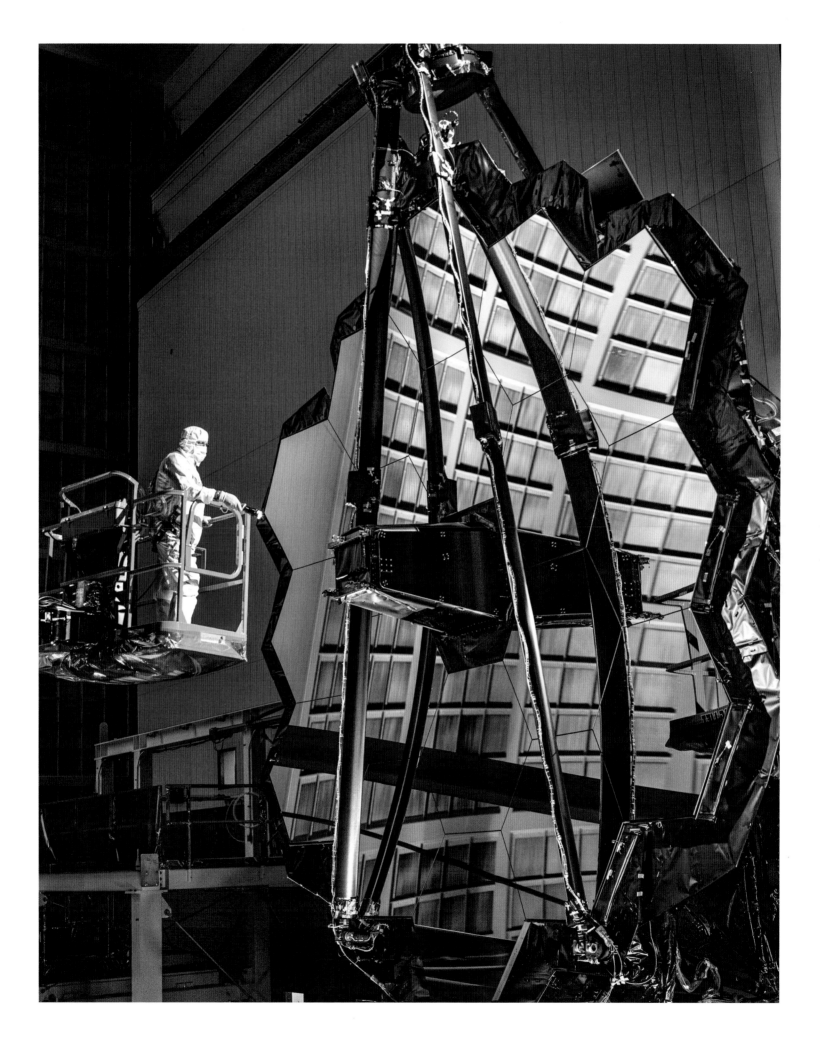

Because a vibration test would be conducted outside the cleanroom at NASA Goddard, the OTIS needed to be fitted with a portable clean tent, seen here being lowered over the unit. A seemingly straightforward operation takes hours to complete, as more than two dozen team members observe from every angle. Such abundance of caution was typical every day throughout the creation of Webb to prevent damage to the mirrors and instruments.

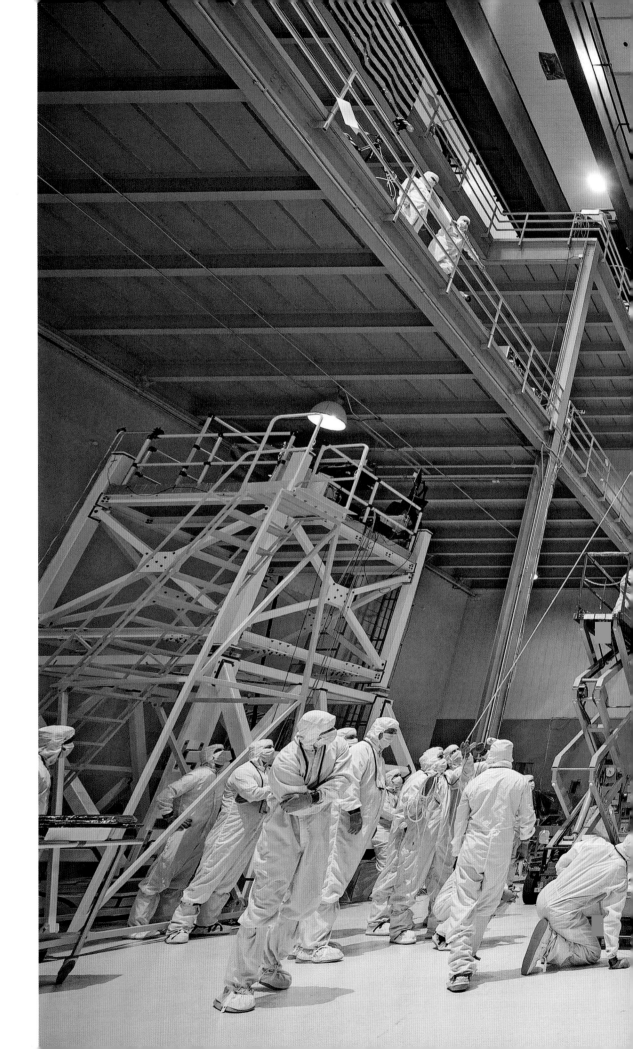

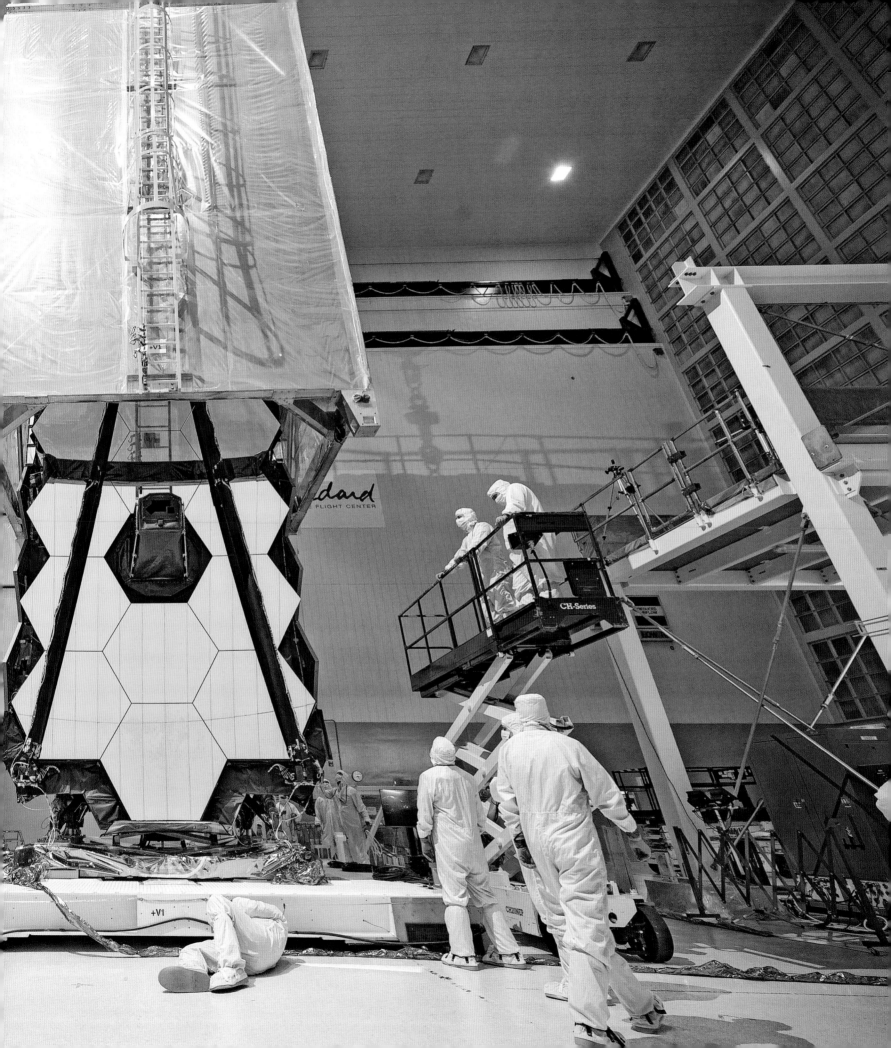

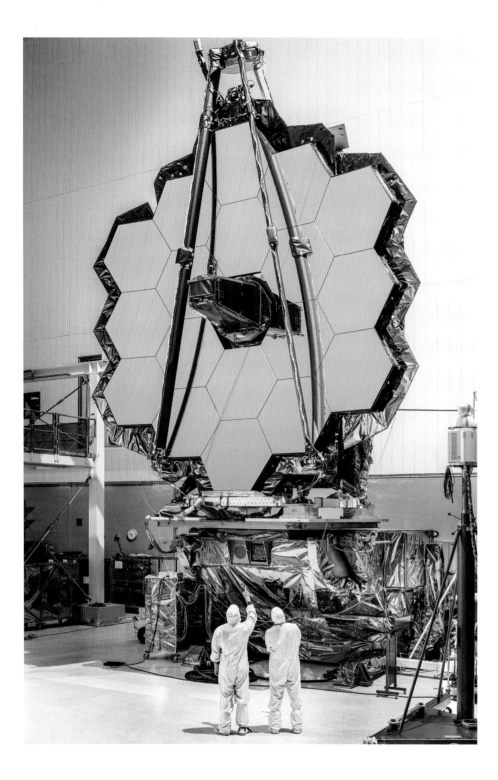

A full deployment of the primary mirror.

After completion of vibration and acoustic testing, the Webb Telescope undergoes a detailed "lights out" inspection in April 2017. Engineers use bright white LEDs and ultraviolet lights to search for possible contamination at nighttime, with the lights inside the cleanroom switched off to improve the contrast. I captured this image with a two-minute exposure, resulting in an electrifying, ghostly image of the Webb team.

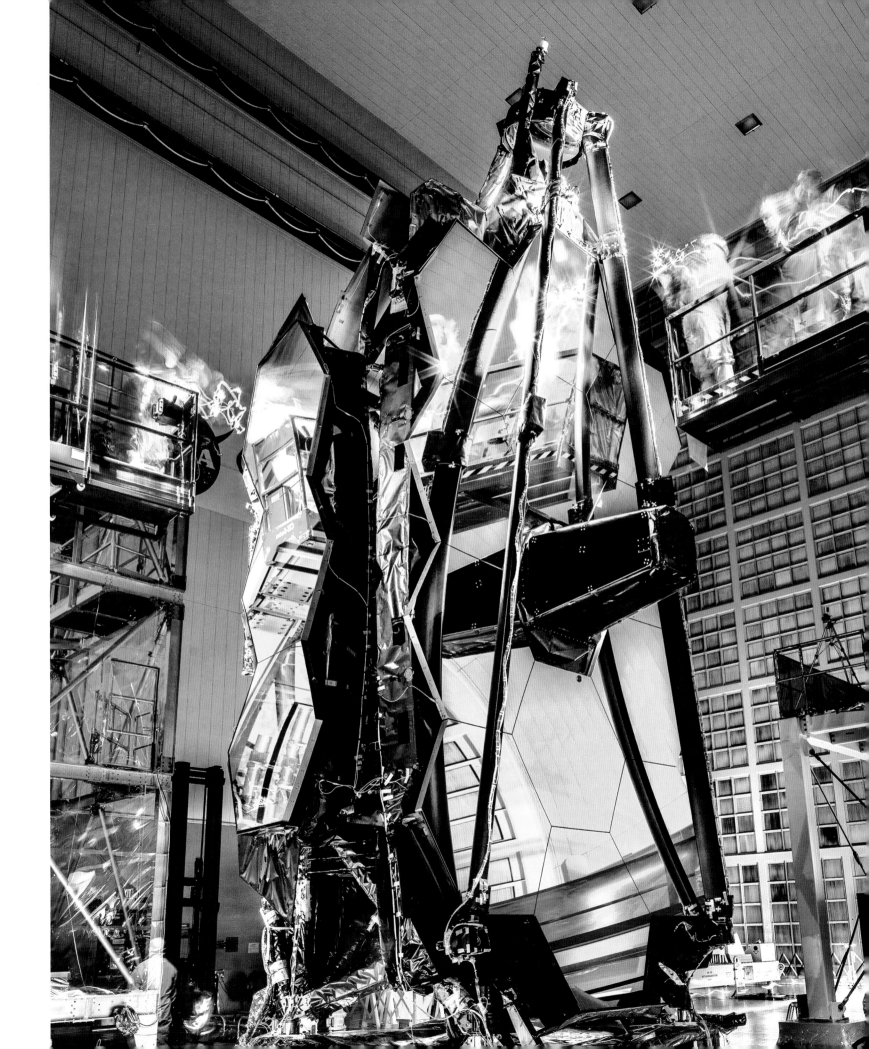

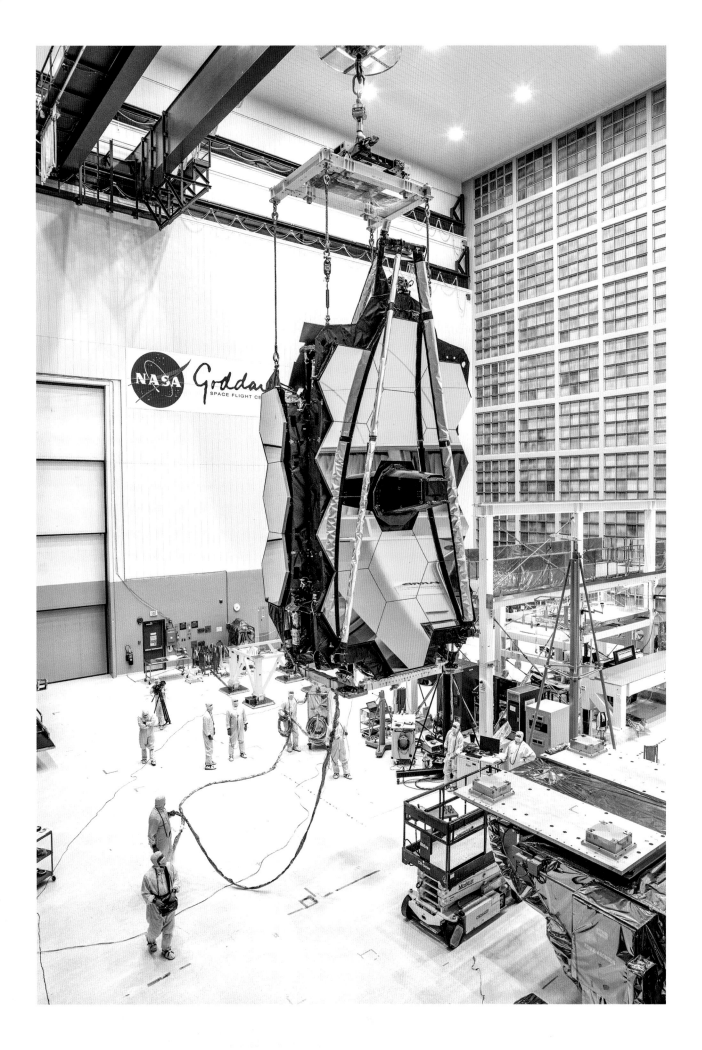

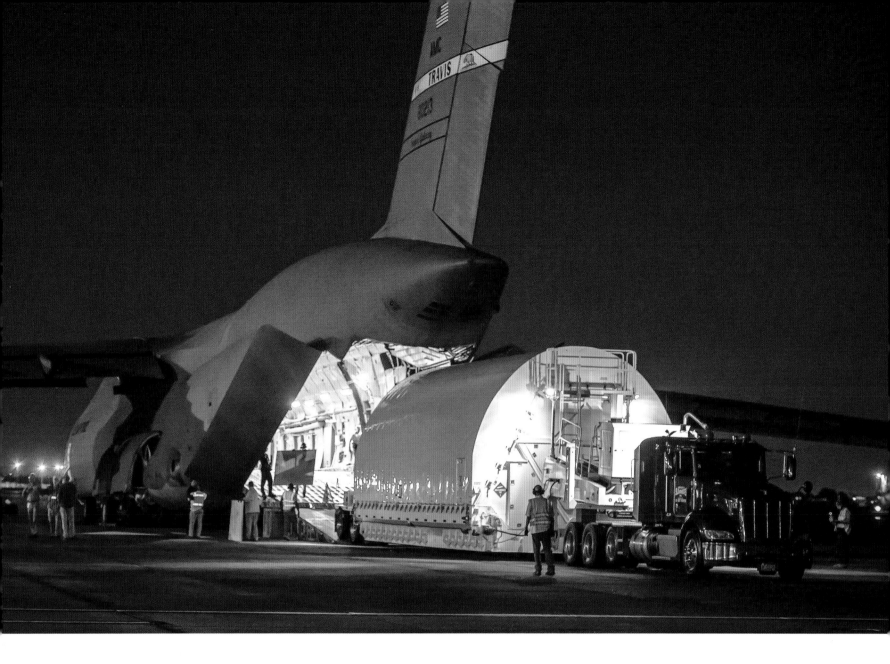

The OTIS is suspended during the last days at NASA Goddard, soon to be shipped to NASA Johnson for thermal-vacuum testing. The hosing dangling from the ISIM behind the primary mirror is what engineers call the umbilical cord. For more than five years, during the telescope's "gestation," engineers pumped pure nitrogen gas continuously to purge any oxygen within the ISIM to prevent oxidation of the instruments.

Webb, packed safely in a custom-made carrier called the Space Telescope Transporter for Air, Road, and Sea (STTARS), arrives at Ellington Field, Houston, from Joint Base Andrews in Maryland in a C-5 cargo plane. The telescope would next journey by truck to NASA Johnson Space Center for cryogenic testing of the OTIS. NASA Johnson's Chamber A is the only thermal-vacuum chamber large enough to hold the OTIS.

The OTIS is lifted onto the Hardpoint Offloader Support System, a rail system specially designed for the Webb project to move the mirror and instruments into Chamber A for thermal-vacuum testing. Seen in this photograph atop the Aft-Optics System in the center of the primary mirror is a star simulator, a small box that simulates projected starlight during the testing.

Webb's OTIS slowly makes its way into the thermal-vacuum testing chamber. Chamber A is 16.8 meters (55 ft) wide and 27.4 meters (90 ft) high. Despite careful measurements, clearance was always an issue with this massive telescope. The primary mirror clears the entry here by just a few inches. A spotter eyeing the operation from up high is on the same lift with me as I took this photograph.

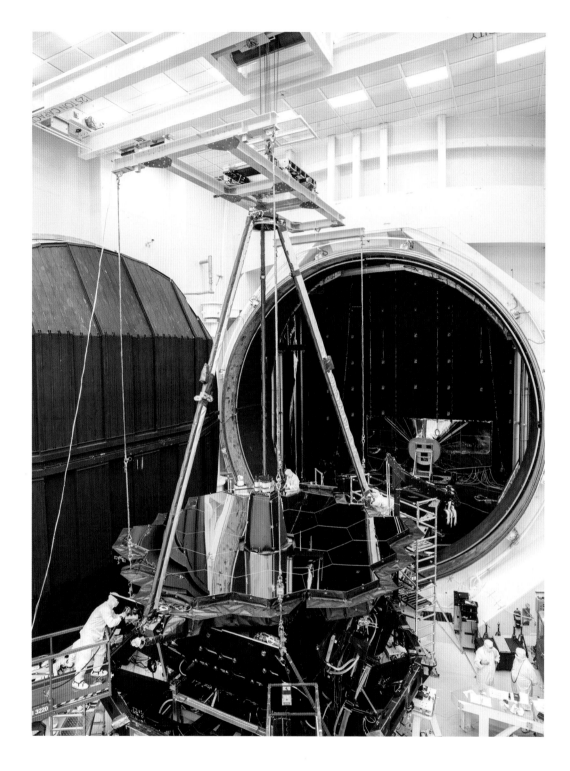

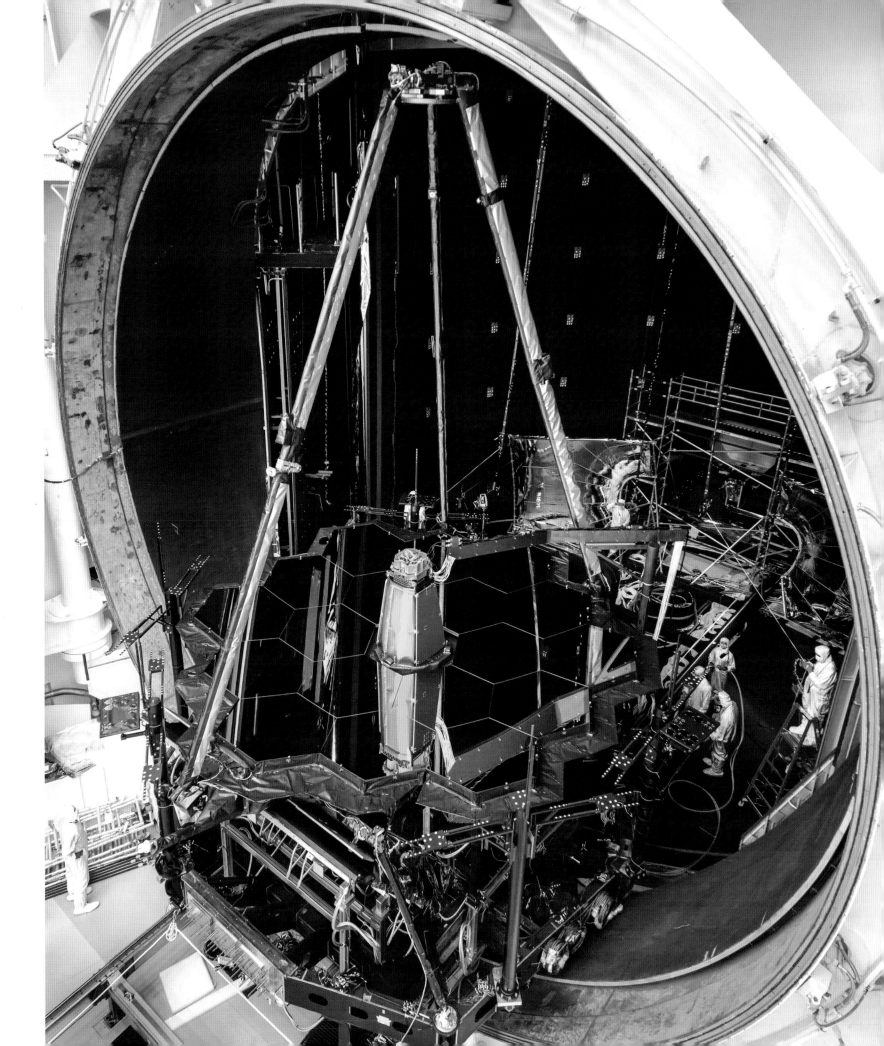

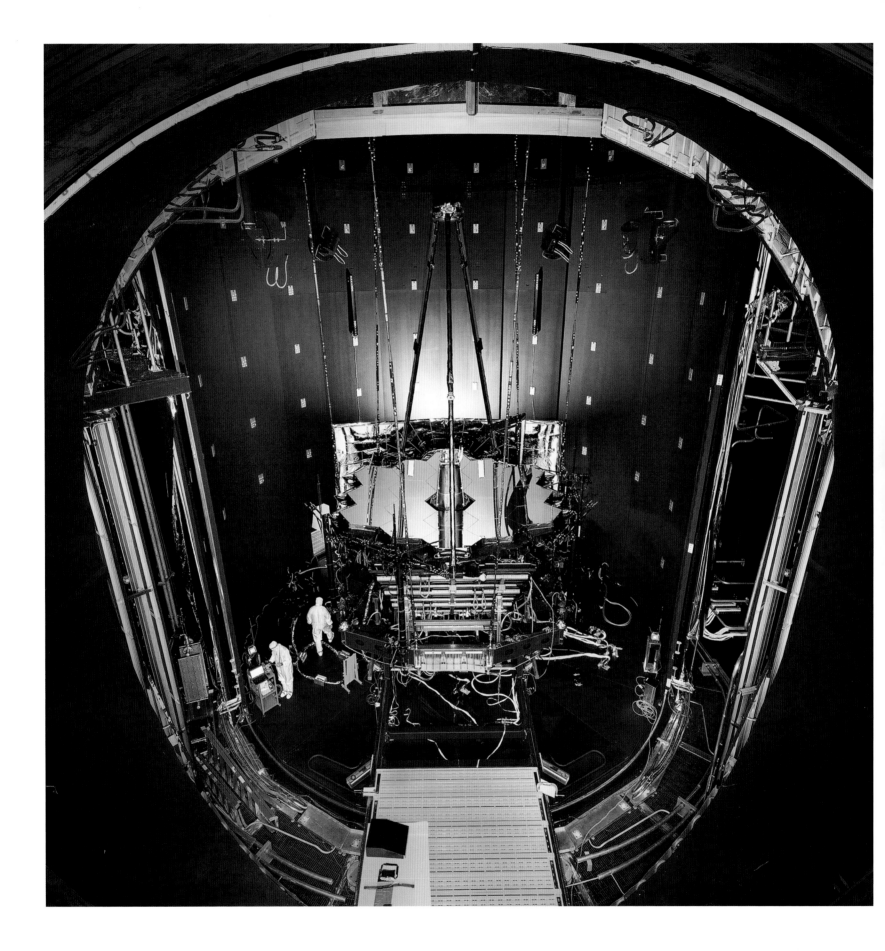

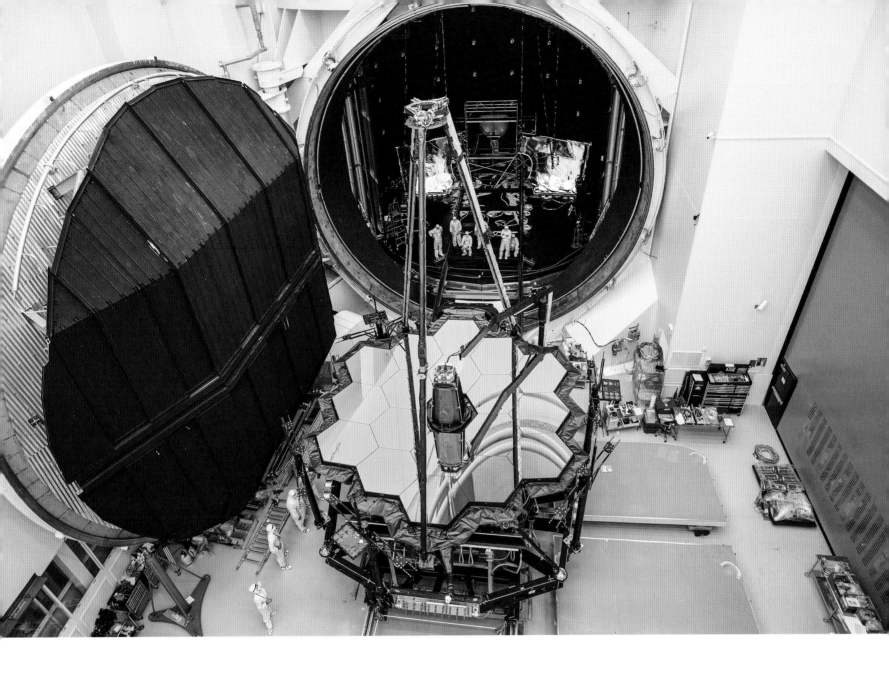

The OTIS is placed inside Chamber A to prepare for thermal-vacuum testing, to simulate the cold vacuum of space. The famed thermal-vacuum chamber was reconfigured for the telescope, with instruments that themselves needed to work at cryogenic temperatures. Seen here are several photogrammetry cameras suspended from the ceiling. Evenly placed silver-colored objects along the wall are the photogrammetry targets. Photogrammetry is a technology to precisely measure three-dimensional space through two-dimensional photographic images, an essential element of astronomical observations.

A fully deployed OTIS, with the secondary mirror extended over the primary mirror, is removed from Chamber A after a successful thermal-vacuum test in 2017. Seen still in the chamber is a sunshield simulator, called the L5 Simulator, representing the fifth and innermost layer of the sunshield. The telescope would be shipped to the Northrop Grumman facility in California to be integrated with the real sunshield. I was suspended on a lift for this shot.

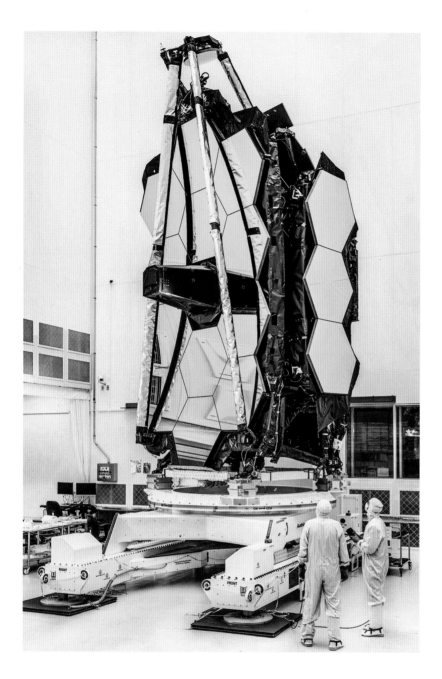

The OTIS stowed at Northrop Gruman in anticipation of the US government shutdown, on December 18, 2017. The 35-day shutdown was the longest in US history and prevented the Webb team from working on the project at a crucial time in its development.

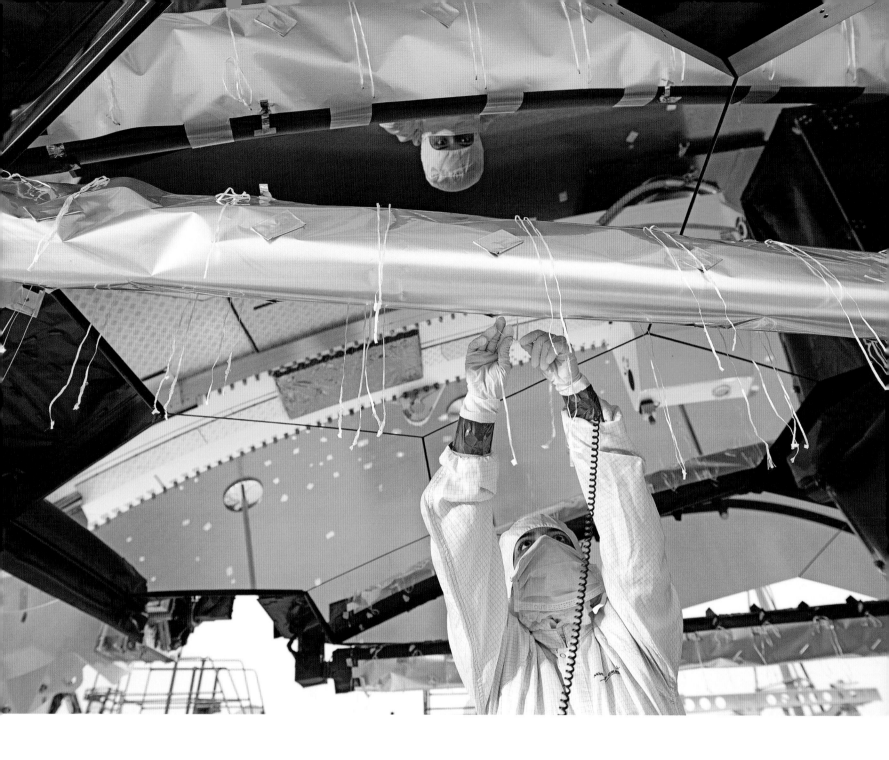

Webb's framework needed to be wrapped with thermal blankets to maintain a constant temperature and to minimize heat transfer via conduction to the infrared detectors. Here, Paloma Rubio of Northrop Grumman secures a thermal blanket with lacing cords. Such cords allow blankets to be securely attached without adhesives (which can lose strength over time) and provide room for wiring.

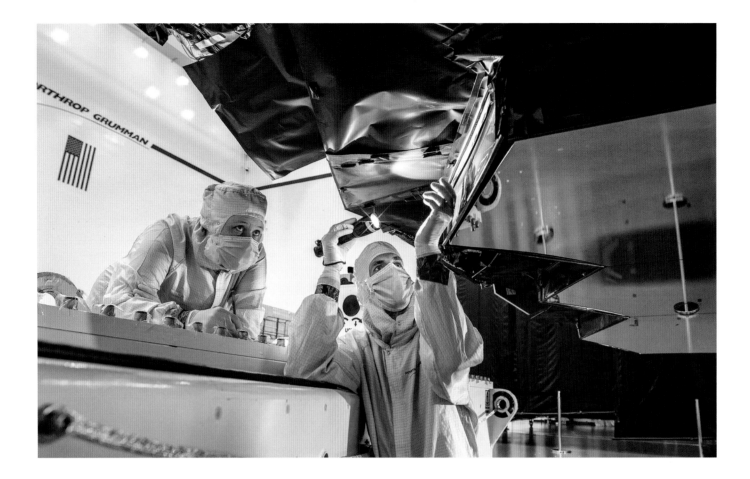

Northrop Grumman blanket technician Ann Meyer and Ball Aerospace optical engineer Larkin Carey inspect the black Kapton frill around the primary mirror. The frill acts as a baffle to prevent stray light from sneaking around the primary mirror and potentially striking the secondary mirror. The primary mirror's origami design did not allow for a rigid baffle used on other telescopes. Once again I found myself in the glow of the mirrors, standing so close to this $10 billion observatory. It was another moment of feeling so grateful to have such access to the Webb project.

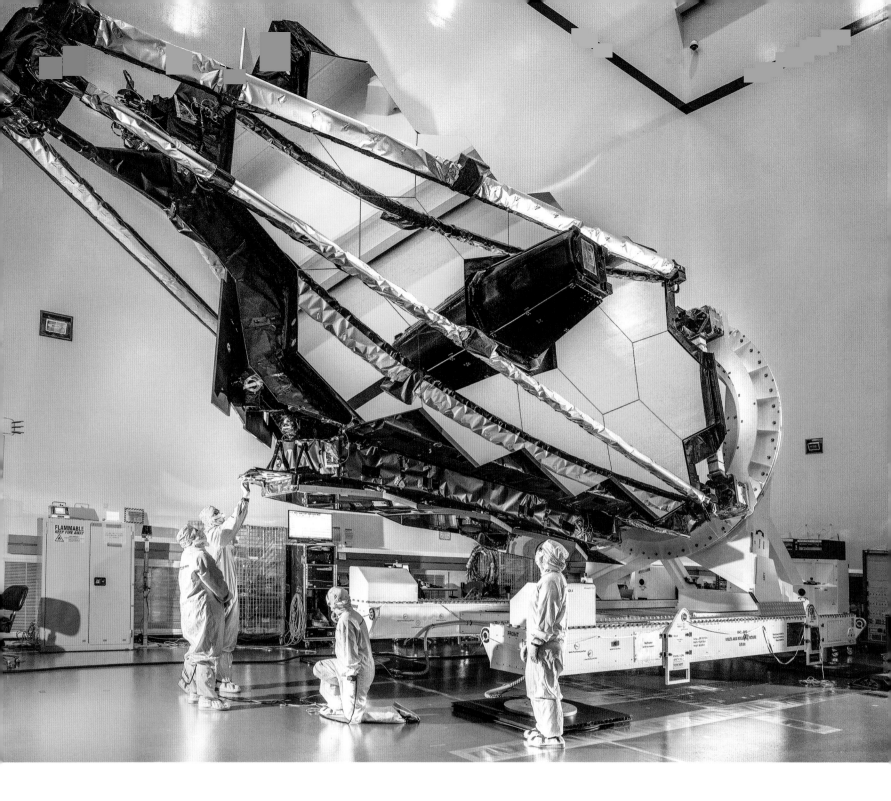

The Secondary Mirror Support Structure (SMSS) is seen here stowed in its launch configuration as engineers inspect the frill.

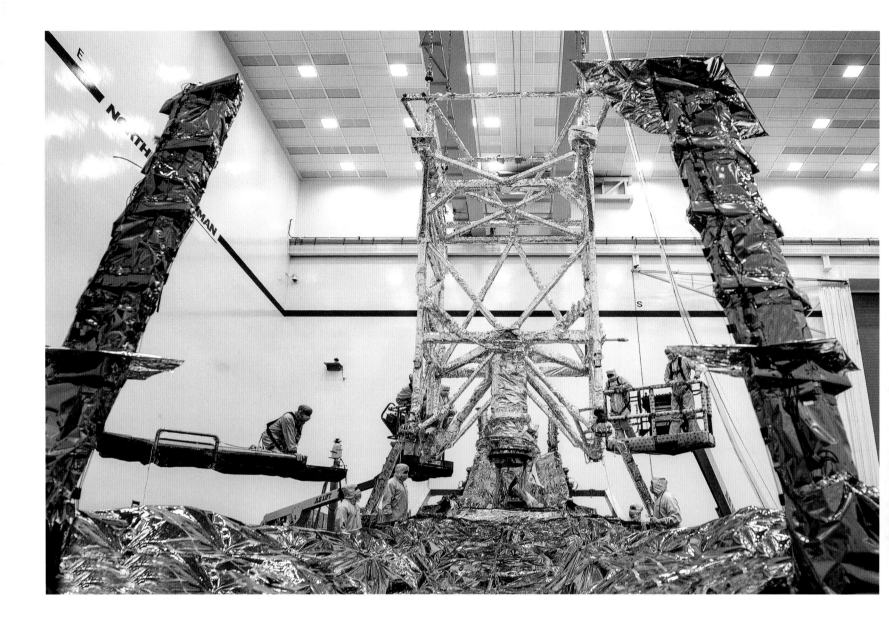

At a Northrop Grumman facility in Redondo Beach, California, the Webb team prepares the OTIS simulator. The simulator emulates the main mass properties of the actual flight OTIS, such as mass, center of mass, and moment of inertia. The simulator here is in silvery wrap; the sunshield is protected in purple foil. The use of a simulator instead of the "real thing" streamlined integration testing of the OTIS onto the sunshield.

A multitude of reflections illuminate this test of the Secondary Mirror Support Structure (SMSS). The secondary mirror, extended several meters above the spacecraft, focuses light from the primary mirror onto central tertiary mirrors in the Aft-Optics System, which then feeds the light to the detectors. Structures seen here with a golden hue are reflections of the silver-colored arms of the SMSS and the secondary mirror itself. That's me captured in the orange-gold reflection of the secondary mirror near the center of this photograph.

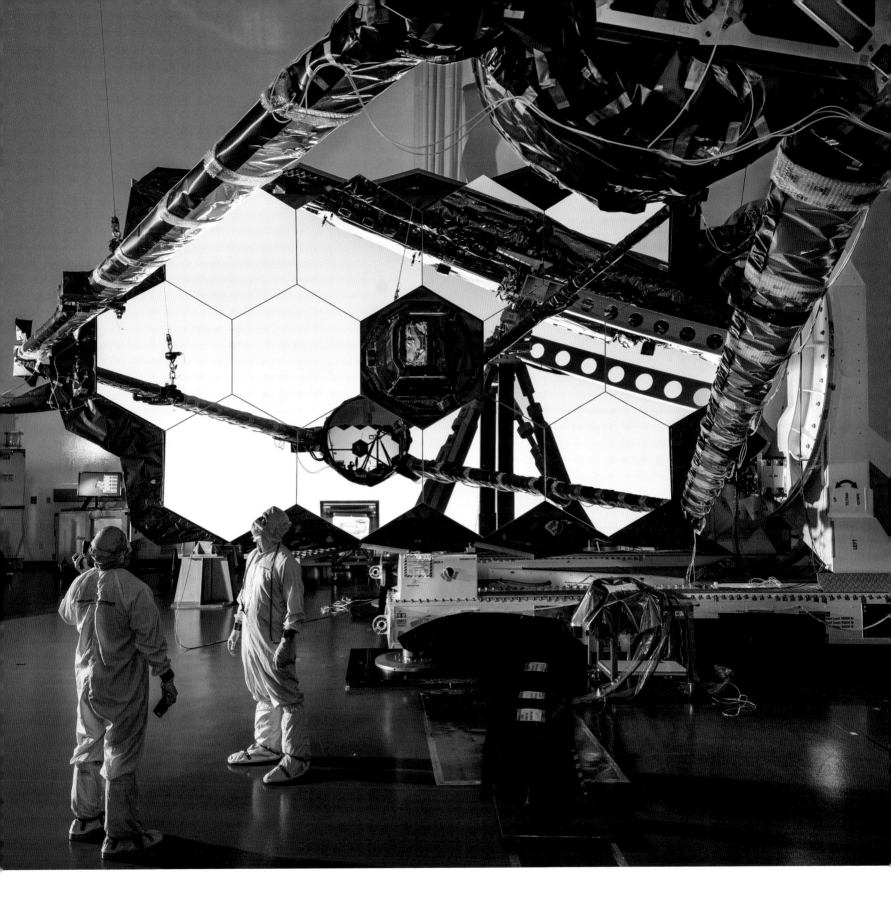

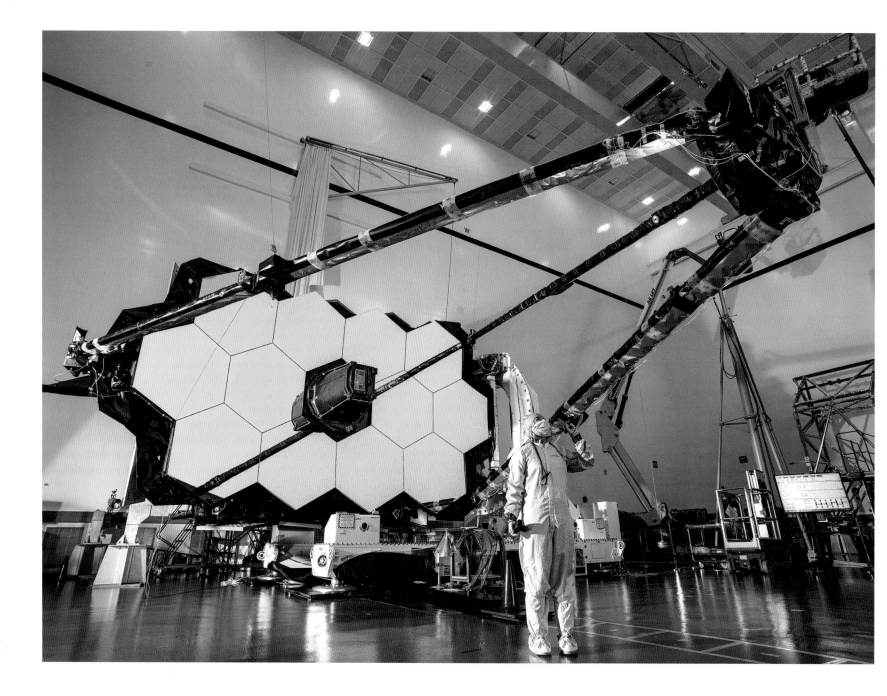

A contamination control engineer inspects the secondary mirror, fully extended in space-flight configuration.

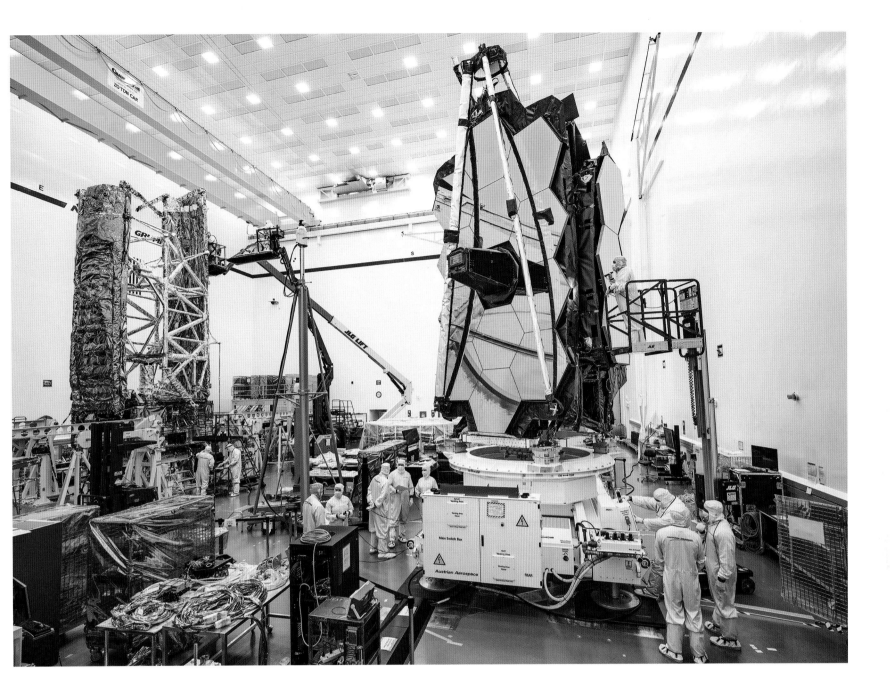

The sunshield (left) would be joined with the Optical Telescope Element (right) in a few more months. In the center of this photograph is the OTIS Simulator, the pole-like frame to which the sunshield was attached for testing before arrival of the OTIS.

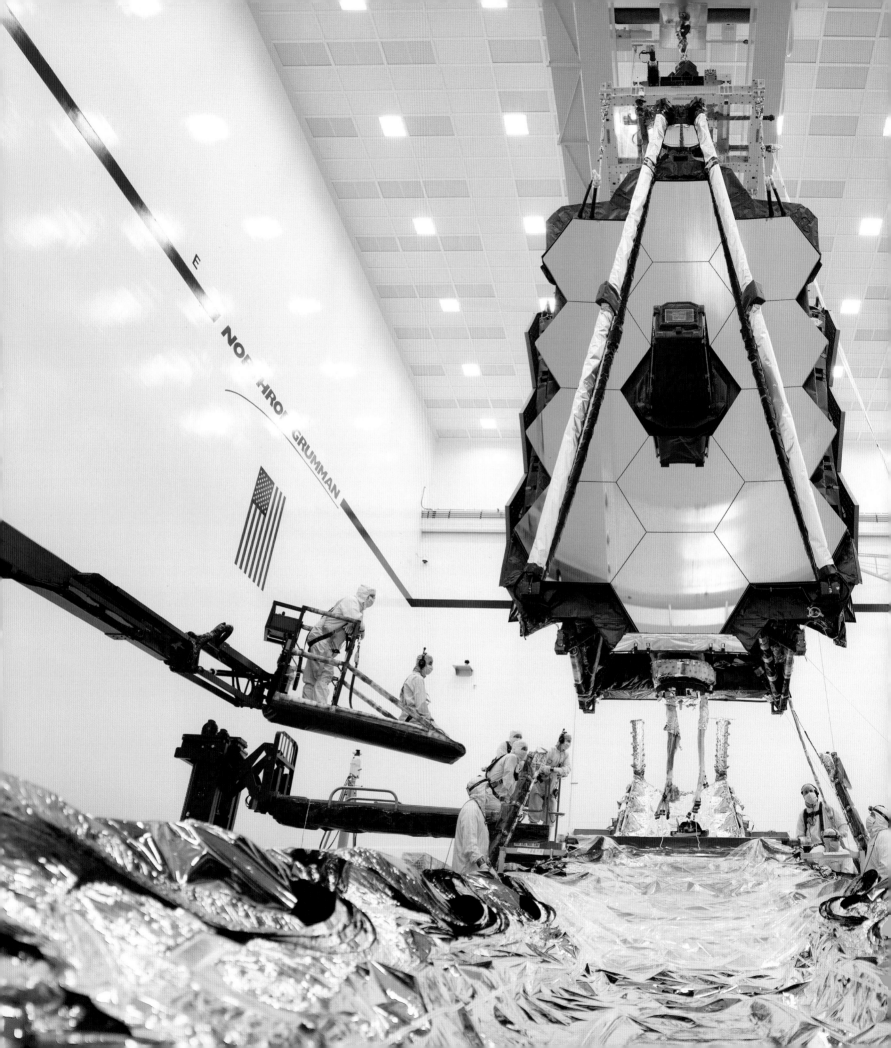

Two become one. The OTIS is lowered for integration with the sunshield unit, seen here resembling a silvery river.

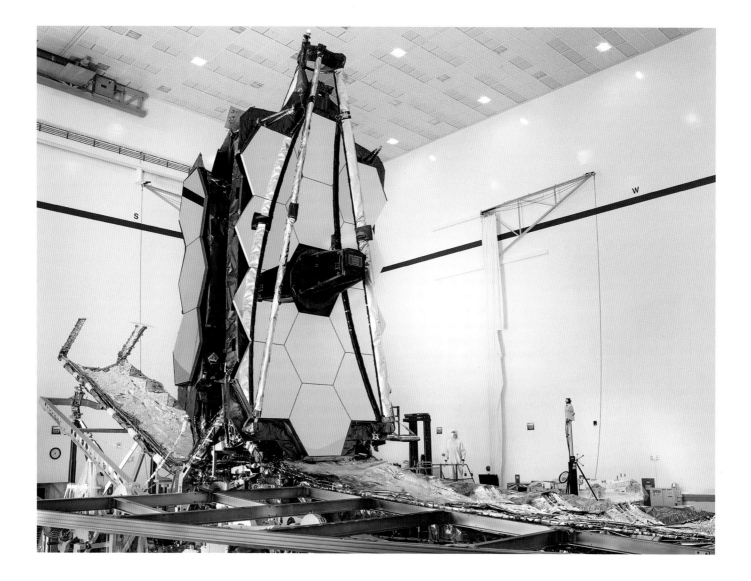

The OTIS is joined to the sunshield frame for the first time, in August 2019, at the Northrop Grumman Space Park facility in Redondo Beach, California, a mission milestone.

The yellow support structures seen here raised and lowered the folded sunshield during the early stages of the telescope's full assembly at the Northrop Grumman facility.

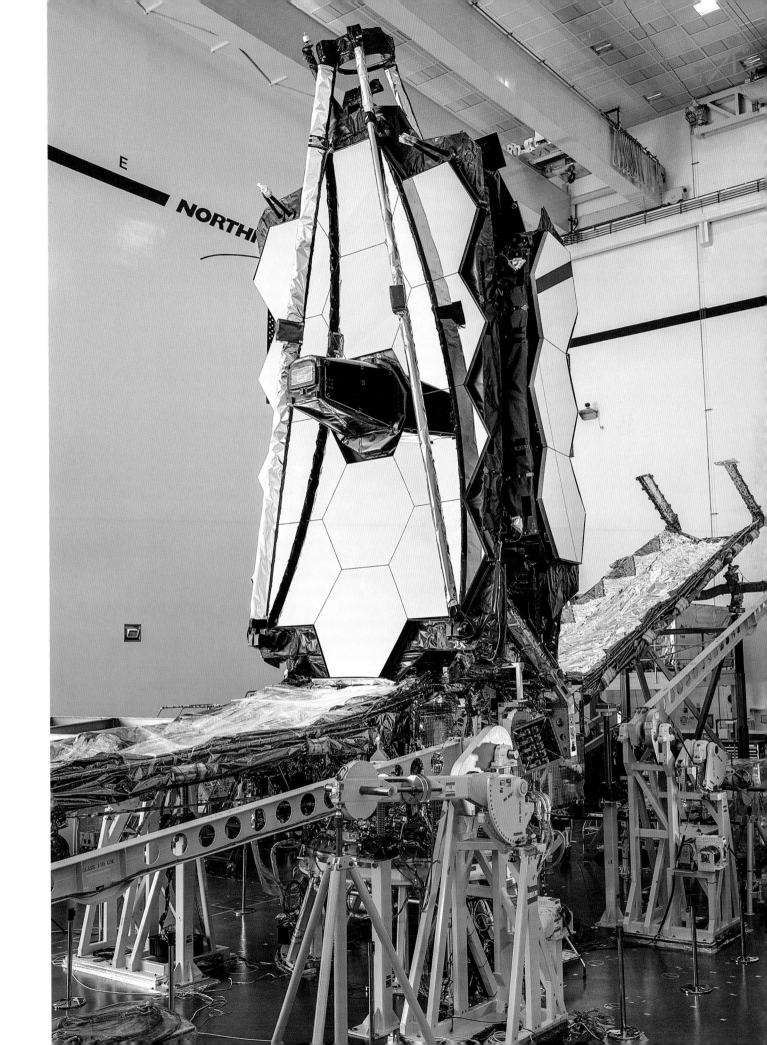

Perhaps surprising, the most technically advanced telescope ever built needs only 1 kilowatt of power to operate. That's the same as what's needed to heat up leftovers in a microwave. Seen here are four of the five solar panels that supply the energy to telescope's scientific instruments and the communication and propulsion systems. They are hinged for easy folding and stowing during launch. They now sit extended on the sun-facing side of the sunshield in orbit.

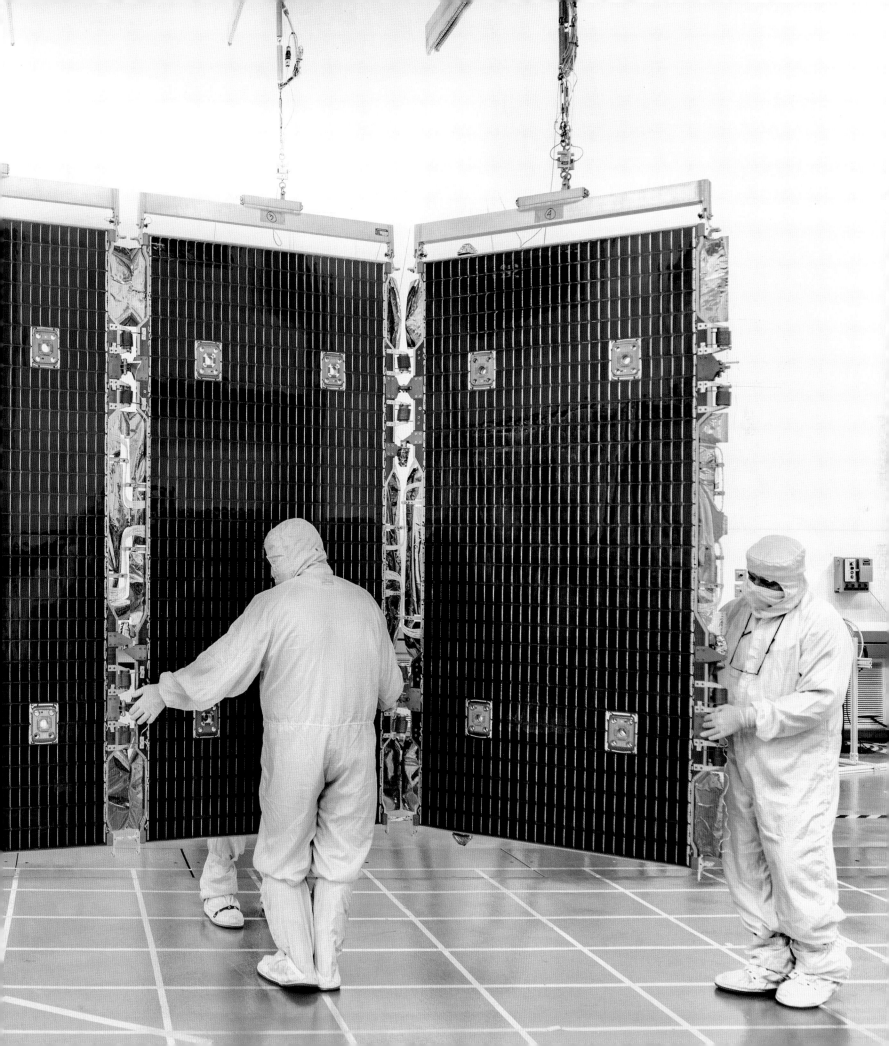

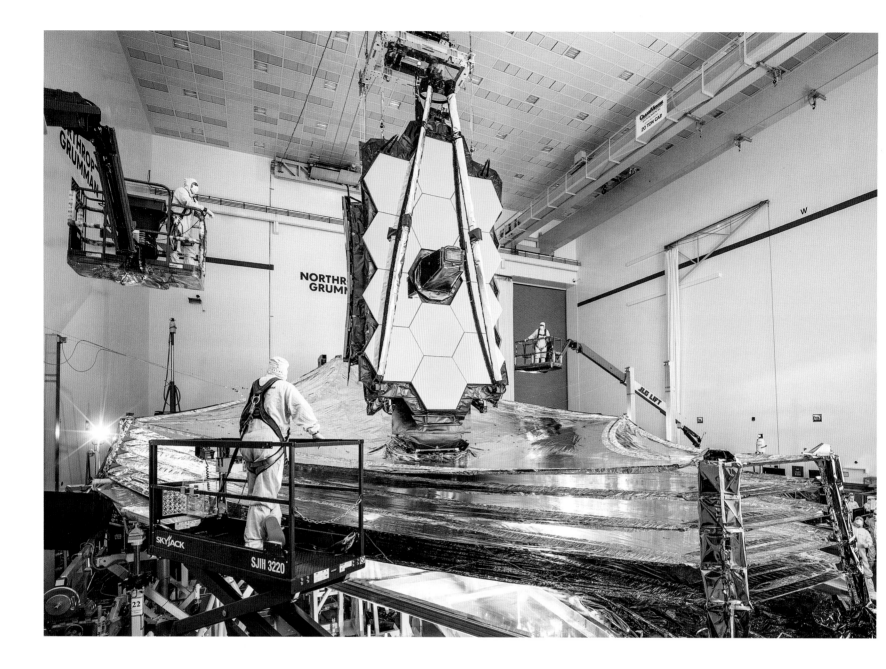

Feel the tension? Engineers inspect the telescope from every angle as it undergoes a full-tension test of the sunshield for a whole day. Accidental tears during testing in 2018 added to project delays. Each of those five layers is about the thickness of human hair and is made of Kapton film coated with aluminum for enhanced reflectivity. The purplish hue on the bottom layer—the first layer when facing the Sun—arises from a doped-silicon coating, which provides extra toughness. This first layer blocks 90 percent of the solar heat hitting the observatory.

Paul Reynolds (seen holding his hand to his head) inspects a test of the mirror wing deployment, the first time while powered directly through the spacecraft itself and not an external power source. Paul was the Northrop Grumman engineer responsible for all deployments.

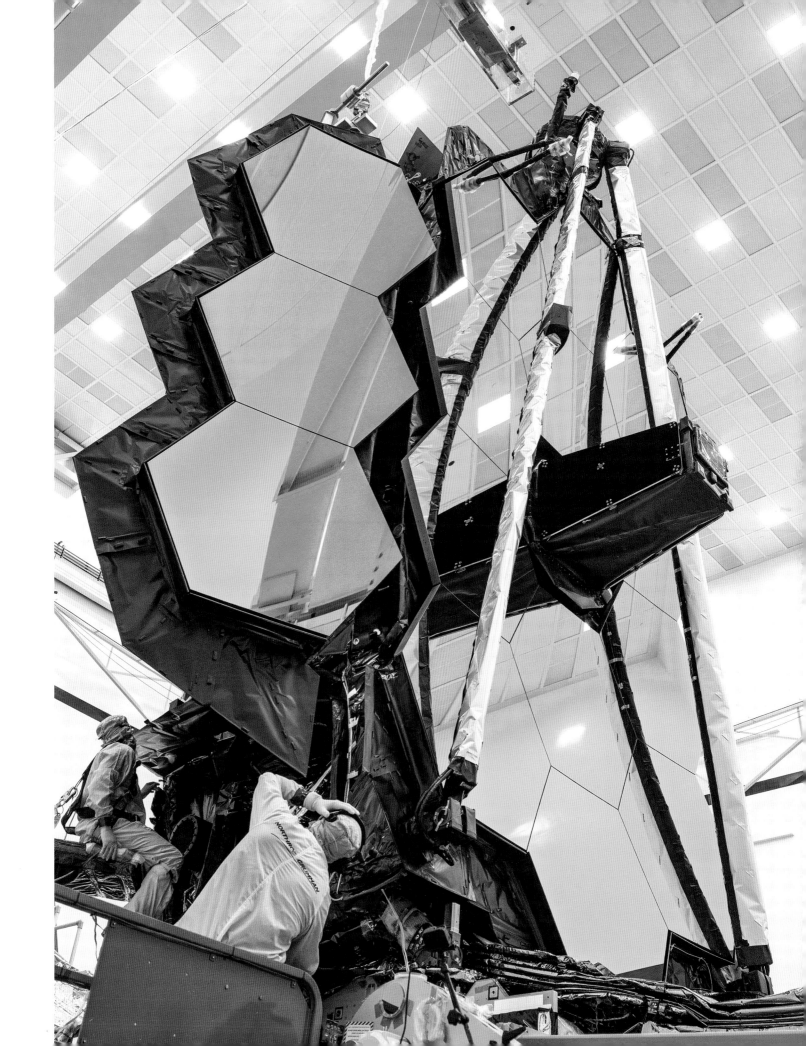

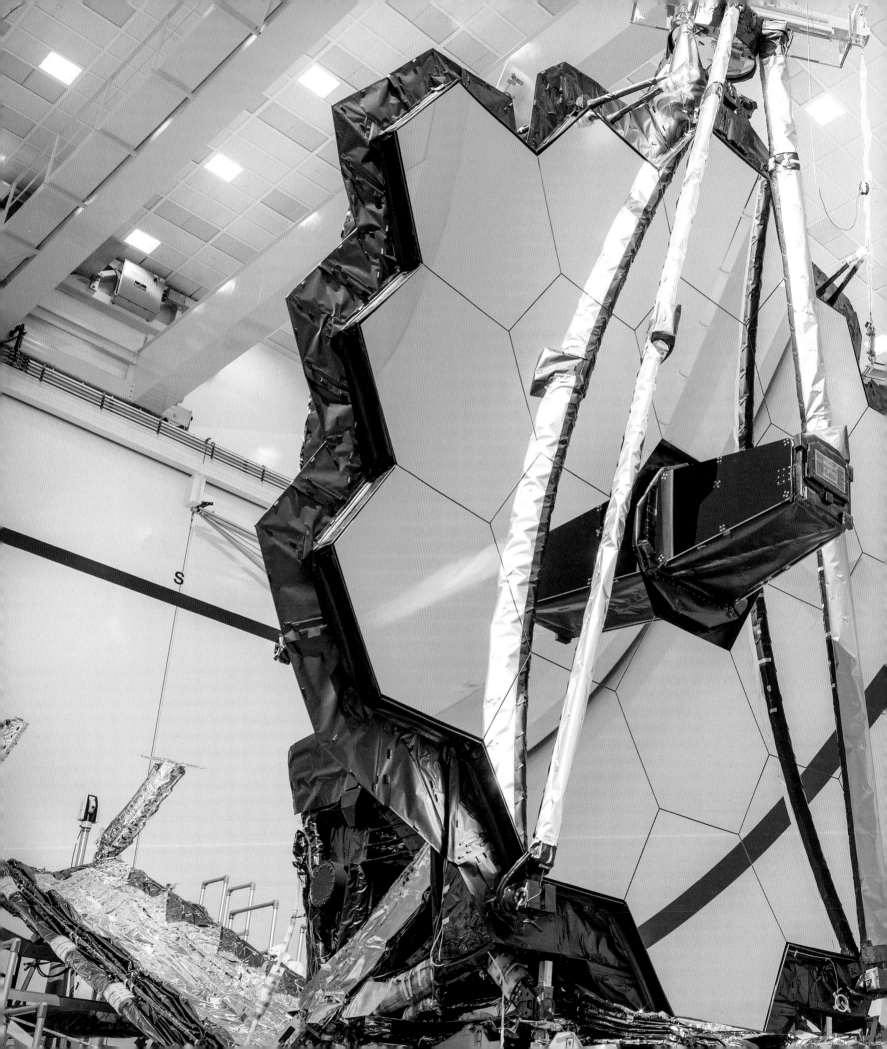

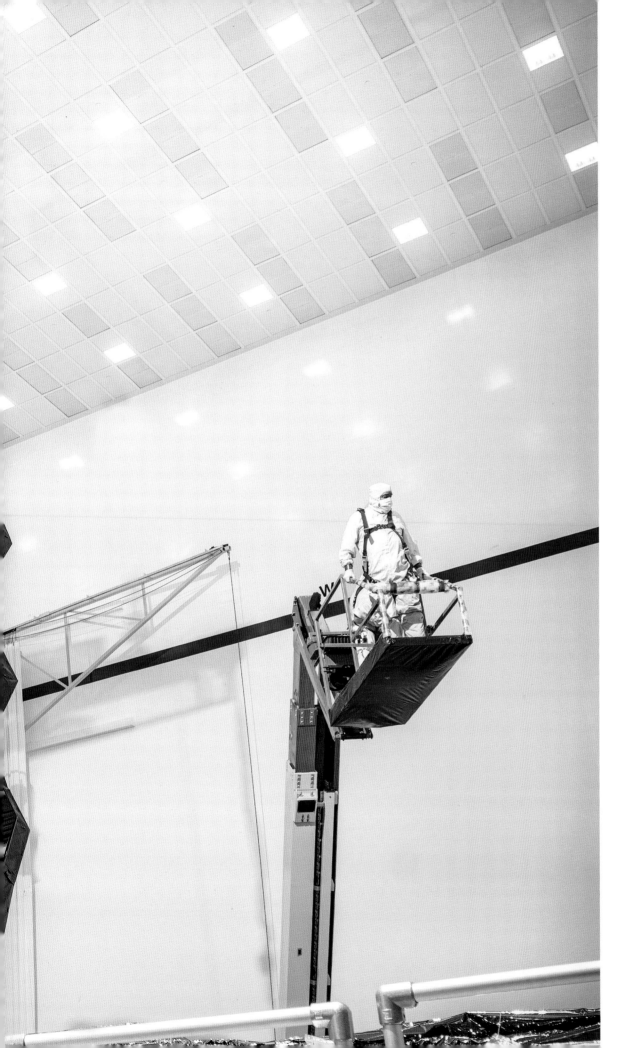

Webb engineers deploy all 18 segments of the primary mirror one last time, in spring 2020. The primary mirror would not be fully deployed again until en route to its L2 orbit.

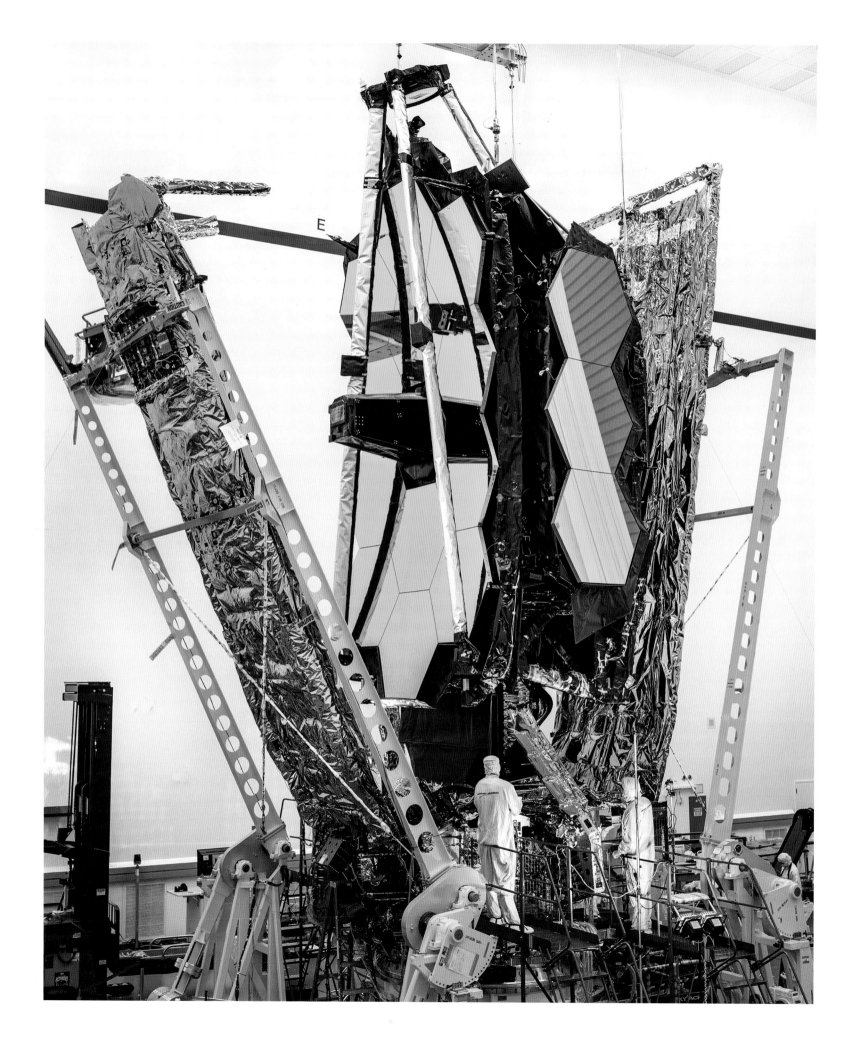

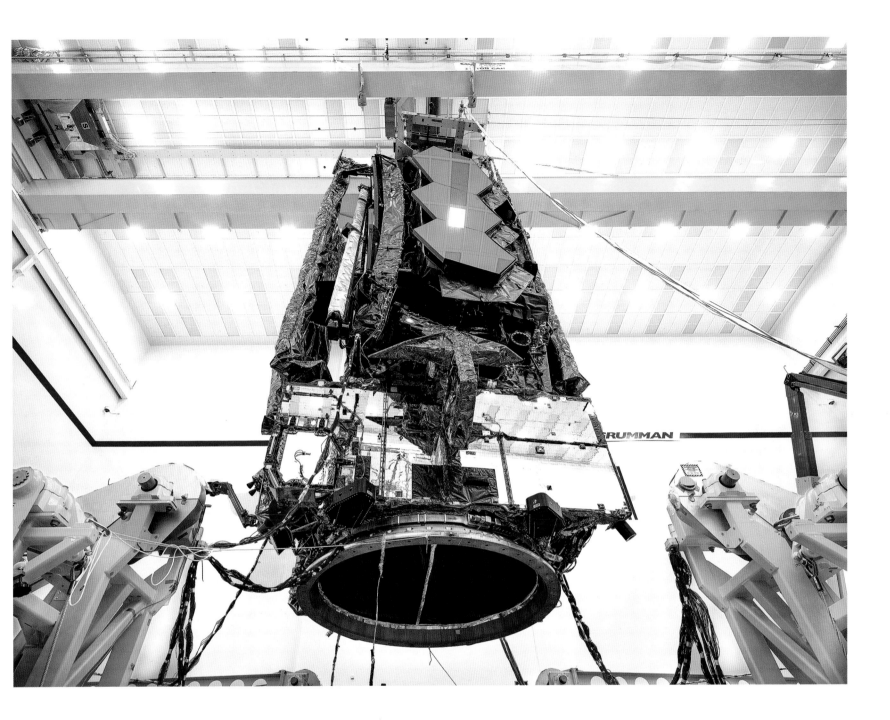

When fully stowed for launch, the sunshield would cozy up to within millimeters of the Aft-Optics System, the black object seen here in the center of the mirror.

The telescope is lifted while fully assembled for the first time, in preparation for a vibration test on August 1, 2020. The large silver box above the ring is the spacecraft bus and contains all the computing, communication, and propulsion elements of the spacecraft. The segmented roof of the Northrop Grumman facility is reflected in a three-segment wing of the primary mirror, creating an illusion of pixelation.

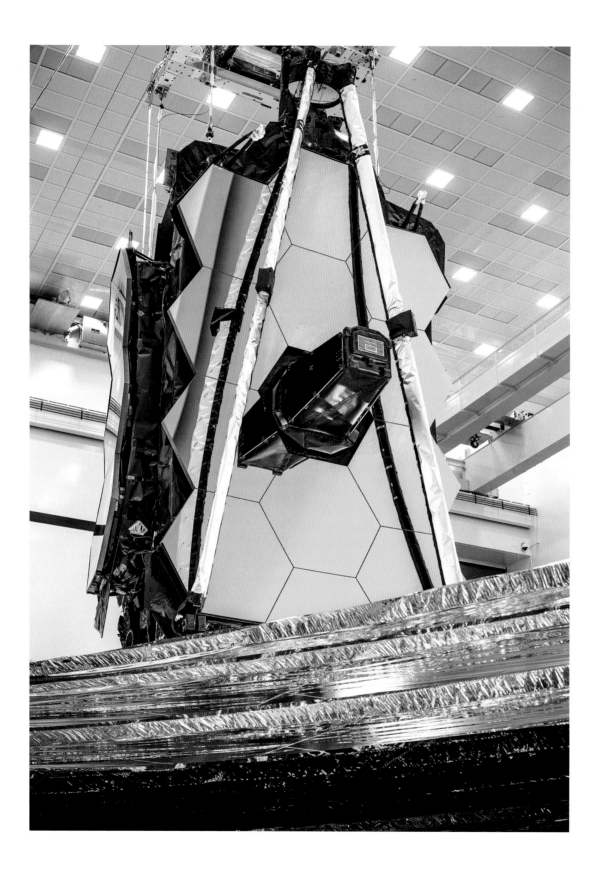

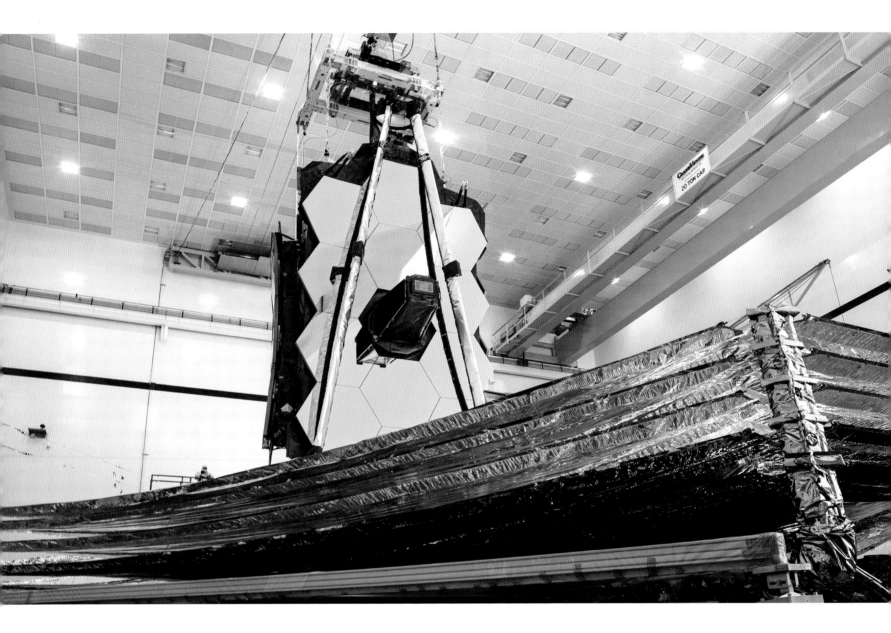

A commanding view. The Webb Telescope's primary mirror, partially deployed, is seen towering above its fully deployed sunshield. The engineer near the back wall serves as testament to the massive scale of the sunshield, about the size of a tennis court.

Webb's primary mirror maintains a small gap between segments to allow for thermal expansion and contraction and for the micro-movements of each segment. I was mesmerized by the precision. The mirror segments don't touch. The precise alignment was measured again and again through sophisticated metrology.

Both sides of Webb's sunshield are folded in preparation for shipment to the launch site. Note the rust-colored "lens cover" on the central Aft-Optics System, soon to be removed; indeed, you may be able to discern the words "REMOVE BEFORE FLIGHT."

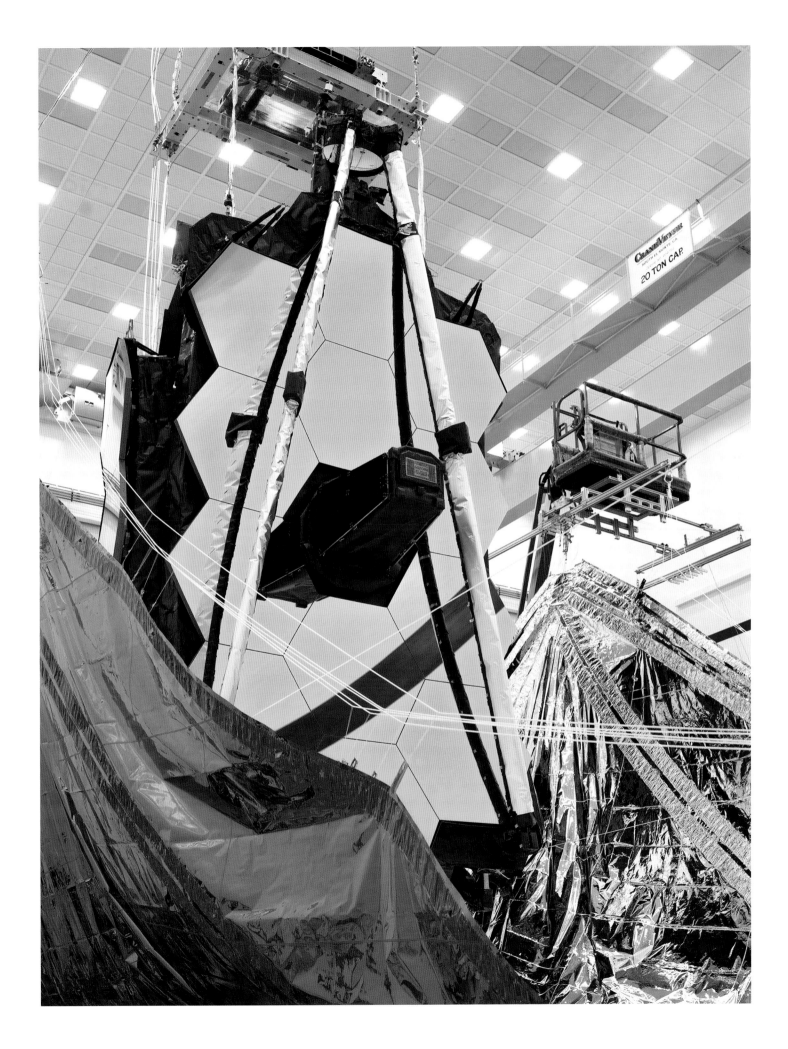

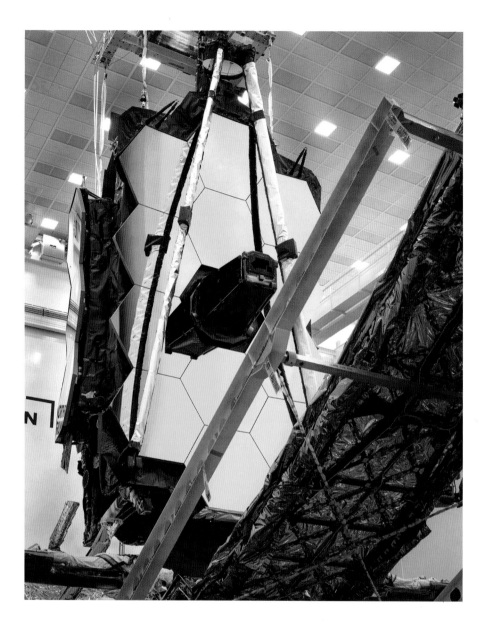

Final stow. This photograph captures the Webb Telescope just after the protective "lens cap" was removed and thus shortly before its final shipment from Northrop Grumman in California to the launch site in Kourou, French Guiana.

Packed up and ready to go. Folded in launch configuration, the Webb Telescope is hoisted off its supportive "elephant stand" to prepare for shipment by boat from Northrop Grumman in California to French Guiana for launch. The telescope would not unfold again until en route to an L2 orbit several months later.

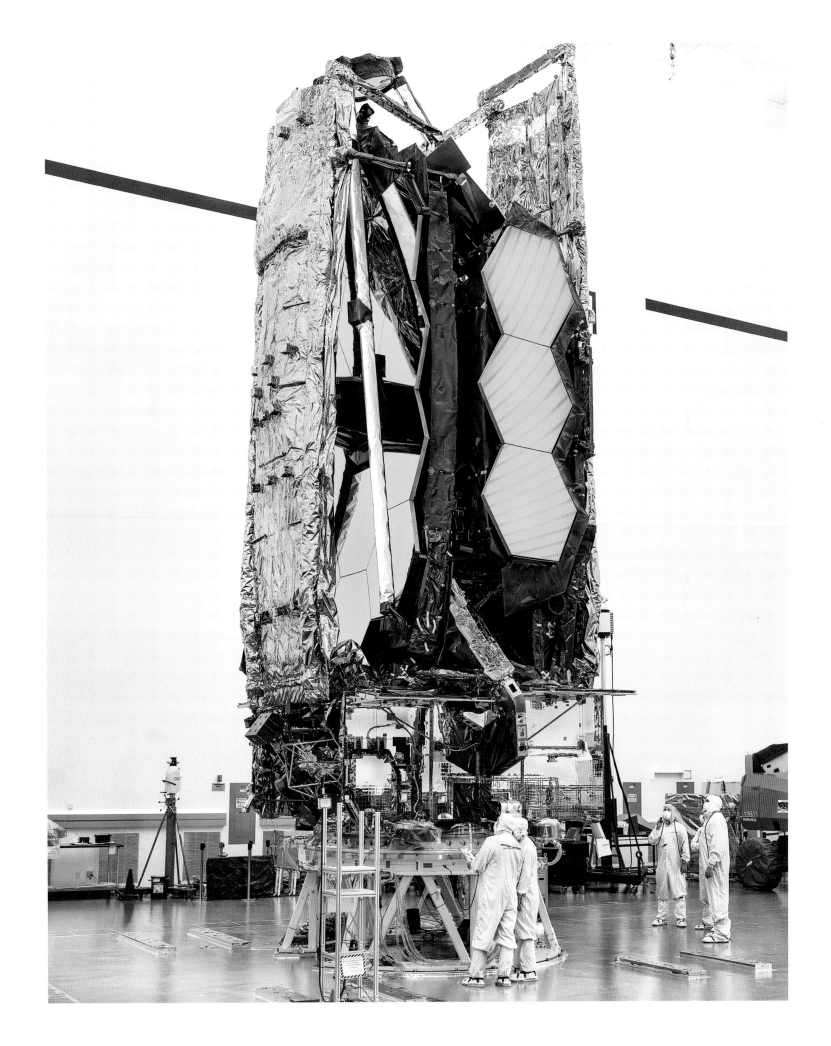

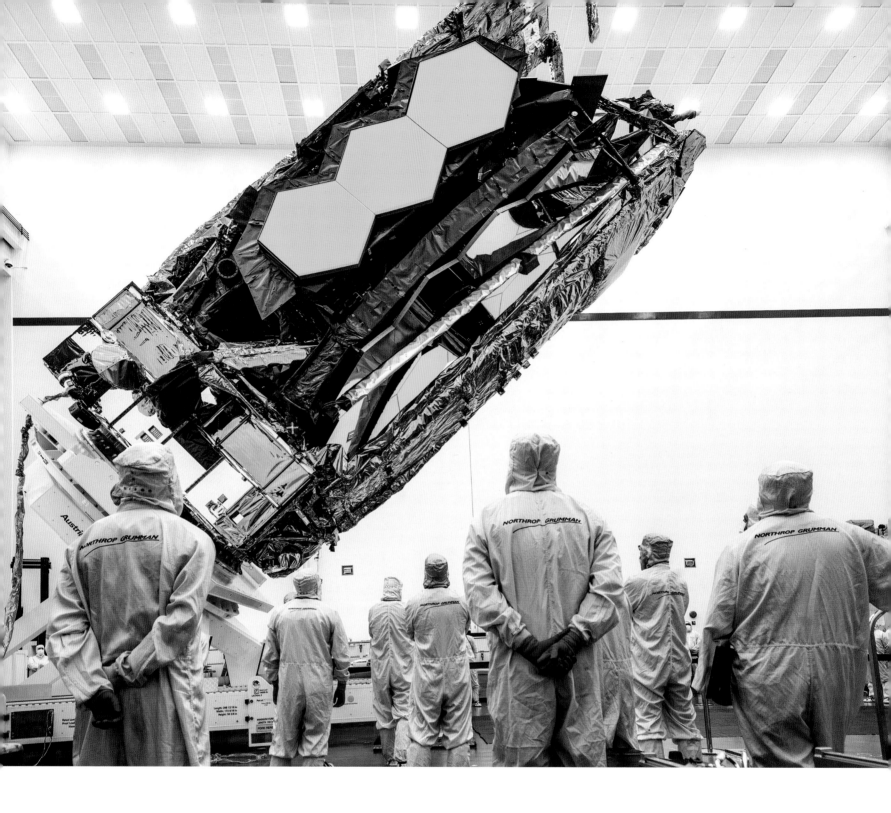

The telescope is lowered to a horizontal position to be inserted into a custom-made shipping container, the first time the fully integrated telescope was tilted. The partially assembled Webb had traveled from NASA Johnson to Redondo Beach in the Space Telescope Transporter for Air, Road, and Sea, or STTARS. Fully assembled, Webb required a larger version called "Super STTARS."

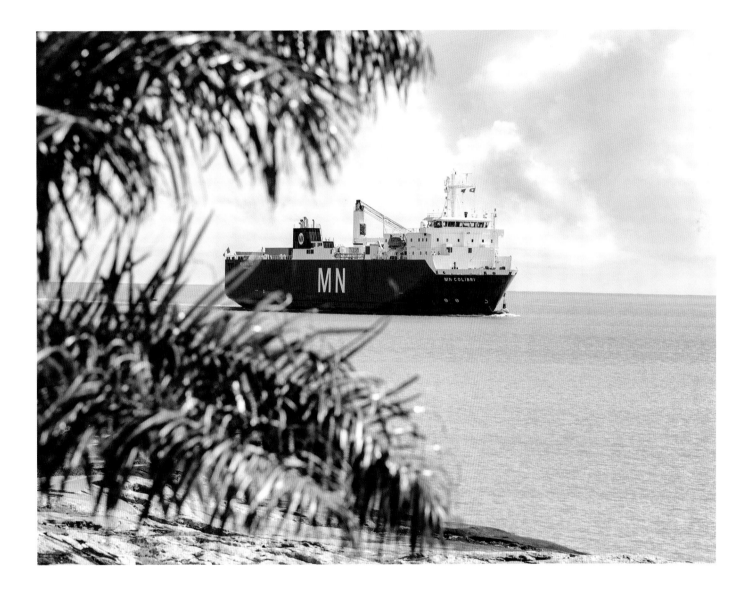

The James Webb Space Telescope arrives via a French-flagged cargo ship, MN Colibri, to French Guiana—a sixteen-day, 5,800-mile sea voyage from Redondo Beach through the Panama Canal to Port de Pariacabo on the Kourou River, with a cargo more precious than the treasure chests of gold that passed through these waters centuries ago.

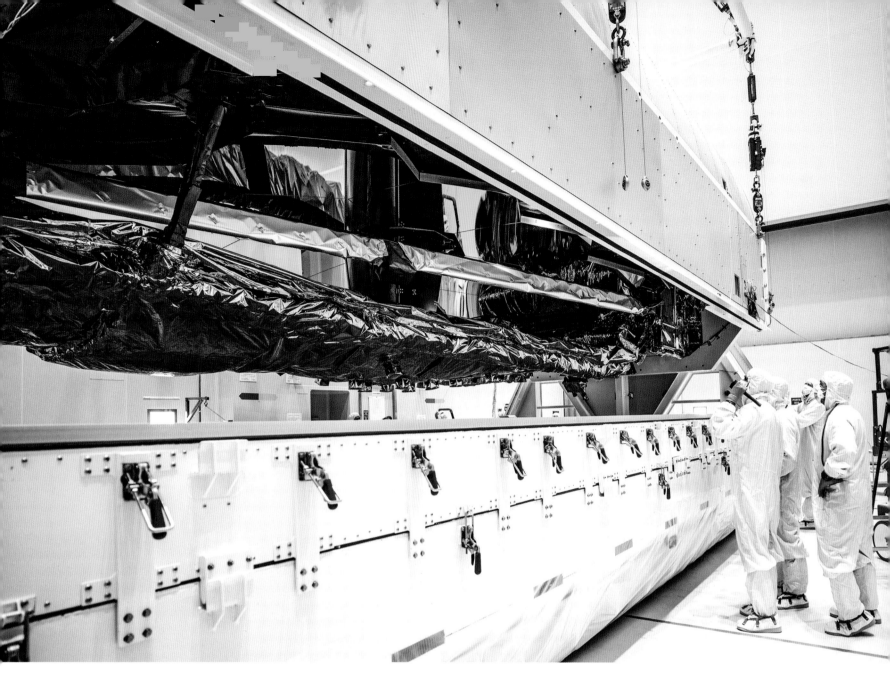

Webb arrives in Kourou on October 12, 2021, and is being removed from the Super STTARS container.

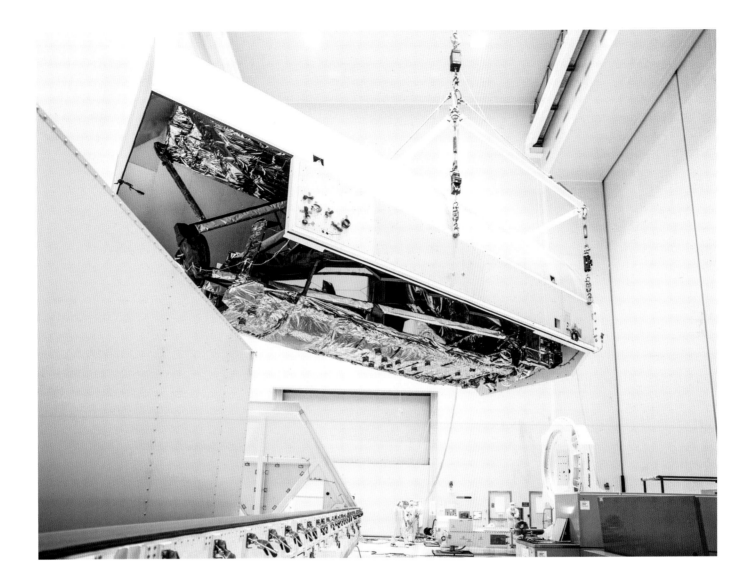

Webb is lifted out of the Super STTARS container. The entire craft is seen here in folded, launch configuration, albeit horizontal, not vertical.

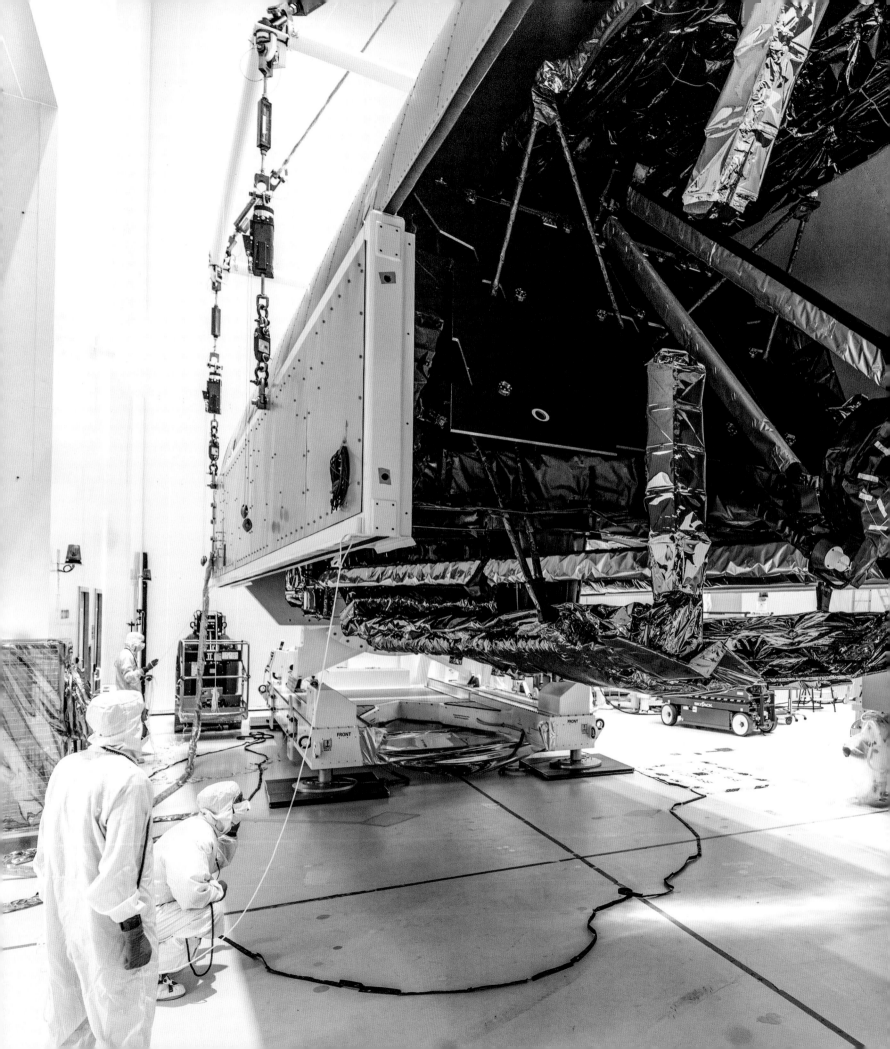

Whew. All's well with the cargo.

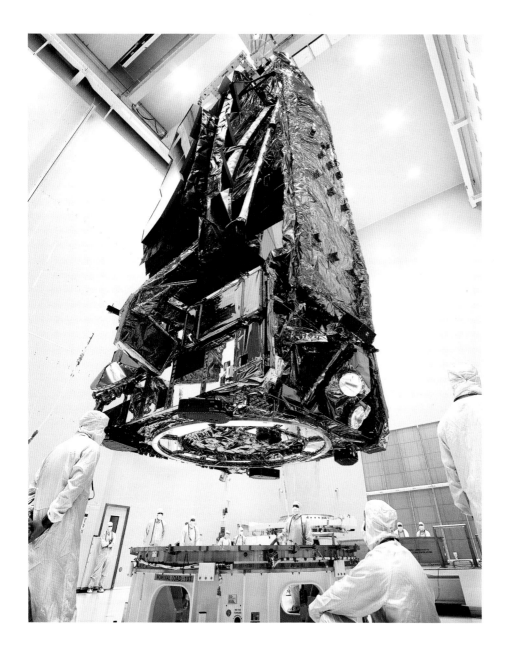

Engineers lower the telescope onto the "launch adaptor," a device that will secure the folded telescope to the launch vehicle. During a prior attachment attempt, the clamp band popped, sending vibrations throughout the telescope. No damage was detected, but the incident was enough to delay the launch for several days while engineers assessed the incident.

It's a wrap. Webb is ready for the rocket. Engineers absorb the fact that this will be the last time they see the telescope. There was a sort of happy sadness in the room. Many of the team members, including me, had spent more than ten years on this project.

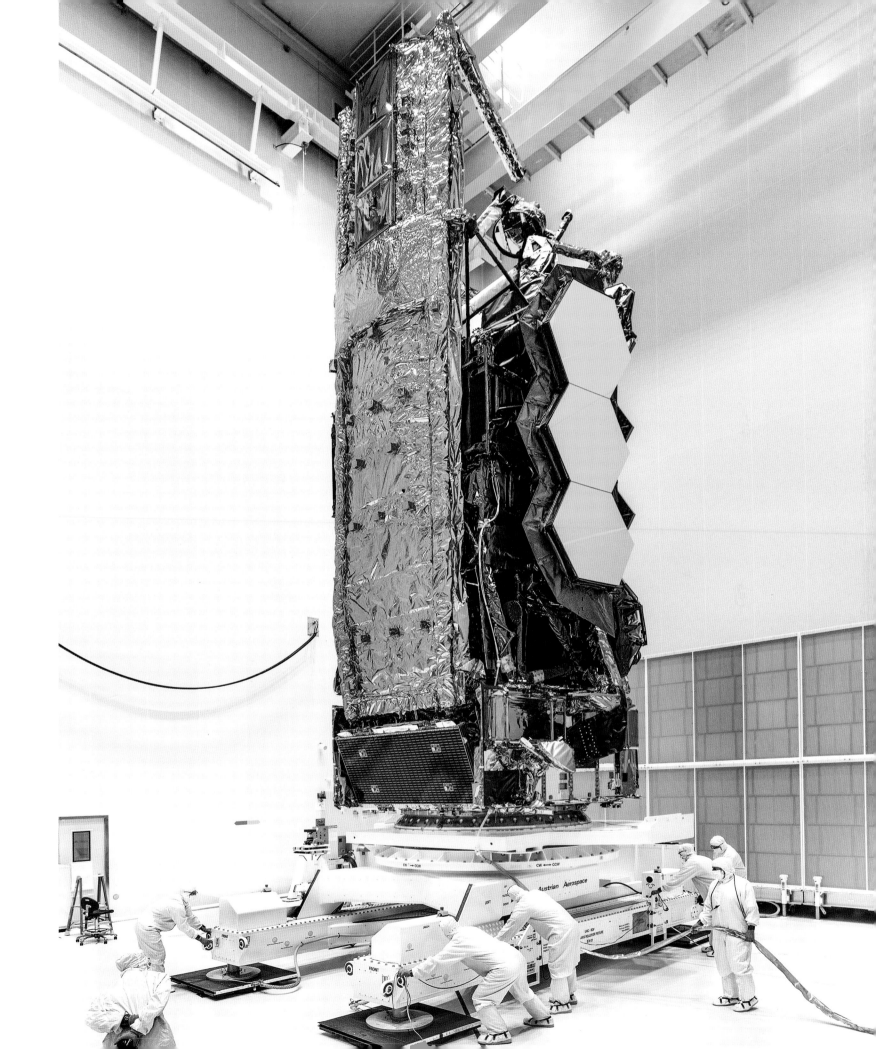

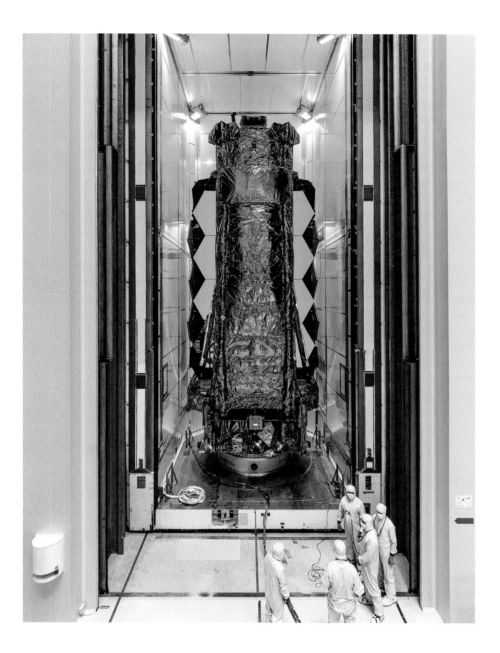

The telescope stands tall in a mobile transporter, waiting to be moved to the launch vehicle. Webb's purplish first layer of its sunshield, its golden mirrors, and the cool orange glow of mercury vapor lights make for a colorful contrast.

The folded Webb Telescope sits atop the launch vehicle—not seen, below the platform—awaiting to be encapsulated in the rocket fairing. A clean tent around the telescope provides an additional layer of protection.

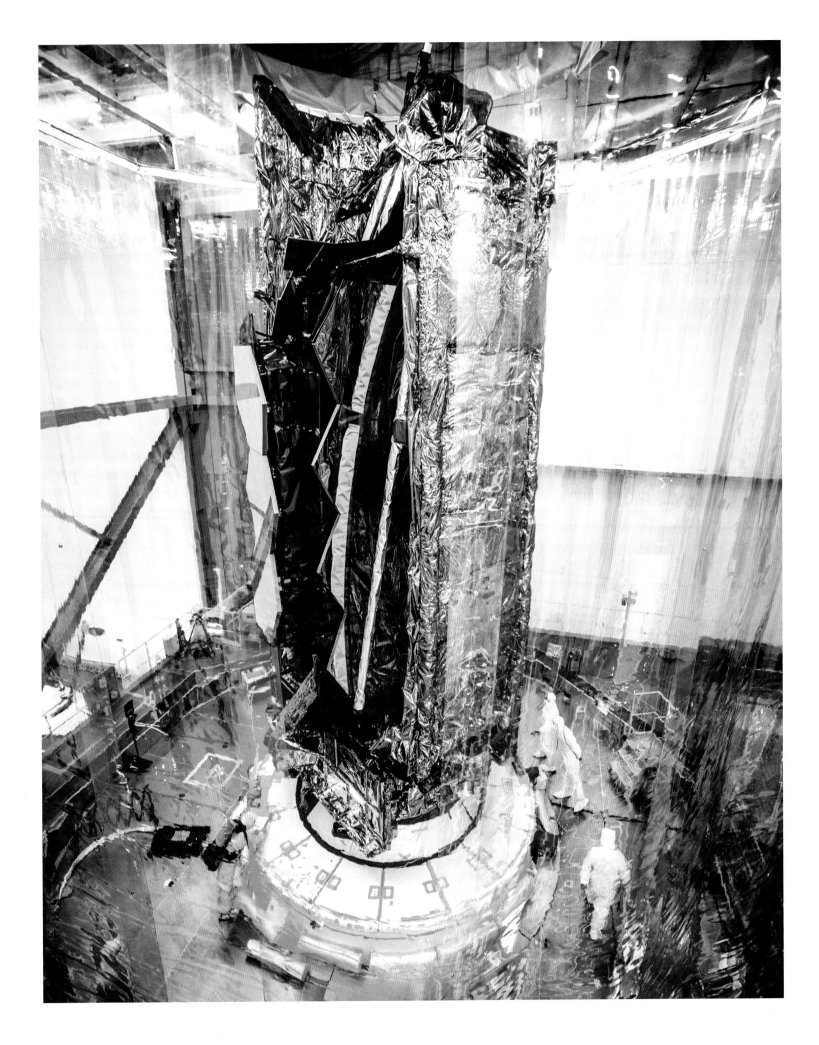

December 17, 2021: The Webb Telescope is securely enclosed within the Ariane 5 rocket fairing, or nosecone. The piping seen here helps maintain an ideal temperature and humidity in the fairing, crucial in Kourou's tropical environment. Launch would be in eight more days.

The ESA-Arianespace Ariane 5 rocket with Webb onboard, still in the final assembly building ahead of launch from the Guiana Space Centre in Kourou, French Guiana. Seen below are the rails on which the upright rocket would slowly roll to the launch pad.

Rollout: The Ariane 5 rocket with Webb onboard is rolled out to the launch pad on Thursday, December 23, 2021. This entire apparatus will inch along a train rail to the launch pad.

Thursday night, two days before launch. The ESA-Arianespace Ariane 5 rocket towers above the launch pad at the Guiana Space Centre, with the James Webb Space Telescope tucked into its fairing.

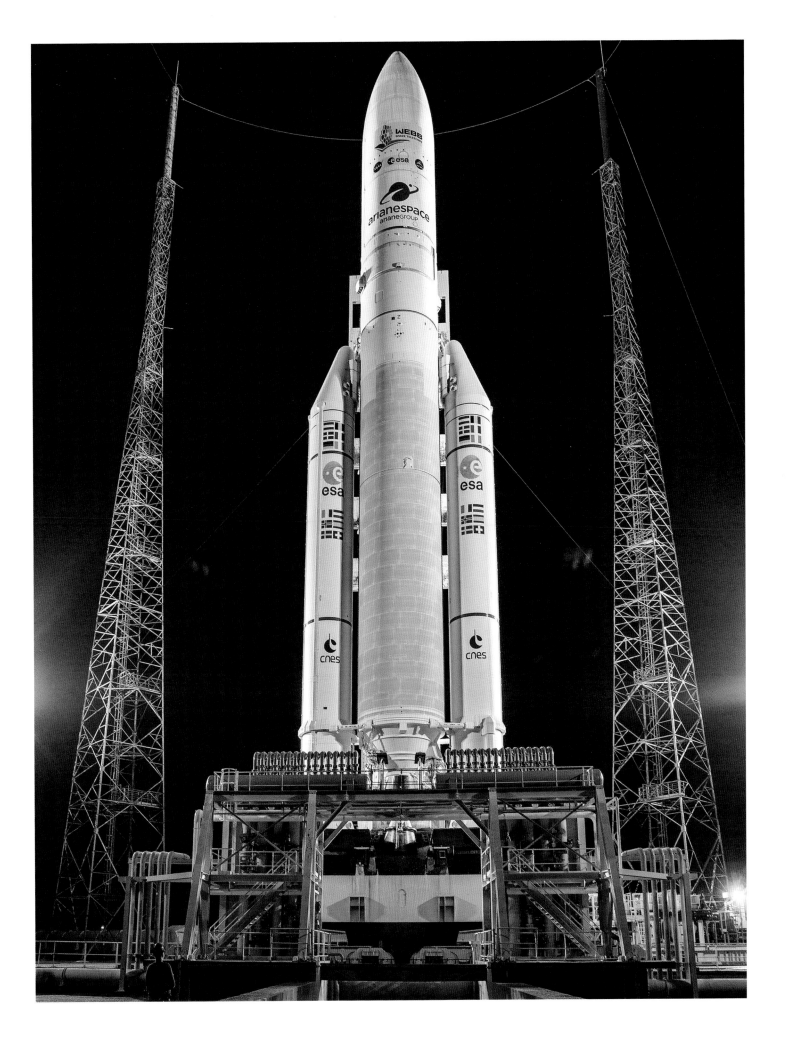

The ESA-Arianespace Ariane 5 rocket with the James Webb Space Telescope pierces the sky en route to an orbit more than a million miles from the Earth. ESA executed the launch with such precision that Webb would not need to expend any extra fuel to fine-tune its trajectory. The telescope can now use that saved fuel to operate 10 years longer than expected. Bravo ESA! And hats off to the extraordinary international Webb team!

I had two remote cameras set up for launch with triggers activated by sound. There was a high probability this wouldn't work. I had to set them up the night before the launch, covering them in plastic to protect them from the rain. It poured. The humidity was intense. I couldn't retrieve them until that evening after the launch. But when I finally processed the images, I couldn't help but tear up.

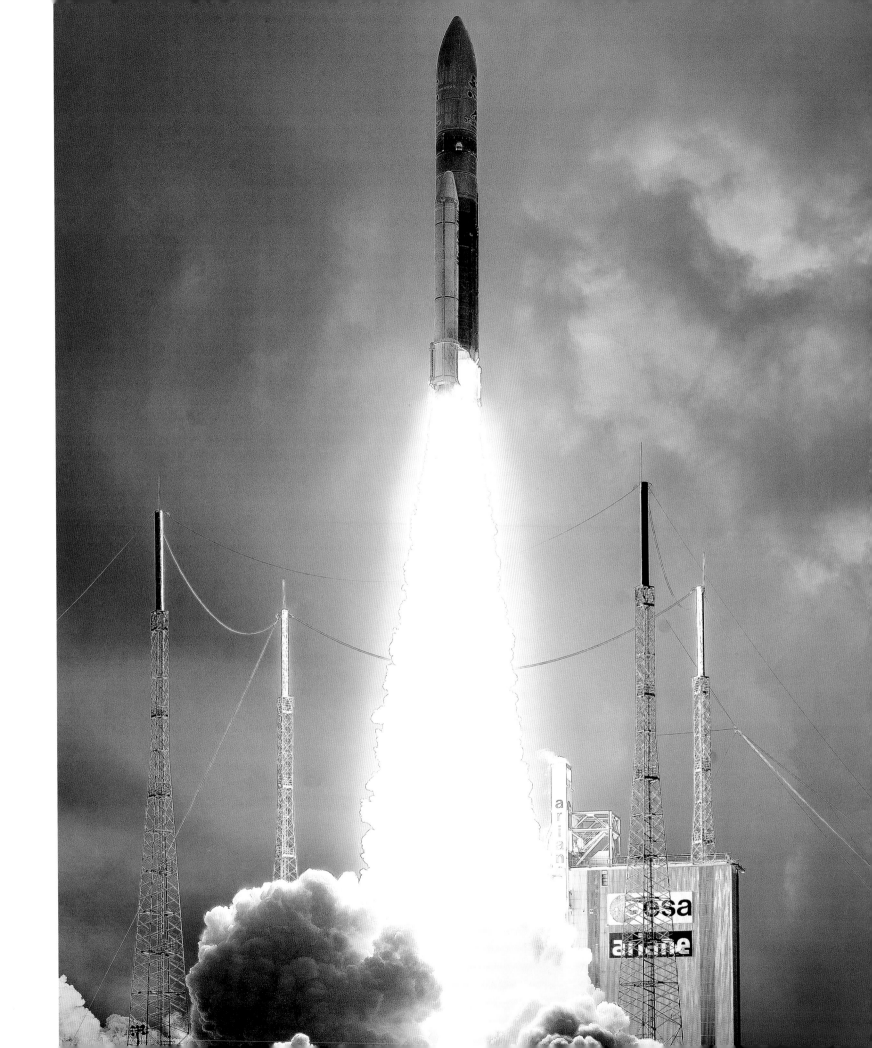

Meet the Components

Near Infrared Camera (NIRCam)

NIRCam is Webb's primary imager, built by the University of Arizona and Lockheed Martin. This is the camera that produces "Hubble-quality" images we have come to expect from space-based observatories. The range is near-infrared, wavelengths between 0.6 and 5 microns. Targets include early stars and galaxies, young stars in our galaxy, and icy Kuiper Belt objects at the edge of our solar system. This also is an instrument with a coronagraph, a device that can block the glare from a central source, such as a star, to better examine objects around it.

Near Infrared Spectrograph (NIRSpec)

NIRSpec is an advanced spectrometer to detect near-infrared wavelengths between 0.6 and 5 microns. This was built by the European Space Research and Technology Centre (ESTEC), the European Space Agency's technology development center in the Netherlands. NIRSpec's charm is its ability to observe up to 100 objects simultaneously by employing a new, hinged microshutter technology developed by engineers at NASA Goddard Space Flight Center. These shutters, about as wide as a human hair, open or close to allow NIRSpec to focus on just the objects of interest in any given field of view. Doors open via magnetic hinges.

Near Infrared Imager and Slitless Spectrograph (NIRISS)

NIRISS is another spectrometer, this one built by the Canadian Space Agency (CSA). NIRISS will be the primary instrument searching for biosignatures from exoplanets. It is integrated with another CSA instrument, the Fine Guidance Sensor, and together they often are referred to as one instrument; but NIRISS works independently.

Fine Guidance Sensor (FGS)

FGS is not a detector but rather an essential observatory tool to stabilize Webb's line-of-sight during science observations. Without it, the telescope's images and spectra would be blurry. Coupled to NIRISS, a spectrograph, the FGS was built by the Canadian Space Agency.

Mid-Infrared Instrument (MIRI)

MIRI is a combined imager and spectrograph, like NIRCam and NIRSpec combined, but in the mid-infrared range, between 5 and 28 microns. This is the instrument that can best capture highly redshifted stars and galaxies from the very early universe, just after the so-called dark age. MIRI's camera also will capture breathtaking images, like those from Hubble. Unlike the other Webb instruments, which are passively cooled to about 40 Kelvin, MIRI has to be additionally, actively cooled to 7 Kelvin, marginally above absolute zero. MIRI was an ESA instrument built in collaboration with NASA, by an extensive team led by the UK Astronomy Technology Center in Edinburgh and the University of Arizona, with technical support from NASA centers and several European countries.

Integrated Science Instrument Module (ISIM)

The ISIM is the framework that houses Webb's four main instruments: NIRCam, NIRSpec, MIRI, and the FGS/NIRISS. This is the heart of Webb, what engineers call the payload. It was built by NASA Goddard Space Flight Center. The ISIM is one of three main sections of Webb, the other two being the mirrors and the sunshield/electronics unit.

Optical Telescope Element (OTE)

The OTE comprises Webb's mirrors and support components, built by Northrop Grumman and Ball Aerospace: the gorgeous 6.5-meter gold-plated hexagonal primary mirror; the secondary mirror, 74 centimeters in diameter, which focuses light onto the detectors via a tertiary mirror; and the fine steering mirror (in the Aft-Optics System). The OTE is one of three main sections of the Webb Telescope, the other two being the ISIM and the sunshield/spacecraft bus.

The Sunshield and Spacecraft Bus

The spacecraft element of Webb comprises the sunshield and spacecraft bus. The sunshield is a novel engineering element for a space-based observatory. Roughly 21 × 14 meters, the five-layer sunshield will allow the telescope's mirrors, instruments, and detectors to cool passively to about 35–45 Kelvin. The sunshield needed to be folded twelve times to fit within the Ariane 5 rocket's 4.6 × 16.19-meter shroud. The spacecraft bus houses the computing, communication, power system, and propulsion elements of the spacecraft, as well as the cryogenic cooler compressor for MIRI. It faces the Sun for power as well as the Earth for ease of communication. The spacecraft element was built by Northrop Grumman.

Conclusion

Photography has been a part of my life since I was a child. My interest in photography grew out of a natural curiosity that extended to the sciences, including astronomy. However, I never imagined my interests would be combined as extraordinarily as they have been in the past twenty years. Witnessing and capturing the building and testing of Webb has changed my perception of human capability. Thousands of individuals played a part in making Webb a successful mission. I often liken Webb's construction to the building of *Star Trek*'s fictional Starship Enterprise. Webb's team of engineers, technicians, and scientists is a living analogue to the Enterprise's crew, boldly constructing the most impressive space-based astronomical observatory ever built. I am both honored and humbled to be a part of this voyage.

My coauthor Christopher Wanjek and I hope this book has inspired you with its chronicling of the Webb mission's origins, development, construction, and launch.

Chris Gunn

Acknowledgments

The near entirety of Chris Gunn's images displayed in this book were captured using a digital medium-format camera made by Hasselblad. Special thanks to Bill Ochs at NASA for supporting the acquisition of this equipment.

Additionally, we would like to acknowledge the support of the eleven Webb team members profiled in this book, as well as the following people in alphabetical order: James S. Abell (1), John G. Abraham (1), Scott Acton (4), Cynthia K. Adams (1), Tanjira Ahmed (1), Shaune S. Allen (1), Serhat Altunc (1), Leslie L. Ambrose (1), Satya M. Anandakrishnan (3), Gregory C. Andersen (1), Kristen Anderson (3), Benita J. Archer (1), Charles B. Atkinson (3), Lynn L. Baker (1), Kimberly A. Banks (1), David A. Baran (1), Larry K. Barrett (1), Allison Barto (4), Larry Bellagama (3), Timothy W. Berger (3), Laura E. Betz (1), Kurt F. Bjorklund (3), James D. Blackwood (1), Stephen Blossfeld (3), Nicholas A. Bond (1), Rene A. Boucarut (1), Charles W. Bowers (1), Leslye A. Boyce (1), Judith L. Brannen (1), Hannah Braun (5), Brian J. Broiles (1), Bruce Brown (3), Jonathan G. Bryson (1), Edwin D. Bujanda (3), Blake M. Bullock (3), Irving J. Burt (1), Marie C. Bussman (1), Steven Cale (1), Charles D. Calhoon (1), Thaddeus Cesari (1), Lynn Chandler (1), Dave Chaney (4), Jeffrey I. Cheezum (3), Mark Clampin (2), Charles R. Clark (1), Stephanie M. Clark (1), Edward E. Claybrooks (1), Keith A. Cleveland (1), Andrew L. Cohen (3), Knicole D. Colón (1), Brian J. Comber (1), Dennis C. Connolly (1), James Contreras (4), James L. Cooper (1), Michael F. Correia (1), Brian F. Costanza (3), Ray T. Coyle (3), Christopher T. Dailey (1), Greg S. Davidson (3), Michael S. Davis (1), Ratna Day (1), Bruce H. Dean (1), Amy S. Delisa (1), Lawrence C. Dell (1), Sandor Demosthenes (4),

Maureen O. Disharoon (1), Keisha L. Dominguez (1), Cristina M. Doria-Warner (1), Heather Doty (4), Phillip A. Driggers (1), Jamie L. Dunn (1), Sanghamitra B. Dutta (2), Lee D. Feinberg (1), John I. Francisco (3), Randy Franck (4), David E. Franz (1), Katheryn E. Friend (3), James R. Frost (1), Anthony D. Galyer (1), Jonathan P. Gardner (1), Paul H. Geithner (1), John C. Gereau (3), Robert Giampaoli (3), Paul C. Gibbons (1), Larry Gilman (3), Stuart D. Glazer (1), Shawn J. Gordon (3), Christopher M. Grau (1), Matthew A. Greenhouse (1), Edgar M. Greville (1), Stefano Grimaldi (4), Frank E. Groe (3), John Guldalian (3), Anthony Gurule (4), Jeffrey Hammann (3), Pamela Harris (1), Hashima Hasan (2), Sujee J. Haskins (1), Vince J. Heeg (3), Reem Hejal (3), Kristopher A. Helm (3), Nicholas J. Hengemihle (1), Michael R. Hinz (3), Michael Hirsch (3), Joseph M. Howard (1), Jean M. Huber (1), Spencer W. Hurd (1), Jason E. Hylan (1), Sandra M. Irish (1), Wallace C. Jackson Jr. (3), Jasmin Jahic (3), Amir Jahromi (1), Bryan James (1), John C. James (1), Raymond D. Jandra (3), Basil S. Jeffers (1), Alan T. Johns (1), Eric L. Johnson (1), Thomas K. Johnson (1), Gregory S. Jones (3), Ronald A. Jones (1), Reginald Jue (3), Mark H. Jurkowski (1), Samuel K. Kan (3), Leigh L. Kelley (1), Ritva A. Keski-Kuha (1), Randy A. Kimble (1), Richard C. King (1), Jeffrey R. Kirk (1), Marc E. Kirkpatrick (3), Lana Klingemann (4), Paul U. Klintworth (3), Scott Knight (4), Perry J. Knollenberg (3), Earl T. Kofler (3), Vicki L. Kontson (1), Monica R. Kristoffersen (3), Claudia Krogel (1), Scott D. Lambros (1), Matthew Ed Lander (1), Jon F. Lawrence (1), David W. Lee (3), Joshua S. Levi (3), Frederick C. Lim (1), Sai-Kwong Ling (3), Lisa J. Link (1), Lynette Lobmeyer (4), Jennifer M. Love-Pruitt (3), Robert A. Luetgens (3), Annetta J. Luevano (3), James M. Lund III (3), Ray A. Lundquist (2), Matthew J. Macias (3), Keith I. Macklis (3), Rishabh Y. Maharaja (1), Konstantinos G. Makrygiannis (3), Eliot M. Malumuth (1), Kristin L. Martinez (4), Gary Matthews (1), Glen A. McBrayer (3), Leslie A. McClare (1), Michael D. McClare (1), John C. McCloskey (1), Taylore D. McClurg (3), Martin McCoy (1), Michael W. McElwain (1), Roy D. McGregor (3), Douglas B. McGuffey (1), Andrew G. McKay (3), William K. McKenzie (1), Lindsay McLaurin (3), Kimberly L. Mehalick (1), Michael P. Menzel (1), Michael T. Menzel (1), David D. Mesterharm (1), Luis E. Meza (3), William C. Miller (1), Cherie L. Miskey (1), Eileen P. Mitchell (1), Martin Mohan (3), Emily E. Montoya (1), Michael J. Moran (3), Michael Moschos (3), Gary E. Mosier (1), Jason S. Muckenthaler (3), Stephanie M. Mullen (1), Alan J. Munger (3), Jess Murphy (4), Fred Richard R. Myers (3), Adrian F. Nagle IV (4), Susan G. Neff (1), John Nella (3), Michael N. Nguyen (1), Mary Ann Nishisaka (3), Marcus B. O'Brien (3), Robyn C. O'Mara (1), Raymond G. Ohl (1), Richard Ottens (1), Daria J. Outlaw (1), Keith A. Parrish (1), Laura Paschal (1), Keith Patrick (3), Robert A. Pattishall Jr. (3), Shirley J. Paul (1), James M. Pierson (1), Joseph T. Pitman (1), John A. Pohner (3), James T. Pontius (1), Susana C. Porges (3), Gregg D. Potter (3), Christine Pulliam (5), Robert Rapp (1), Robert A. Rashford (1), Bernard J. Rauscher (1), Tynika N. Rawlings (1),

Carl A. Reis (1), Tom B. Reoch (3), Paul J. Reynolds (3), Karen V. Richon (1), Richard E. Rifelli (3), Jane R. Rigby (1), Nancy J. Ringel (1), Scott O. Rohrbach (1), Felipe P. Romo (1), Jose J. Rosales (1), Anthony F. Roteliuk (3), Marc N. Roth (3), Chunlei Rui (3), Michael B. Ryan (3), Richard M. Ryan (2), Rick Sabatino (1), Stephen Sabia (1), Bridget S. Samuelson (3), Tina M. Schappell (1), Ron Scherer (3), Conrad Schiff (1), Donald J. Schmude (3), Curtis H. Schwartz (1), Michelle B. Scott (1), Bonita L. Seaton (1), Even Sheehan (1), Kartik Sheth (2), Noah Siegel (4), Debra D. Simmons (3), Jeffrey E. Slade (1), Corbett T. Smith (1), Eric P. Smith (2), Erin C. Smith (1), Koby Smith (4), John L. Smolik (3), Jeff Sokol (4), Peter R. Sooy (1), Dana M. Southwood (3), Joseph Sparmo (1), David T. Speer (1), Joseph D. Sprofera (3), Marcia K. Stanley (1), Christopher C. Stark (1), Carl W. Starr (1), Diane Y. Stassi (1), Jane A. Steck (1), Christine D. Steeley (1), Matthew A. Stephens (1), Ralph J. Stephenson (3), Alphonso C. Stewart (1), Scott Streetman (4), Jingping F. Strobele (3), Pamela C. Sullivan (1), Sandra M. Sumner (1), Diane F. Swenton (1), Robby A. Swoish (3), Andrew Tao (3), Scott C. Texter (3), Shaun R. Thomson (1), C. M. Tierney (3), Omar Torres (3), Christine L. Tsukamoto (3), Julie Van Campen (1), Dona D. Vanterpool (1), Michael R. Vernoy (3), Maria Begoña Vila Costas (1), Ray Villard (5), Mark F. Voyton (1), Darryl J. Waddy (1), Frederick E. Walker Jr. (3), Francis C. Wasiak (1), Matthew F. Wasiak (1), James Wehner (3), Kevin R. Weiler (3), Stanley B. Weiss (3), Lauren Wheate (1), Christy L. White (3), Paul Whitehouse (1), Donna V. Wilson (1), Cindy Woo (3), Robert T. Woods (3), Carl Wu (1), Dakin D. Wun (3), Isabelle C. Yan (1), Keith C. Yang (3), Gary Young (3), Gene Yu (3), and Christian A. Zincke (1).

(1) NASA Goddard Space Flight Center
(2) NASA Headquarters
(3) Northrop Grumman
(4) Ball Aerospace
(5) Space Telescope Science Institute

Index

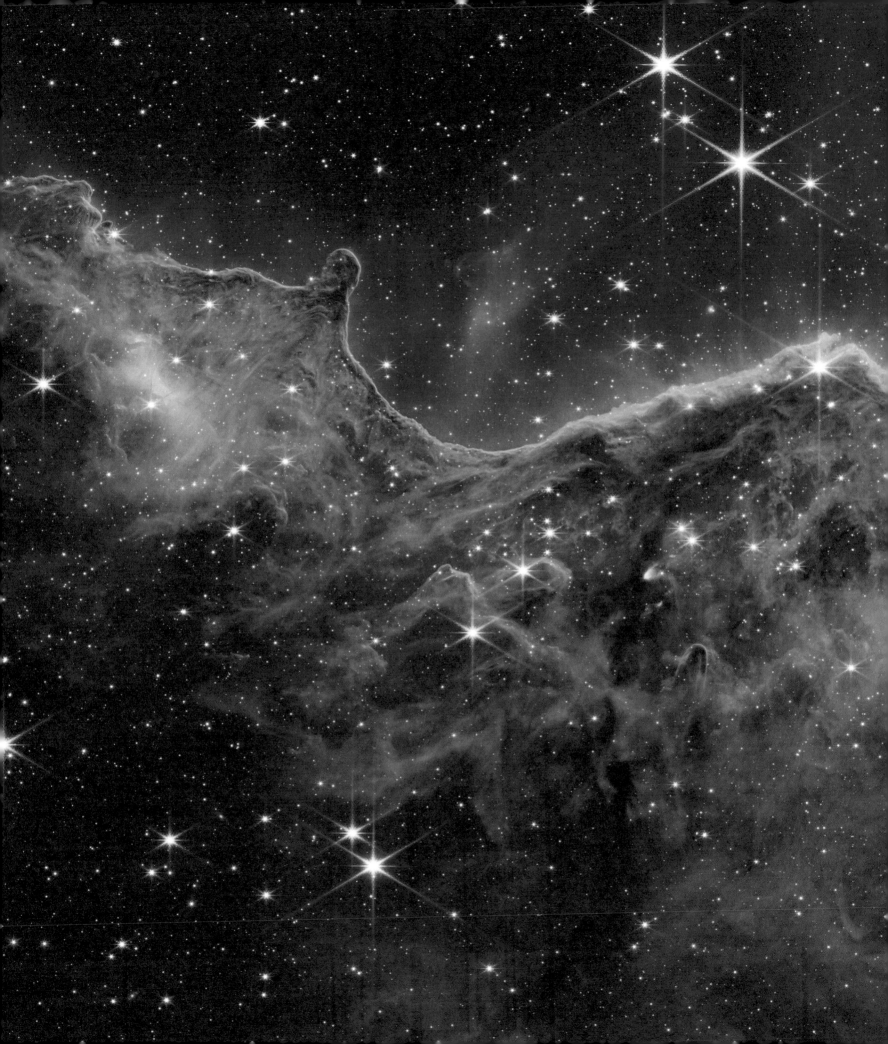